SHERIDAN

THE CUTTING EDGE IN CRAFTS

SHERIDAN

THE CUTTING EDGE IN CRAFTS

Edited by James Strecker

The BOSTON MILLS PRESS

ACKNOWLEDGMENTS

Thanks to all contributors and to the faculty, alumni, and students of the Sheridan College School of Crafts and Design for their many generously offered suggestions that ultimately helped to shape the final form of this book. Special thanks for timely encouragement from Peter Hogan, Betty Kantor, Donald McKinley, Daniel Crichton, Skye Morrison, Anne Lemiieux, Robert Diemert, Ronald Holgerson, Winn Burke, Bruce Cochrane, Stefan Smeja, Alison Vallance, and Sheldon Levy.

Published with the assistance of Sheridan College

Thanks as well to the following: Lisa Prinn, for her sympathetic insight and skill in the portion of interviews she conducted; Karin England, for her dedication and informed input in the realization of this book, especially her many editorial suggestions; Gloria Marshall, for her diligent proofreading; Sheridan College, for granting me sabbatical leave to research, compile, and write this book; Diane Janzen, for helping research to flow smoothly; Finnegan, who served supportively as my office cat-in-residence; Gillian Stead, Noel Hudson and John Denison of Boston Mills Press; and, as always, Margaret, for the gifts of perspective, sanity, and everything else.

Canadian Cataloguing in Publication Data

Main entry under title

Sheridan: the cutting edge in crafts

ISBN 1-55046-301-0

1. Sheridan College. School of Crafts and Design. 2. Sheridan College.
School of Crafts and Design–Alumnia and alumnae. 3. Artisans–Ontario–
Biography. 4. Decorative arts–Ontario. I. Strecker, James, 1943–

NK420.C3S53 1999 745.071'1713533 C99-930167-5

04 03 02 01 99 1 2 3 4 5

Published in 1999 by
Boston Mills Press
132 Main Street
Erin, Ontario N0B 1T0
Tel 519-833-2407
Fax 519-833-2195
e-mail books@boston-mills.on.ca
www.boston-mills.on.ca

An affiliate of
Stoddart Publishing Co. Limited
34 Lesmill Road
Toronto, Ontario, Canada
M3B 2T6
Tel 416-445-3333
Fax 416-445-5967
e-mail gdsinc@genpub.com

Distributed in Canada by
General Distribution Services Limited
325 Humber College Boulevard
Toronto, Canada M9W 7C3
Orders 1-800-387-0141 Ontario & Quebec
Orders 1-800-387-0172 NW Ontario & Other Provinces
e-mail customer.service@ccmailgw.genpub.com
EDI Canadian Telebook S1150391

Distributed in the United States by
General Distribution Services Inc.
85 River Rock Drive, Suite 202
Buffalo, New York 14207-2170
Toll-free 1-800-805-1083
Toll-free fax 1-800-481-6207
e-mail gdsinc@genpub.com
www.genpub.com
PUBNET 6307949

Design by Gillian Stead
Films work by Rainbow Digicolor Inc.
Printed in Canada

This book is dedicated

to the students, alumni, faculty, staff, and friends

of Sheridan College School of Crafts and Design,

in part for the inspiring standard of creativity they have given to us.

It is especially dedicated, with deepest gratitude,

to the memory of Betty Kantor and Donald McKinley,

for their presence then and now.

What the Book Is

Sheridan:The Cutting Edge in Crafts is intended to celebrate the thirty years of Sheridan College School of Crafts and Design as a learning institution and the school's major contribution, through its alumni and teachers, to the excellence of Canadian crafts.

This book focuses, therefore, on the works of forty-eight alumni, twelve from each of the school's existing four studios — ceramics, furniture, glass, and textiles. These alumni were selected, by faculty in the studios in which they studied, as representative of the creative accomplishment of SOCAD alumni and of the profound contribution of SOCAD alumni to crafts in Canada and abroad. Each alumnus is presented through a photograph of a representative creation, the craftsperson's discussion about the work, and an appreciation of the work by an informed person in the craft world.

Needless to say, limitations of space required the omission of many dozens of equally important craftspersons who had at one time studied at SOCAD. Their immense contribution is gratefully acknowledged and celebrated here nonetheless.

Craft Culture is also intended to take the reader inside the many realities of the craftsperson's existence. Thus the book includes six theme chapters and each one, in turn, explores six significant issues or aspects of the craft world. Although these thirty-six mini-chapters do not claim to be comprehensive or thorough in dealing with their respective issues, they do provide a concise richness of many informed insights from inside the craft world, a richness the reader might carry into future experience of crafts. The quotations in these mini-chapters are taken from interviews with a variety of persons connected with the School of Crafts and Design, including alumni, students, teachers, and patrons of crafts.

At the end of the book, the reader will find brief biographies of the craftspersons whose work is featured herein and of all contributors of appreciations and theme discussions. The book ends appropriately with a brief and flavourful memoir by Donald McKinley, SOCAD's first Director and longtime Furniture Studio Master, who was, until his recent death, the furniture studio's artist-in-residence.

Finally, except for the Statement by each craftsperson and several of the Appreciations, the text of this book has been compiled from in-person interviews in order to capture the flavour of how people actually talk in many shades of nuance about crafts and related issues.

Contents

Portfolio: TEXTILES

Portfolio: GLASS

The Life of a Craftsperson

The Craftsperson's World

Biographies and History

Introduction

James Strecker

The stone I touched seemed barely more than a residue of chance, a blade formed by natural accident into a point and sharp edge. But in the Leakey excavations of Kenya we were told that 2 1/2 million years ago, Homo habilis had walked on the earth where we stood and that human ancestors had made these very blades, now on casual display, for their own survival.

A million years was certainly more than my mind could grasp and make true in day-to-day terms, so I could not easily visualize how hand and imagination had worked together on this spot long before written history. Moreover, we were not that far from the comforts of Nairobi, where survival, at least for tourists, might be taken for granted. More and more I felt like a voyeur among these objects that some unknown creature not too unlike myself had made and actually used to live one more day.

Still, no matter the buffering jargon of guidebooks, the place was too bluntly naked for conceptual meaning, too intricately rooted in silence for words. My thoughts, as they came forth, brought nothing to equal the solitude of the place, and I kept quiet. But from time to time I ran my hands over the white powdery dirt near some of the displays. Very soon my pores were penetrated with dust and I could not wipe them clean, could not distinguish between my living sweat and the inorganic matter that dried it on my skin.

I sensed my flesh dead as dust while, at the same instant, I sensed the earth on my hands alive to my touch, and very soon organic and inorganic seemed one. Thinking back, I believe I was almost acknowledging that the earth would one day swallow my death and make it into dust, as it had done with the makers of these blades. At the same time, the earth did not seem indifferent to my touch, but more a welcoming extension of my physical essence, and I felt part of it. I felt seduced by the earth and I felt uneasily alive.

Perhaps this experience in Kenya explains why I envy the unmediated truth of craftspersons. Quite simply, they are made of the earth and they reshape the substance of earth from which they come and to which they will one day return. There is no greater intimacy than this, nothing more fundamentally true.

Moreover, as mind and body combine to create with basic materials, and these materials, in turn, make their own conditions known, each maker learns to take ensuing restrictions into a realm of new understanding, ironically into new freedom. It's a process in which one is freshly alive, one that demands deepening introspection and awareness beyond the security of one's limitations, a process that is at once intensely practical and, to many, implicitly spiritual.

Materials have their own qualities and their own behaviour, and each one must be learned as a working reality. Meanwhile, as hands become calloused and dirty, one senses something bigger in the works, something more to be done with each discovery, something new in the stuff that earth provides. If one is made of the earth and uses the earth to create, one is also taking the next step into some unknown. Thus, one is bound to an unknown initially born of the very ground on which one walks.

Still, if each craft made by hand speaks a tangible echo of the earth, it also voices a tradition of skills tried out and passed on, a tradition of making. Our connection to this planet is deeper than any other, perhaps, but we also know ourselves rooted to other lives, those lives who used their bodies and spirits to create. In what we make as they made, these lives are in our work; in what we make that is new, the spirit of making within these lives inhabits our flesh. No wonder that a craftwork resonates, for it is made of both many lives before it and some unknown dimension of its creative maker.

Of course, no craftsperson can think primarily, if at all, of profound connection or tradition or meaning as he or she works. There's too much else to actually do, after all, too much of immediate, nitty-gritty concern. Because the

creative process involves minute steps, some of which, once taken, alter those to follow, one concentrates very hard and does the job, however small, at hand.

The meaning of what is made is, in a crucial sense, therefore in the act of making. As mind and body work out their relationship in some effective manner, they know what they are doing because they are doing it. The words that come after may echo this reality or they may miss the point completely, but that's another issue.

Whatever their reason for origin, crafts objects continue to intrigue me, often thrill me, and inspire me to touch them with my hands, with my fingertips. Their pleasures and their resonance are immediate, potent, and subtle. They fill me — and this is no romanticism speaking — with awe, and each one delivers the goods in a distinctly different, though often inexpressible, way. I love how touching handmade things renders me speechless.

I realize, in writing this, that crafts objects are among my dearest possessions. They include the shards of Anasazi pottery I picked up in New Mexico, the siwa I bought from Omari Boroso, the village musician of Lamu, two kachina dolls, a gourd fiddle my friends had made for me somewhere in the deserts of Niger, and a sweetgrass turtle blessed by a medicine man on the east coast of Canada and given to me for its protective powers by a native friend.

Above all, I treasure the four-inch wood figure my mother's uncle Charlie, from central Europe, carved for me when I was a child. Its outstretched arms hold a saw parallel to its body, a saw three times its length with a weight at the bottom. The figure is made to stand at the edge of a table and rock back and forth, sawing. I saw one on TV recently and was surprised that it came not from Galicia but from Appalachia.

Charlie also made me a wood puzzle that I've never dismantled for fear of never getting it back together. How he actually made the thing, I'll never know. But I do remember the way he drew the blade of a pocketknife toward his thumb as he carved a small, dry branch into something once again alive. His hands seemed strangely subtle, for in the morning they also plowed and hoed and planted, and wiped away the sweat that came with heavy work on a summer's day. So, in a way I can feel very deeply, the maker and the object are bound together as one. Without question, I need to feel the intensity of human life in a work of craft.

Happily, that's what I experience in the pages that follow, not only in the photographed pieces, but also in the words of the craftspersons collected herein. I feel human lives devoted to making, lives that create in crafts, because, for the most part, they are able to accept no other choice. They have found crafts and crafts have found them, and neither is able to let go of the other, perhaps because the stakes of personal purpose are too high. Some might call this single-mindedness passion, others might call it a kind of destiny. The name doesn't matter, as long as life means as much as it can as one is creating, as long as making is as natural as breath.

I feel privileged to know many of these makers in ceramics, furniture, glass, and textiles, privileged to know both their art and their dignified passion. They verify for me the unique and genuine connection with earth one must have to be real in this world. That their connection to the natural world manifests itself in creative excellence is another boon for our species. As they use and remain true to materials the earth provides, they take the wondrous elements of this world and make new wonders. They inspire us to see both the natural world and our own lives anew.

Each craftsperson lives simultaneous lives. One is a unique configuration of senses and spirit intensely focused in the act of making; one is a kindred echo of other lives, their concerns, their will, their truth. So the maker of crafts does heavy work for us, coming to unique terms with the earth while making an object only he or she can. At the same time, the craftsperson's making calls upon similar creative energies within each of us, energies that can also make something or at least understand the act of making more deeply. Thus we must put our hands on what the craftsperson makes of earth and therein find the world in ourselves. For the sake of creative life on this planet, it must always be so.

Hands, Mind, and Raw Material: Who's Running the Show

Jim Todd All five senses are necessary in making a piece, but I think that the sixth sense, the intuition or gut feeling involving all the things you can't put your finger on, is the most important sense to the craftsperson. It's important that you get all your senses intact to a point where your hands automatically do what you want them to do and that your mind is separate from that. And then your instincts can take over and you have this overseeing identity inside of you that is sort of watching over the body as a machine is performing the task and the brain, where the instinct is, is guiding it and sort of saying, "Try this, try that." Meanwhile your brain hopefully shouldn't be distracted by the needs of your body and its motor functions.

Terry Craig Initially, I hope I'm running the show. I have an idea about what I want to create, but if it starts to go a little different than I wanted at first, I follow and let the glass lead me in a kind of partnership. I feel that I'm a really good friend with glass and sometimes I lead and sometimes the glass leads. But the trick is to stay a little in control of it and make it do what I ultimately want.

Sherry Pribik I'm inspired first by raw materials, and then the creative process of the mind combines with the hands.

Susan Edgerley It takes all the senses to be a craftsperson, especially the senses of vision and touch. Creativity focuses itself among all the senses, but also has to work on an emotional level and reach something in you. But it's the mind that runs the show. The hands follow the mind while the raw material inspires the mind. A lot of my ideas come from my writing and thinking and finding associations, and I'll be working for a long time until I find the right materials to express my idea. I don't simply get inspired by the material, but the material does lead me and I'll play with something I'm making and then get an idea that way too.

Jeff Goodman I would hope that my mind is always running the show, because that's the one that sorts everything out. Hands are a very light one in it for me. Everything's done by the time you get to the hands, though the hands are involved in the important refinement stage, but to me that's pretty late. The mind is most critical because, although many craftspeople have the same level of ability, it's the ones who are able to design something or really put their emotional state into a piece who are doing the work that's the most provocative.

Ingrid Bachmann There is a kind of knowing that happens through making, one that we find traditionally in crafts and textiles. There's also a potential for a kind irrationality, but that's such a cliché now and I've always hated the overly dramatic talk around craft that says, "There's this intuitive process that flows though me and mystically through my fingers...." I just gag when I hear it.

Yes, there is part of all making — and I don't distinguish between art and craft and other kinds of making — that is extremely irrational and necessarily so, but I don't think that excuses people from taking responsibility for the objects they make or the images they produce. And yet it is an essential part of a process to let a work have its own life as you shape it, create it, but critical editing is really crucial as well. Too much of the discourse in crafts, if there is any discourse, has always collapsed into the romanticism about, say, the clay springing to life. No, it didn't spring to life. Someone formed it and the creative process is a very rigorous process.

It all depends on how you work and people generally within a craft tradition associate with one material and one process as they develop a knowledge that comes from practice. Materials have limits which are incredibly frustrating, but because they provide limits they are also challenging and intriguing for both mind and body. As well, people work in very different media, and materials shape enormously not only how an object is made but also how it's received and perceived.

In the process of making, it's very personal in terms of an individual's process as to what goes on. Some people come up with a design or a form and then they try to make it and get close to it. Others try to approximate. Many learn through making. I myself believe that thinking is a social activity and thinking for me doesn't happen sitting alone in my studio, but more in relation to other people in situations. And I don't feel there's a split between thinking and the hand. When you're working with your hands, your mind becomes much freer and in fact the mind's working with your hands can be one of the most important things to allow interesting thoughts to come in. So I don't separate them, since they're parallel activities that intersect at many points.

Our body has a memory too. There is a memory of motions that have been done over and over again that brings a kind of knowing that takes place in the body. So work becomes very rich if that kind of knowing, knowing that really only comes through doing, is combined with a really well worked out and exercised brain. But we often put too much emphasis on the rational side of things and interpret our thinking that way. We have to rethink how we look at what our hand does and what our mind does. Our mind is still in our body even though we separate the two, and it's a much more sympathetic relationship without firm boundaries.

Personal Unmaking and Transformation Through Crafts

Donald McKinley I like learning. Access to objects and time to reflect on them is a privilege. The most memorable lessons are those from our own experience. When you have tried things yourself, you can then compare the thing intended with the thing attempted and the thing achieved. Then it's a case of people, or at least their perceptions, that change. One benefit of making things is that we experience cause and effect. Once we have observed that alternatives are not just possible but probable, we can develop our skills to influence and control results in the next piece we do. Viewers and potential buyers and users can and should question the appearance, enjoyment, purpose, permanence and price of objects, and so should makers. Whenever possible, we should all add to our knowledge. Discussion and observation of objects and ideas contribute to an informed opinion, an understanding attitude, and a change of mind.

Gernot Dick It's a constant high to know we can create and be what we haven't been before. However, we are so inundated by physical convenience, by things we can measure by labels, and it needs a big rethinking to realize we can actually be conscious through making an object and thus define our possibility. The issue is doing. By doing I feel a consciousness, I gain a consciousness, and I don't lower myself into comfort. If you are comfortable, then when reality comes to you and you have to connect with it, the lights all go out. So I think that contemplation, meditation, spirit, and inspiration come through the process of doing. When you shape things responsibly, creatively, you become conscious and you change.

Joan Chalmers In crafts, the good ones move on from a style at some point. There's the story of a man who priced a chair at $300 and when asked to make twenty-four more, said they would each cost $500. "Why would they now cost more?" He answered, "I don't want to produce twenty-four more, so that's why." Spoken like a true craftsperson.

Susan Edgerley Crafts have transformed my life in a very fundamental sense. Self-knowledge and self-awareness that crafts tend to bring out put me on a path, a journey, and I transform through working in craft.

Cathleen Nicholson The proximity of like-minded individuals in a crafts school is quite liberating and, as a student, I am being lifted by the challenge of working with interesting and intelligent artists. I see at first hand the range of creativity available since, if a project is given to twenty people, there will be twenty different takes on it. This kind of incubation helps loosen my creativity and I also learn about satisfying myself in the end. School teaches process, but my work in turn goes beyond process because I am invigorated and inspired to try something new. I learn a hell of a lot from other people. In ceramics, I learn that throwing must become a second nature, that the only way to achieve this end is to throw and throw again. While I become confident in my progress, I come to realize that there is a long way to go before I achieve a transcendental sense of play in working, one that liberates creativity from facility. I also find that my confidence to lose the "preciousness" of a work is an intriguing step toward artistic growth. Thus, smashing our pots before they would have been fired was an eye-opening experience. So far, my development has a lot to do with just becoming aware of my ideas and shaping them.

Don McDougall When I came to SOCAD, I had a sound knowledge of technical drawing and I knew what I liked, but I could not tell you why. I was too performance-oriented. I felt there was no room for error, but I've learned to allow my creative side come to the fore, to experiment without the idea of producing a final product. I've learned I have a long way to go.

Donald Robertson Turning points in your work and how they transform you are not always evident immediately. Often the big turning points come from great personal changes in your life which in turn always reflect in your art. Art comes from life, life doesn't come from art, and art or craft is the artist's expression of life. Fortunately, crafts also help us to appreciate finer qualities in life and teach us that you need to take time to live.

Daniel Crichton When you fall in love with a medium like glass, the question about belonging is answered in an instinctual way because you feel and understand that glass is part of you. Most people in our society don't get their hands into anything and they don't get dirty. They often don't understand the nature of material and how it operates, so they don't have to conform to the sort of demands that material makes. When you work with glass, you are initially confronted with volcanic heat and danger and you need very quick, decisive moves or the glass will dribble on the floor and probably burn you. Over a period of time, a person in glass has to confront his own physicality, his own movements, and an ability to perform over a short period of time. Each piece is the performance of an idea and technique with the materials, and you've got to get it all together in that piece if you're going to make it work. So the impact on craftspeople is that crafts help them keep the meaning of their lives in focus, though crafts are not necessarily the meaning of their lives. Working like a dancer with physics, gravity and form helps people move away from some of the more indulgent qualities of our ego-centred lifestyles.

Design, Inspiration and Luck in Creativity

Peter Fleming An object I make would not exist were it not for me existing. No one else would approach the work in exactly the same way that I would and that sets individual designers apart. I still don't regard myself as an artist and there are lots of times I don't regard myself as a craftsman either, because I make a distinction between designing and making. At one point I'm designing something that is informed by my ability to make and then there are other points at which I'm making something that is informed by the fact that I've designed it. There's a cut-off point for me and that's generally when I get into the workshop and start to make alterations to something I've designed, but in general I don't change the nature of the materials or the overall concept or the arrangement of parts. Part of that comes from doing most of my work on commission, where I'm contracted to do something exactly in the way I had shown clients. I find the complex layering of my motivations to be interesting.

Sherry Pribik My work involves a lot of inspiration and not so much design. I let the process carry me along because it's actually the doing that inspires me, rather than trying to have my work all designed out ahead.

Susan Edgerley I study and research, but my own creativity comes from inspiration. If I'm not inspired, sometimes it's just luck that things come together and set me off in a direction. The process of creating is a long-term thing and something that happened ten years ago might be used now, but often you don't really remember you had it until you start working with it. It's a matter of keeping yourself inspired too by ordinary daily things, like people and the land. My things don't function in a strictly utilitarian sense, so I don't have to think about design and the issue of design doesn't touch me as much. My work comes from awareness of what's around me as much as from my material.

Barbara Walker One of my inspirations is my own work. I develop from one piece to another. I'll do research and figure out the piece beforehand, but often I experiment while I'm weaving and one piece will trigger the next piece. Other inspiration comes from looking at nature or other people's work, and there isn't just one source, but each one triggers a thought process. Then I start drawing and a design develops.

Jeff Goodman At school I was studying glass, but a ceramics course was available and it inspired in me a new way of thinking, a more comfortable way of working with glass. This exposure to a medium other than my own, in a crafts school, really influenced my future work.

Donald Robertson You have to lose a fear of change and also realize that learning will never end. Why I enjoy my work is the constant evaluation of it and knowing there's always something more to learn. So inspiration and luck in creativity come from life experience, from living life and knowing how to accept what comes your way and turning it to your advantage. Sometimes I have accidents as I work that don't suit a piece that I'm working on, but later I'll take the accident and exploit it and create a whole other work from it. So I try to work most with the luck in creativity and this comes from a positive attitude about what I'm working on.

As in life, if you are negative about something and dwell on the negative, it's harder to see your way through it. If you're working on a piece and it goes wrong, if you get overwhelmed you won't use it as a springboard to something else that might be wonderful. You actually don't have much choice, since we are not perfect. In fact, I don't even strive for perfection anymore, since the more I look at nature the more I find that the imperfections are the beauty.

I really believe in nature, far more than I believe in mankind, and looking at nature allows me to be a little looser with my work. I used to spend a lot of time worrying how perfect things are, but now it's a lot easier for me to make them simply good enough. Now I put my energy into the gesture of a piece or into other qualities. Anyway, perfection seldom lasts and if you look at, say, Henry Moore's original plasters, it's the lack of perfection that gives visual interest.

Jeff Goodman Inspiration comes from anywhere. It's a simple procedure. I'll go to the library and look at things, and it will be one tiny element that grabs my attention and I'll write it down or photocopy it. Then, by the time I have maybe twenty elements, I'll weed through them and put them away and forget about them and then go design some stuff. But I know those elements are now in me and will come out through the work in some way. But it's more of a kickstart, and not looking to steal ideas.

I just visited the Museum of Modern Art in New York, and the abstract expressionist Jasper Johns, Antonio Tapies, and a whole group put me at a heightened level. I have a lot of books, like one on Motherwell, and I go through them all the time, but to actually see the works in real life takes me to the height of awareness that the painting deserves. Mark Rothko's another. You sit and look at a Mark Rothko and it's unbelievable what can happen. That's a big part of inspiration, fuel for the fire for me. It's fuel that gets me to a heightened state of awareness and then I usually just disappear to the back of the studio or at home and do lots of sketches, then I take those sketches and decide what we should try. It's a real long process, maybe two years, before something comes of it.

The Hard Lessons of Working in Crafts

Peter Fleming I did a piece based on a sarcophagus that I'd seen in South Holland, and I went through exhaustive sketches and models. I really liked this piece, but after I finished I realized it was something that should have stayed as a quarter scale model, as a jewel-like thing rather than this massive thing. It turned out to be emblematic of all the excesses of the pieces I'd been making up to that point. I put it on exhibition and it didn't sell, so I hung onto it for two years. One day I was really tired of it existing because it was everything that I didn't want my pieces to be anymore, just opulent and dramatic and idiosyncratic and hugely architectural. One night I had a tremendous amount to drink and when I got up the next morning in a numb and relaxed state, I took a car jack and blew it apart. I kept individual parts, and eventually made them into something I really like, but I cut up the rest and put them into the firewood pile. My desire was definitely to see the piece finally end. It was the last piece I did that extreme and after that things just kind of shifted.

Sean Ledoux If only I could be more right-brained about things and know the large picture and question my work before a crisis arises. A turning point for me is a crisis feeling when I look back at a project that was painful and make a decision not to repeat it. You have to learn that there's something significant to be learned from a difficult experience, however, and that maybe now is a good time for a turning point. Also, just because a road you're going on isn't bumpy doesn't mean that it's not time to turn. You have to be really aware and conscious of what's happening all the time, because I know when I've had rough times and made them into turning points, it made all the difference in my career. There was one turning point where I realized I couldn't survive doing custom residential work anymore, so I decided to diversify my business. This is something I never dreamed of until I met some adversity, and nothing but good has come of it. Some lessons are hard, but they're also powerful and influential.

Barbara Walker I put hours and hours into a work, and it's frustrating to not be able to command prices that value the quality of the work. It's hard on my back too and I have back problems, though weaving is the medium I have chosen, so I struggle on. Also, a lot of people classify textiles as traditional and undervalue it as something many others can do. There's a whole undercurrent about textiles that sees grandmothers quilting and crocheting, and that puts a negative stamp on new work.

Jim Todd Some people envy my way of life and I just smile and don't tell them what I've got to do today or I don't get paid. I can't take a sick day and I don't have summer holidays per se, and I can't get on a plane and visit my family when I really want to. I don't have extended leaves or a dental plan and I have no pension plan. Nothing. Nothing when I'm sixty-five. I suspect a lot of crafts people are aware of this and try to tuck it in the backs of their minds because you get pretty depressed once you consider your financial future. This is one of the reasons I'm working my ass off to put something away for the future. I know that ten or twenty years from now my energy will start to dwindle a little bit from what I need for the fourteen-hour days and seven days a week I do now.

But I'll probably remain a sole designer on my own for the rest of my life, though a lot of people don't think you're successful in the furniture business until you've got a crew of eight people working for you. I've done that, had three people working for me while I was just an administrator, and I didn't touch a piece of wood all day. I wasn't happy, that was all business. Yuck! So it's comfortable enough right now, and come November I'll have my monster loan paid off for all my machinery, and I'll have six hundred bucks in my pocket a month to put into creative fuel, and that's fantastic. .

Gernot Dick Teaching in a crafts school has offered me choices, and all these years I have had absolute freedom within the classroom which was sometimes compromised by external forces. But it doesn't matter how free we want to live; no matter our ambition, it still takes ninety per cent discipline. It's important then to see this discipline as an outlet to freedom. And if you can live the simplicity of life and use it as a positive catalyst, especially in craftsmanship and along with patience and endurance, it's very important. But the regurgitating and the regurgitating of the shadows where we come from is not worth it, especially as life speeds on. We have to simplify and be able to look ahead. Unfortunately, information always looks to the past, we always find this.

Sherry Pribik You don't make any money in crafts, and on top of that, everything takes much longer than you think it will.

Susan Edgerley There are lots of lessons I've learned. The hardest is that at first I was prepared to work incredibly long hours, but as I get older I'm not prepared to do that anymore. There's also the hard work involved. Almost everyone I know who is not involved in craft is quite stunned at how hard we work. We are always working, and for small financial return. Coming to terms with that is the hardest lesson I have had to learn. I did it without enormous angst or anguish, but I did have to accept that reality. Motivation has to come from somewhere besides making money.

Working in Crafts as a High Like No Other

Bruce Cochrane Clay is a very responsive material. Its plastic nature, once under control, is ideal for quick exploration of ideas. I enjoy its immediacy, the manipulation of fluid form on the wheel, and its ability to alter form several times before hardening and becoming permanent. The technical requirements are challenging too. The chemistry of glaze, firing processes, and the transformation of form and surface as it reaches extreme temperatures continue to keep the process alive and exciting. Ceramics also boasts a rich and broad history which serves as an ideal resource for initiating new ideas. As well, the international contemporary field is experiencing a burgeoning of innovative talent within the realm of ceramic sculpture, vessel-making, and functional ware. It's a wonderful time to be part of this community.

Robert Diemert When someone says, "Wow, it's nice to see something different, I can sure appreciate this piece," to me that's worth almost as much as the paycheque at the end of the job. Still, although the recognition is good, it's not the "high" point of what I do. The recognition by others is probably a small part of the "high" which for me is creating something that challenges my abilities as a designer and a maker, something I feel good about. I have always pursued work that would elicit this satisfaction, and I find the "high" addictive. So I usually take on interesting or challenging work for the joy in doing it, and I usually end up putting too much into it, perhaps to prolong the "high," but much to my detriment financially.

Winn Burke My profoundest connection with clay has everything to do with discovery, the enjoyment of discovery, through the medium, about the medium and about myself. I hate to say that it's a joy totally and leave it at that, but it is. There's a lot of pleasure involved, and though sometimes the process can be painful and hard and difficult, it's still pleasurable, this whole process of making objects. But only in retrospect. When you're actually working, it's awful and frustrating. It's hard to go through everything else that goes along with the lack of discovery or the lack of insight or the lack of motivation, hard to keep going through whatever gets in the way.

I'm not a strong object-maker and never have been, but I still continue to strive for something stronger. And I do definitely feel I'm trying to change the behaviour of myself when I make objects. As an object-maker you realize very early in the experience of getting deeply involved that you have to be open-minded and broaden your outlook rather than narrow it down.

At the root, whatever the kind of profound experience, it is almost cathartic and it can change your life. There isn't any one kind of profound experience, and I simply enjoy the series of little profundities that happens. Without the profundities of discovery, you can die from being static.

Kevin Lockau Working in crafts is a high. When things are clicking and fitting in, it's wonderful. Even when that's not the case, it's not really so bad, not a real downer, because you're still on the track of making something really good. It's a matter of inspiration and inspiration is where I'm living, especially with inspiration, from nature. When I used to live in the city, there were a lot of ideas around and I was like a shark feeding on the frenzy. Someone would get an idea, they'd throw it around the water and then everyone was using it. It would just get muddier and bloodier. So now, living outside the city, I don't get to see many shows of what artists are doing, and that can be a real positive. I'm afraid of being influenced too much since I live and create in the inspiration of nature. It's a high.

Daniel Crichton To some extent, the sense of isolation in the creative experience allows for going over the top and then coming back. Two or three hours will pass because you've totally lost yourself. In another context this might be called going crazy, but in the context of creating we call it concentration. It's like a dream for some people to be able to stop all the noises in their head, stop all the activity around them and enter into that sort of intensity while being able to draw themselves back out. Time does exist, but it's a relative thing. For the feeling of pleasure, of enjoyment, of exploration, of awe, the loss of time has to be outside of time if it's going to work. If you're conscious all the time, you're not going to enjoy yourself, so you have to let time be suspended and let the activity flow.

The actual process of making is as important as the result. The end result may end up in a garbage heap or it might end up being used by an articulate politician to defend some awful cause, I don't know, but no one can take away the process of making, the beauty and enjoyment of that which is so personal. For me the tipoff is the quiet that descends when all the competing poles and energies and voices and intensities of everyday just stop and I'm able to step into this other world where it's just me and the materials and ideas. To me it's a gift that tempers all the other crap we live, one that gives another way of seeing what being human is. You dip yourself into the glass for a time and you come out of the glass, and you've added to history and the issues that are in your contemporary environment, all the while seeing what being human is.

Susan Edgerley There's no greater high than the satisfaction of creating and staying with your creativity. Not every moment, but when things go well for me there's nothing except maybe the birth of my daughter that I've done to date that comes close to the high I feel when I work. It's a very, very big experience. The reason I'm still doing it is for the inner experience. I love it.

The Inner Experience of Working in Crafts

Peter Fleming How I experience time depends on whether I'm enjoying what I'm doing or not. It's an emotional issue and a psychological one too. If there are a number of projects that I'm working on at a given time and people are telephoning me all the time making demands, I tend to get more and more frazzled and less able to control my attention or enjoyment of my work. That's not to say that you need a tremendous amount of peace and space to generate good work, since I live in an urban environment for the stimulation, but my enjoyment of work is really tied to the stress I'm under.

If I'm producing work for an exhibition, I can feel very fatigued by what I'm doing and still feel on top of it because I know what the motivation is. If it's for a client who is demanding concessions, I tend to be more and more frustrated by what I'm doing and I resent it. Time is also expanding and contracting and there are days when I get a tremendous amount done and there are days I get absolutely nothing done, but they tend to balance out. I've always tried very hard to perform to a deadline and that's partially due to my desire for approval of other people. Craftspeople in general tend to have a desire for approval of their work, of their abilities, of their vision. This is one motivation, to be recognized and supported.

Karen Smeja You focus, you concentrate on what you are making, you transcend through time and space, you feel a sense of oneness. It's like doing yoga and you also reach another level of enjoyment, of inner pleasure, and your physical being is in tune with your mind. This involves a release of your self from your day-to-day being. You're being creative and expressing yourself, instead of being diverted or suppressed or blocked. You have to be inwardly open to the possibility of surprise and without your expectations in complete control, because that's how you grow. You also have to respond to the medium you're using and not deny the pleasure of, say, mixing colour and allowing for exploration. When it all comes together, you're in another dimension.

Jeff Burnette The creative experience involves the fun of being able to make the things I want to make. That makes me happy inside. The ultimate for me is being able to create something I enjoy creating and have somebody else enjoy it too. That's a thrill I feel inside too.

Terry Craig Glass is a magical medium and I'm inspired by it. People who stick it out in glass are simply inwardly crazy enough to do so.

Daniel Crichton My earliest experience with glass was like walking into a mine and seeing a vein of gold. I'd never seen material move or do or be like this. When people refer to glass they usually mean something that's cold and brittle and cracks easily and is lifeless. But when you confront it in a hot state and gather it out of a furnace, it's soft and subtle and sensuous, easily formed and easily touched, though it's always at a distance because you can't touch it with your hand as you can with clay. So inside you feel a contradictory situation, and my first time it pulled at two ends of me. I learned that to progress with glass you need to continue this sense of challenge, a sense there's always an edge of challenge that you have to push yourself to achieve. If it doesn't work, you learn to start over and reassess your approach. Another thing you feel is immediacy, though you also go in with an idea or a strategy, and that over six or eight hours you run out of energy.

Over the course of years you get into a frame of mind, a frame of reference about working in glass, and you develop an attitude of patience about the accumulative quality of achieving something. So there's an immediacy of challenge in the studio as you work and an acceptance of the longer time, perhaps a couple of years, it's going to take to realize your initial idea. There's a feeling of tension inside you. And it's not from wanting to be a virtuoso in the studio, since I've never really been interested in being the best from a technical point of view.

My motivation is getting across in some sense my own spiritual vision in the work, speaking about what's important to me from somewhere inside, from the soul if you like. As this voice speaks through me, I'm not necessarily in control and I submerge myself in the work to let my inhibitions go. It's a matter of letting go of your own ego, which for people in the arts is a pretty powerful force. Part of you wants to be in control and not be made to look foolish with mistakes.

But glass teaches you lessons all the time and you learn that you're not allowed to be on top of it to conquer it. It's like swimming in a river where you have to go with the current. If you allow yourself to go with the current, you may end up someplace else, but along the way you've had a good time and in some way you've expressed the nature of the river. So you need to accept the principle of patience and the fact that you're human and quite capable of mistakes and foolish decisions. This tends to promote humility, which can be quite therapeutic.

Helen Beswick There's an evolution in a craftsperson's life and certainly your skills improve so you don't have to concentrate on them. This leaves you a lot of freedom to be creative in a true way that your mind is not concentrating on what you're doing and it's just coming from inside you, through your hands and into the clay. I may continue on a theme and I'll leave it to go off on another direction and then come back — this I don't do consciously because this is simply the way the work does itself — and then the first work is different and stronger, with more freedom and not so tight. That's because I've worked through all the head things inside, and now the work just comes and it's free and spontaneous and it's good.

Trends and Eternal Values

Stephen Hogbin Trends are full of conceits and deceptions. They are really a grasping at straws to control consumption. Trends are fashion-orientated to create more business and they are part of planned obsolescence and trying to get people to give up what they've got and go with something new. This might work for clothing, where there's a quick turnover, but crafts should stay well away from it because we're supposed to be making something that's going to last, that's better made with superior materials and superior workmanship. We need to bring something new of solid value to crafts and not something that's transient or a fickle way of working.

I don't believe, however, that there are eternal values. Our values are still evolving and there are still people out there lying and stealing and killing. We're still in a pretty primitive state and we have to keep our values evolving from the terrible negative aspects of the human experience. Working in crafts, has the potential to facilitate the development of human values since there can be a lot more integrity in the craft activity than there is in some other activity. When you are working with materials directly and you have a client you have to face at the end of it, the work has to be integrated, and that to me is a very important key to discovering proper values and integrity within the craft activity. But I have seen a lot of crafts that don't have integrity. I've made some myself too, but that's part of testing things out and seeing what happens as you find how things work. That's not a question of eternal values, however.

Gernot Dick Trends involve anywhere you feel in fashion. Trends also depend on a bandwagon. They are a delightful escape from responsibility because people need a sense of belonging and arts allow one to belong to a movement and identify oneself with something. Trends allow that. I find recently in crafts, though, that in society we celebrate the individual and don't think collectively anymore. It's quite a challenge, therefore, for the craftsperson to create and still learn to belong to society. On the other hand, you have to realize that never again in a billion years will there be anything like you, and that's pretty awesome. So it's sad if you follow trends and define your work by skill or technique alone.

Ingrid Bachmann We now live in a society where we have the high arts and we have the low arts, and people have adopted the language and vocabulary of a modernist art world. That's a shame because there are parts of a craft tradition that are far more interesting than an art context. Crafts allow for interaction and participation and it's interesting to be part of a tradition that is partially marginalized with a freedom of options to find yourself. Also, in new media you don't have to fight against the boundaries of a tradition in a way. My new medium is installation, and it exists in between times.

Daniel Crichton We are condemned as human beings to be fascinated with technology, and the current fashion involves what's happening behind the computer screen. But one thing the arts do really well is that they are skeptical and critical in nature. If a society tells people to bow down to a current icon, the ones not likely to bow down are the people looking at what they can do with their hands without anyone telling them what they can do. In some basic way, they are free inside, they are free of trends.

In going back into history and rediscovering glass, in exploring it and bringing glass forward and exploring contemporary issues through it, one holds up another mirror to society which is sometimes critical and sometimes just an alternative vision of where society has been and where it can go. Working in glass offers people a chance to re-evaluate things and not just accept that they're on the super highway of information. I love computers, but I also work in this antiquated process that is basically the same as when it was discovered 2,000 years ago. You've got a pipe, you've got the glass, you dip it in, you turn it, the stuff sticks to it, you come out and you try to keep it centred, you try to blow it and it continues on like that.

There is something very anachronistic about glass, definitely, but people's mouths hang open when they see you doing it, because there's something very gutsy about it, something real about it, it comes right out of history. It's maybe stored somewhere in our spinal columns, this desire to stare into the fiery hole and work with this volcanic material. I don't know how else to describe it. There's definitely a contrast between what's happening in our contemporary digital revolution on the one hand and this confrontation with raw earth material power that reaches through history.

Donald McKinley With trends and eternal values, if one exists then I guess the other does, but there can't be a trend that moves away from something that is eternal. There can be trends of evolving things, however, and looking for alternatives, and this can be an individual's evolution.

But I think eternal values are meant to be abused. There are some you keep trying on to see whether they still fit or whether they do indeed fit yet. Eternal values are not necessarily rules that are meant to be broken, but we do encounter things that should not always be honoured. Also, since I don't believe there's a single right answer about most things, I guess I don't really believe in eternal values. This guy I used to study with said, "Stay dissatisfied," which means there isn't anything that can't and shouldn't be changed. So if there are eternal values, you have to stay loyal and you can't even think about being dissatisfied and certainly not staying that way. In the end, I think eternal values are hogwash.

Do Crafts Have a Soul?

Stephen Hogbin Animism believes that everything has a soul, so, in that way of thinking, people, rocks, trees, and maybe even crafts have a soul. The popular contemporary use of soul refers to connectedness where things seem right and inexplicably get to you. I think the idea of soul as being in crafts is a projection that the individual does on the work, but I'm delighted with that sensation when I get it, when I feel that a craft object I've created has a soul. Most scientists, I think, would say that the experience of soul in an object is a projection, but perhaps there is another spiritual plane that we can tap into, where crafts do indeed have a soul, and I'm not about to say it's not there. Some people believe it is there, but I tend to go on the side of empirical evidence and I need something hard-nosed to know it's true.

Robert Diemert Do crafts have a soul or, more importantly, do we give objects a soul through our craftsmanship and sense of aesthetics? As a viewer of objects, I find them inspiring, refreshing, and thought-provoking. When someone has done something special with forms or ideas or a purpose, and given an object a unique presence, it has soul for me. It could even be a very simple object that we take for granted because in most cases it would be mass-produced by a machine, but if the maker has taken time to reinterpret its meaning, use, and form in his or her own manner, it has a new life or something of the maker's personality or self in it. As a result, it sings, it strikes a chord with us. It has soul.

Alison Vallance The question of a soul in inanimate objects is not part of our culture, but again it lies with the perceiver and in the relationship between the perceiver and the person who made the object. It lies in the intent of the person who makes an object combined with the ability of the perceiver to receive. Personally, the question of soul is a little too religious for me.

Joan Chalmers I don't think crafts have a soul. I don't think of them that way, though maybe some of the creators of crafts have a soul. But there is more magic going for crafts than things you buy at expensive furniture stores with eighteen more of them waiting in the back room. So it's sad that there aren't more homes with original stuff in them.

Susan Edgerley It's the people who make craft who have a soul, one that's transmitted through the object, so the object does end up having a soul. The soul extends from the maker into the object and the soul of an object is associated with the maker.

Kevin Lockau Selling crafts is really an exchange of the soul. When I meet people who are down to earth and kindred spirits, they may talk about why they like my work and I can see why they like my work. That makes it worthwhile, and if someone can't afford what I've made, I'll cut the price down two hundred bucks because they like it for the right reasons. I've had people say they've had a dream about a piece of mine, that the piece was in their dream, and that's a real kicker you can't beat. It's encouraging when your work is in a place that has reached the dreams of people.

Donald McKinley Crafts have a soul only if you think objects can. There can be people who are soulful about objects, but I don't think objects possess souls. They may confirm that the viewer has one or that the maker had one.

Helen Beswick Craft to me is what you learn, and you learn the craft of metal or the craft of pottery. And craft does have a soul but it doesn't stir until you get past the intellectualizing, like saying that a mark is too thin or too thick. The soul is there but you haven't stirred it as yet until you can just make that mark. It's your own soul, I would think, but you have to go down another level, soul-searching, and then it comes to you. But you have to get away from thinking about it. When I'm working at the wheel, I can say I'm going to make six pots, but what my hands and the clay do are four jars that are perfectly lovely. And that's soul. The nature of most human beings is to control, and when they stop being in control then marvellous things happen, soul happens.

I find I really don't trust words as much as my intuition, my eyes, and, with my work, my hands. Then I might find that I didn't make a beautiful bowl but it happened. You have to let go of controlling and let soul happen, and this is what I think creativity is all about. But every once in a while I run up on a creative person I respect and they've never had this happen, they haven't experienced the miracle of creativity of not being in control.

Karen Smeja Crafts definitely have a soul. The object a craftsperson creates comes uniquely from that person, since each maker is different, and true craftspersons aren't out there selling their soul, even in mass-producing what they do. Like Don Stinson, who makes bowls. Each one is made from a unique log that has fallen a different direction, and people who buy these bowls are interested in him and the progression and consistent warmth of his work, in all that transcends from the work. There's always a story behind an object that gets passed along from maker to buyer, and the totality of that experience has a soul dimension.

What's Wrong with Bad in Crafts?

Stephen Hogbin There's actually a mountain range of bad crafts in every medium, so you just do the best you can and on occasion figure out how to do it better, especially your own bad crafts. You can't be overly concerned about it because there is so much that is bad. On the other hand, I would prefer actual dialogue to definition in determining what is bad

Kevin Lockau Good craft is art because it has soul, but you can't have bad art and good art, since it's either art or it isn't. Art actually has nothing to do with the object since the object just triggers something in the viewer, who is then enlightened and sees things in a different way. If this art experience takes place, then you have art. A craft object may not be art for you, but if I'm stunned by it, shaken by it, changed by it, then it's art for me.

Sheldon Schwitek Almost everything has been done in craft, so in contemporary craft, aesthetics take on more of a personal meaning. That doesn't mean they are bad and don't have an eternal value, just because aesthetics traditionally are taken more from history. Still, even as art becomes a matter of personal taste, people who push boundaries and become controversial are said to be "bad." But even if they're making poorly crafted work, they're still developing their own aesthetic ultimately.

If aesthetics are tied up with what history says is right or what has gone on in history, I still wonder what current trends may become of eternal value or of particular future aesthetics. You can put work into categories but people are crossing boundaries all the time and that's what contemporary craft is all about. So I don't have any criteria for what is bad in craft or what is good even. My aesthetic has transposed itself into working in textiles at this point and I work feeling that an object is always an object that has more meaning. It has more meaning whether the viewer understands it or not, thinks it's good or bad or not.

Alison Vallance A lot of people won't agree with me, but I insist on seeing the value of craft for the people who make it, because those people have their own purposes in doing what they do and I celebrate that. For me, it doesn't matter if it's good or bad, because those are somebody else's definitions. But again, it's a question of context, and I would take different standards if sitting on a jury for an exhibition. For me bad work is thoughtlessly done for the sake of convenience, only for the market and for no other purpose.

Sherry Pribik A work must be executed well enough so I believe it. I must see commitment in the way it's been executed and see that the maker of an object has taken time to execute it well. Something bad in crafts doesn't meet these important standards.

Joan Chalmers If you go to any craft fair, especially the church basement ones, you just know how awful it's going to be. Or the "One of a Kind Show" with two hundred and seventy-five booths and maybe only fifteen that are showing stuff that's great while the rest of it is filling up floor space. I don't go to them anymore because nobody challenges this stuff. What's worst of all are the crocheted fancy dress ladies that become socks to go over the extra roll of toilet paper. Those are the worst. I've been exposed to crafts for fifty years now, fortunately, and I know my standards are not somebody else's standards, but if people don't have a developed taste it's their problem. All you can do is try to educate people by exposure to beautiful crafts. Still, most people won't usually pay thirty-five dollars for a beautiful coffee cup and saucer when they can get one anywhere for under ten dollars. That's what they see in their lives as the price for a mug.

Barbra Amesbury You have to have a benchmark for what is good in crafts, but we've failed miserably in educating people and we've all seen bad ceramics, for example. There should be a law, as for German beer, that if it's bad beer you can't advertise it as beer. We should therefore put up signs for bad crafts. Everything is wrong with bad in crafts because it nullifies what genuine craftspeople are doing. We mix professionals with amateurs, while in reality we should bring true quality back and into the forefront.

Susan Edgerley I don't think there's anything wrong with bad in crafts, but there is something wrong if there's too much bad that you can't find the good. Bad crafts tend to diminish both people and the good crafts that are around. There's a danger when people don't strive for excellence. Also, when everything from dried flowers to fine furniture is mixed together, it creates confusion and people can't find good crafts. In turn, they don't care about what is good.

Daniel Crichton Bad can mean several different things. When a craft is bad it can actually hurt you, say, if you pick up a goblet and it cuts your finger or you put on a garment and it constricts you. That relates back to craft in its functional nature. When it's actually designed poorly and constructed poorly, you feel it when you're using it and it pisses you off. As fine craft is extended toward the art world, the whole feeling that goes with it combines the aesthetics and longevity of the material together. So you ask, "Should I really use some non-permanent material on the surface that fifty years later is going to flake off and, as a result, there goes the artistic expression with the flake?"

When an Object is More Than an Object

Stephen Hogbin An object is more than an object when the subject is properly comprehended. An object is a physical thing, but that physical thing has a subject in human terms from which the object's content and meaning begin to evolve. The subject often has a pragmatic or utilitarian function, what it's trying to do, and in crafts especially the subject is deeply involved in function. With a teapot, for example, the subject matter is about making tea and whether it's going to make tea well and pour properly. If it doesn't get those things right, it remains a kind of blob. So if you don't look carefully at the subject matter of an object you're making, you're going to get it awfully wrong.

So you have the object and the subject, and also the issue as to whether the object works well in its context. In the Japanese tea ceremony the context of ritual is very important as it works around the pouring of tea. The tea ceremony is extremely specialized, but it works as a metaphor for any activity in life in which the context is very important. The next thing is how the perception of human insight becomes revealed, how humans think and feel, with emphasis on feel, about the subject and the object and the context. That's where the content of the work begins to develop very clearly and you here can verbalize what the individual maker has brought to the subject, the object, and the context of the created piece.

Terry Craig An object is more than an object when it stops matching people's characters and it inspires a strong and deep, really deep emotion. The object stops being just a vase or a goblet when people really feel the piece and treat it with intense emotion as they would treat another person. Of course, at least according to Gary Bolt, the United States border guard definition goes like this: If you can pee on it, it's art; if you can pee in it, it's craft. I guess a work stops being an object when you don't want to pee on it or in it because it touches you too much.

Susan Edgerley When an object transcends its strictly physical form to impact on another level, whether it be spiritual or emotional, it's no longer an object but more like an initiation into the unknown. The object then becomes a stepping stone. You not only look at the object, but you also look back at yourself and somewhere else all at the same time. It's through that object that you are enabled to journey on a transcending level, a trip of your own thoughts until you look out at the world with a different perspective. It's as if the object has lost its existence, like a music has lost its notes, and you are enabled to go beyond where you were. So crafts can be a pretext for something else, a very transforming experience that takes you beyond the original object and makes you feel connected. Crafts can send you somewhere you've never been before and you feel happy to be alive.

Sheldon Schwitek An object always has more meaning in it than the viewer understands, so an object is always more than an object. It entails more. I have all these quilts hanging on my walls and I bought them because they have a physical presence and a certain history and at some point they had a functional life. Anyone who makes an object is partaking of a history, and whether the object is considered to be art by today's standards is not the point. It depends from what history you are looking at it and when I look at an object like a quilt, I think about its history and also try to give it a history of my own, using what I know about this quilt. It was probably somebody making a quilt out of love, making it to pass time, though these are my projections.

With one quilt I own, I have this image of a woman making it, though I have no idea of what its history really is. I just pieced that history together by examining the quilt and using my knowledge of what the history of the object could be. So I already give it more presence in doing so than is there. I may be totally off base, but the quilt still conveys a feeling to me. It makes me question its history and wonder whether it has a soul. Personally, I find that all objects have a soul, all handcrafted objects in particular, especially those that have been around a long time. I wonder who has sat in a chair that has survived four hundred years and I sense in it something of the maker who made it, something more than immediately meets the eye.

Daniel Crichton It depends on how much verbiage and how much history, how much baggage in words, comes with the object. An object can refer back in history or it can go forward and challenge you about some new idea, a new way of seeing things, or implied issues, all of which are beyond what the materials are manifesting themselves. By provoking discussion or the written word, a material steps outside itself or refers outside itself.

Robert Diemert Although I can't write well enough to do a craft justice in words, I have found some writers to be inspiring, worthy, and thought-provoking. But words don't always give me the true or physical sense of an object, since I still have to touch the object or use it to really experience its soul. Also, the pleasure I receive from making an object cannot always be summed up in words since the feeling sometimes is like coming out of a meditation or, quite the opposite, a teeth-pulling, stressful experience

Karen Smeja An object can have an economic dimension and one may buy it as an investment, not because they relate to it but because the craftsperson has a name. That's a different realm and, although there's a need for support, it's nice when there's understanding that goes along with the investment.

Can Words Really Talk About Crafts?

Susan Warner Keene If words could substitute for physical objects, then we wouldn't have to make the objects. Craft objects do have a physical presence that words cannot replace. On the other hand, we are verbal creatures and through words we can enhance our experience of crafts because words do illuminate objects for us. Words can work on the imagination or draw attention to some aspect of a work, perhaps inform people why they are responding as they are.

Stefan Smeja Words can help us a great deal to understand what a maker hoped to do. I would, however, rather experience an actual object over an image of an object or words about it. When each of us physically interacts with an object, we come to an understanding of it through our own impression, perhaps in a way that the maker never intended. However, words of other people can offer new insights into an object. But words are never enough, though some people can make a picture happen in words.

Donald McKinley Words can entitle objects but at some point you don't want to know any more. In fact, we've made talking about objects into a parlour game like, "Guess what this is." But words can explain the occasion for making an object, something only the maker knows, and this helps reassure the viewer about what was going on, so words do help. Words can be helpful and challenging, because they help one experience an object and its possibilities. But words are not essential and they can also shut down some possibilities of experience of an object.

Skye Morrison A friend who worked for an international craft magazine tells me that he used to get musicians to write reviews about crafts exhibitions because they seemed to have the best language. They had an intimate relationship with handcrafted objects because they played handmade instruments. Another thing, lots of people say if you have an exhibition and you don't have a catalogue, it doesn't exist. Words can do it, they can talk about crafts in an important way. They aren't exclusively the whole experience, but they certainly help make the experience.

Stephen Hogbin Northrop Frye has a really neat quote: "The attempt to bring criticism into direct experience will destroy the integrity of both." He's dead right because you can't walk up to a craft object and immediately start pouring forth your own projections onto it. Instead, you must first start perceiving what that object's about.

Sight is our most important sense, the one we use most often, and we just have to let the image play on our retina and experience it at that level first. After that sensory experience, the critical ability steps in and we start to evaluate what it is we are receiving and sort out what's going on there to make further sense of it. Then we look back and out with our minds to evaluate and develop a critical mind-expanding appreciation for the craft object. So there's the seeing and then there's the looking part of it.

Then the final thing is whether we can really talk about crafts. Language is our primary means to communicate our percepts and our perceptions. If you don't talk about your perceptions, you end up losing a terribly important part of human experience. So to live just in that first state of sensory experience is very shallow, in my view, and you need all those different levels to get a full appreciation of what it is we are looking at.

Talking about a craft object can therefore extend or magnify or alter the initial experience. You can get a real strong initial sensory experience but then, after you evaluate it, you might say it's inappropriate or it can be done better by bringing the rational side into it. Talking about a craft provides a back and forth discussion with another person that helps you shift your perception a little bit to line up to theirs and see the object through their eyes.

Each of us has a unique way of seeing, and although there are obviously a lot of crossovers, my understanding is that there's an enormous variation in just the sensory aspect with the rods and cones and how the light is received. Then how you process it — from one person to another, from one culture to another, one age to another, one gender to another, one orientation to another — gives you a huge number of things that come to play once you put a perception into the mind. It's a little scary that we are seeing things very differently, but that's wonderful that it's so unique for each of us.

Language, therefore, allows a sort of checking out for a common language or experience, though you may decide you don't agree with someone else. For example, I don't see the same as fundamentalists, be they Hindu or Islamic or Christian, since it's a fundamental ideological difference that I have. I believe life is very, very complex and that you can't nail it down too easily.

So, in essence, what hits my retina can be changed from a discussion, though I'm not always sure. I know that if I look at something in the day as compared to the night, the object seems different, but it's just that light plays on the object differently. So maybe if someone talks me out of my point of view, I perhaps see it in another light, though maybe that's not actually a different light at all. I do, however, feel I've had that sensation of being talked out of something and seeing it afresh, and it does feel like a retinal change, but that might be scientifically absolute nonsense. So the issue of words talking about crafts is very complex at a very basic level.

The Criteria of Good

Stephen Hogbin The criterion of good involves the convergence of significant patterns that come together at the same time in one place. Not just visual patterns, but also important cultural patterns of meaning that one can experience in a work. This overlapping gives incredible richness. But if you separate, say, technique from form or you have form without meaning or form without subject, the craft object isn't as interesting as when all those factors layer. And if there are culturally significant forms and functions in a work, then you get a momentum in your experience of the object towards a point where you come out saying, "Oh, wow!" That's what good would be for me, though an object can also be good if it's missing one of these components.

Jeff Burnette A piece is good if it turns out the way I planned it to turn out. But I could make another piece tomorrow and that could be even better.

Donald McKinley Objects are not changed by either acceptance or rejection. Things are no more or less original, valuable, structural, comfortable, elegant, aesthetic, flawless, functional, or appropriate for being put into one category instead of another. My decision, or that of anyone else, does not affect the object.

Susan Edgerley A lot of the criteria for good and bad in crafts are centred around technical ability, a mastery in technique. For me it's very much a combination of resolution and aesthetic concerns. No matter how good the aesthetic idea, if the person can't express it physically or in the manner she wants, if the person can't lead observer where she wants, then the greatest idea falls flat on its face. So good combines aesthetics and technical mastery.

Jeff Goodman I'm totally against giving people information about a work. I like people to take their own experience away from it. I shy away from giving conceptual information or any kind of information to the viewer and I almost never title anything. I title only about four or five per cent of my pieces, therefore, and let the viewer decide for himself.

Kevin Lockau Each person takes away something different from a craft work, and I'd like to hear what it is. I don't think, however, that most reviewers ever try to talk "about" crafts. In most magazines it's mainly a physical description of the work, and this is boring.

Kee-hung "Eric" Wong People like to argue about the separation of arts and crafts, but for me the only words that matter are "creative" and "quality". There is no difference between the artist and the craftsperson at this level. More important, you find you can describe an object up to a point, and then any labels you have don't work anyway.

Winn Burke The act of making an object creates something you have to stand away from. You must stand away from it so that it can speak. If the object then requires you to talk about it, you're dead in the water because you haven't been successful with the stimulus you've taken on to make the object.

Grace Traya If it's been given careful attention and made wholeheartedly by the craftsperson, then it's good.

Rachel Young My idea of good craft is something with a purpose that completes that purpose. It breathes its own breath. It speaks and is heard. It lives or dies. Its beauty is its texture, its height, its weight, its movement, its lack of movement, its emotion or lack of emotion. Overall, all that matters is that it is powerful or subtle and tells a tale. It is the idea, its genesis to its completion and is everything in its world, the one and the all, the individual and the universe combined.

Robert Bowes Sometimes it's critics who convince the masses as to what is good.

Patricia Taylor A piece is good if it captures a person's curiosity, emits a soul, and holds its own by commanding a space.

Paul Pearson At times people love a work and call it good even though it is garbage. But in the end, as long as the craftsperson sets a goal and creates toward that goal, you have very good craft.

Dalley Wark For a work to be good, I must have an emotional response to what I see, be it fear, anger, joy or something else. The work must hold me here in it and I have to be captivated by the piece. I have to feel the energy of the piece and the sweat that has gone into it.

Vera Polischuk An artist has become one with his piece when it is good. There are no boundaries and the creator flows and responds to his tools as if they are part of him. This connection shows through the work.

Working for Oneself, Working on Behalf of Others

Winn Burke In many cases, working for oneself and working on behalf of others can be the same thing. Ideally they should be. One should be able to work for oneself even though he or she may be doing, say, a commission for others. In the meantime, self-integrity and confidence will define oneself in the process of making.

Laura Donefer When I began working in glass I was concerned with certain social issues, leaning toward feminist thought. My work has changed from the earlier more visually jarring pieces and as I grow older I enjoy the way in which my work is evolving. What an incredible leap from where I began over twelve years ago to now; I have learned so much on this creative voyage of self-discovery.

Since my third year at school I have been working on one particular series called "Witchpots" and because I have become known for this, people expect to see this type of work, so I always make each Witchpot fresh and exciting. I never ever want to show something that is dull and unpredictable, because I put my whole creative self into each piece. There is an unabashed joy in making something that people really want to have in their homes, as I found out when producing happy, colourful vessels. I must admit, though, that some of my work is a bit heavy for some; they are issue-orientated pieces that people just do not want to deal with.

Jeff Burnette If I'm going to make a piece, I'd rather make it for myself than for anybody else.

Alison Vallance I'm all for small producers and people who are doing crafts with a sense of manufacture for others, like a lot of the people who show up at craft shows. But sometimes the objects don't seem to have integrity because they're either blatant rip-offs from other traditions that you've seen a million times before and the work has a look of expedience because people do it because they think it will sell. That's not very good craft, though I support the reasons why people want to do it

Joan Chalmers Once we had fifteen members from the Museum of Modern Art over, and one of them couldn't conceive that these commissioned craft pieces were part of our everyday life. But if we like what a craftsperson has already done, then we tell them how long or how high to make it, and then they go away and do something. Most craftspeople have never had that degree of freedom in working for someone else.

Valerie Knapp I usually worked for clients before, so I had exterior pressures as to what was current. Now that I'm away from the market-driven life, I want to work out a new direction and discover new

things about myself along the way. When I worked for others, I used feel a nagging for more contemplative and quiet times. At the same time, with my own business, I had to keep fuelling the process myself with creative energy and that was very rewarding and very exciting. But I wasn't being restored sufficiently on a regular basis and I led an imbalanced life weighted toward critical acclaim and status. The rewards did not feed my soul, though I'd pick up the *Globe and Mail* and see a big article on me and, in truth, I also loved what I was doing. I was continuously making and selling new works because there was an audience, but once you're established it still becomes a bit of a treadmill that you can't get off.

But I guess I don't really analyze what I do or why I do it. It's just how I am, what I make, and I don't think of my work as being all important and all moving for other people. I simply get personal satisfaction from creating and knowing I've made things other people may enjoy. Designing a piece of fabric is a very small part of our culture, but in making things I feel part of a history of a culture. I'm part of a textile history and very much perpetuating an aesthetic. Cloth is all about the need we have as human beings for warmth and for covering and for something that feels good to the touch. Cloth is the closest thing to the body all day and it comforts us from the day we're born until we die. When I did a lot of fashion, I was strongly aware of this essential connection of people and cloth. At the same time, in our culture textiles are really taken for granted.

Barbara Walker I don't mind working according to someone's guidelines on commission, but I prefer weaving as self-expression.

Daniel Crichton The most demanding thing one can do is to dig down inside one's self and draw out forms and ideas and expressions that have individual and personal relevance and then somehow transfer that to other people so they understand some of it as a universal quality in themselves. Vessels are good in this way because people's response to a vessel is always immediate and they are notas intimidated by it as they might be by some other art forms. There is an accessibility to this medium because it's been around for so long and people are used to seeing very simple glass forms that they have in their everyday life.

Robert Diemert The commissioning process calls for a delicate balance between the client and the maker, in other words a compromise. One needs to satisfy the client while also pursuing new ideas and not become hung up on reproducing old work and simple variations. Commission work provides constraints that can stifle creativity, since the process doesn't always allow time for open investigation of ideas.

Elitism in Crafts

Winn Burke No doubt elitism exists, supported by the agents of craftspeople and artists. These agents are gallery owners, critics, and private collectors; in other words, the tastemakers.

Haakon Bakken When expression became the primary focus of the contemporary maker, rather than the melding of sensitivity to form and material, and the fulfilment of function, the elitist "artist/craftsman" was born.

Joan Chalmers I never think of craftspeople as an elite. They are artists who produce beautiful things, which may or may not be functional as well, and I'm happy to have them in my life. They create using great knowledge in their heads, which they can get through their hands, and they have worked out a lot of technical problems to produce something marvellous. It's a very special talent because you need to know so much and then forget three quarters of it and have it so much a second nature.

When people say there's an elitism involved in crafts, it's because a lot of people are afraid to go into an art institution. Somebody might ask them a question and they have no exposure to beautiful things in their day-to-day life. In their world everything is mass produced. A painting of Elvis Presley on black velvet is not particularly beautiful, but it's mass-produced and therefore acceptable. Nobody's going to challenge them if they buy something like that. But we never have enough of the beautiful things real craftspeople make.

Barbra Amesbury At one point we felt there was a failure in the Canadian crafts movement to focus on the quality of craft in this country. The crafts councils really were just going to the lowest common denominator and not playing a leadership role. Nobody was marketing high-end craft properly as a pure art form. We wanted, however, to have quality craft marketed as a viable option and decided to support the kids coming out of craft schools, since craft is not a hobby but actually a profession. There's no organization to represent the professional craftsperson, since many councils are run by amateurs for amateurs.

What's wrong with standards? What a high standard for crafts does is that it glorifies the position of being an artist or craftsperson in our society and brings lustre back to a name that has become meaningless since every Tom, Dick and Harry can walk around and say, "I'm an artist." So in the craft world, it's the amateurs and amateur organizations who are elitist. It's a reverse elitism, a snobbery of the uninformed at the bottom end, with organizations saying it's the amateurs they should protect.

Ingrid Bachmann If you look at great literature, everyone had a day job. Right now V. S. Naipaul is the only writer I can think of who doesn't have a day job and P. D. James quit her job only at sixty. In terms of fiction, poetry, literature, the whole history of art is done by amateurs except for maybe a handful. So it's great to have amateur groups to support amateurs, since, in a way, it's amateurs who are doing the work .

Donald Robertson To an uneducated public, a work might seem extraordinary. But the more educated you are, it takes more to satisfy you and some people might consider you very elitist. This doesn't mean you're going to enjoy a work more than somebody who isn't educated in crafts, but as you learn more and more you develop your taste for certain types of work.

It's necessary to create on many levels and that doesn't mean that one is better than another. I once worked with blacksmiths, and they're an elite group, though pre-industrial revolution in their outlook and what they do. I can cut a piece of glass with a glass cutter or I can cut it with a water jet using a computer program, and I'll personally go for the quickest and easiest way of getting it done, rather than struggling with an unnecessary process. But a lot of people think that's wrong and are threatened about losing their craft. Fearing a contemporary piece of equipment is elitist in a negative way.

Daniel Crichton Crafts have always been pretty close to the ground, usually in the hands of the average person. On the other hand, a desire for highly refined and beautiful things combined with craftspeople who pushed material to its furthest degree, all in an economy that can afford to purchase very expensive objects that serve a higher purpose than functionality, might possibly be construed as elitist. Another way to think about it is that you have a group of people working intensely with little contact with the outside world and they extend their own language in a closed environment, so a kind of elitism develops, mostly in the form of technical jargon and a taste for different techniques.

Alison Vallance Elitism is not a word I use. Crafts can, however, be highly esoteric and appreciation of craft depends upon the receiver. People do need some background before the appreciation extends to a work that demands some sort of appropriate knowledge. But even esoteric work can communicate immediately at some level to most people, though the piece at the same time is demanding. So the work is not elitist, in fact, but demanding.

In the Crafts Tradition

Alison Vallance Objects made by craftspeople contain crafts knowledge and these objects are much easier for people to relate to because they return us back to our natural senses. A computer chip is completely unknown in a sense, while crafts objects have a lot of meaning for us because we know where they came from. They are natural, made from common material, so you can imagine them in nature, and they tie us back to simpler times and simpler activities. They make reference to the workers who produce them and we can imagine how they were made. We can imagine the relationship between the mind, the eye, and the hand.

We respond to crafts objects and a tradition of making because they remind us of really essential activities of people over time, basic activities that have involved people for centuries. The forms of crafts are rooted in centuries and they provide a continuity that embodies a sense of understanding the world and being unalienated from the world.

Barbra Amesbury The greatest art has always been the art of the tribe, but in the last forty years after the war, everything has been plastics with all those punch presses and moulding. We've forgotten that in other times everything was made by craftspeople and that they were honoured within their villages, within their towns. The better craftspeople were considered masters who served as apprentices first. For example, in Germany, up to very recently you couldn't become a craftsperson unless you went through five stages of being an apprentice and that's where you got your education. Nowadays kids want immediacy in their jobs without paying their dues.

Jeff Goodman It's definitely important to have a tradition of reference for glassblowing behind me. Also my affinity for historical bowls, like the Japanese tea bowls and pre-Columbian ceramic, is very strong. I'm also interested in basic serving bowls, partly through archeology. People have made bowls for so long and it's a fundamental human experience to make bowls and even more fundamental to use them. At subsistence living you had to have a bowl to put your food in, a vessel to store goods in to travel, and before refrigerators, vessels were an important storage container. The history of glassblowing is compelling, but the history of the vessel itself is even stronger for me.

Skye Morrison Throughout time, the making of crafts has always involved extraordinary ordinary people.

Ingrid Bachmann I don't feel so much a part of a tradition, but more in between a number of traditions. That's why I like being in a field related to textiles, a field that is unclear as to what it is right now and still in the process of redefining itself. It has links with so many different aspects of daily life. Textiles are a commodity, they function on an industrial level, they're an art medium, they have traditions and associations with women's work. I also like the fact that textiles aren't pure in any sense and have commonality with people's lives. Yet although textiles are part of real life in so many different forms, I'm not interested in their tradition as such, but in the guild mentality that was part of textiles, a kind of anonymity they involved. As well, I'm interested in the way that textiles and other craft media interact in people's lives and the fact that they're not a pure realm like oil painting that speaks to its own tradition. So all the things that are usually said to disparage craft work are the ones I find most interesting. Textiles are like video and photography in that they connect with people's lives in a whole lot of different ways.

I'm not someone who has a sense of valorizing the hand or the individual. I'm more interested in the history of craft that stresses the team approach that built medieval cathedrals or made book illuminations, one that involved incredible individual talents put to use to make a whole that is greater than the individual parts. I don't have a lot of nostalgia for handwork or lost skills or trying to reclaim a past that is actually quite fictitious since a lot of craft labour wasn't quite slave labour but it was down and out labour. I do admire people who find their way through a material and there still is a place for people who make ordinary things that transform how we use something and shift our knowledge of a particular object or put us off guard.

Donald McKinley Even if you have little contact with people of other cultures and other centuries, if you can remember what you did yesterday, then there's a possibility of improving yourself and therefore valuing tradition. You're not ever going to be aware of all other cultures and it's probably possible to spend so much time trying to be aware and informed of tradition that you become a great scholar but you don't make diddly squat. In this case, you're studying the past instead of changing material today. There's really no substitute for the physical activity, and being part of a tradition rather than just a student of what's gone before, you can actually show what you have contributed to a tradition.

Karen Smeja What I do certainly evolves from a long craft tradition, since I started off as a weaver. But now I am more a textile printer, which is a newer form, so I'm not as aware of the tradition of textile printing as of weaving. In both I feel an obligation to do quality work to reflect myself and what I believe in. In crafts you have personal standards and traditional standards of your field to guide you.

The Social Impact of an Object

Winn Burke If enrichment takes place, not only in the owning of an object but, as well, in the making, then social good has been achieved.

Robert Diemert A craft object promotes change. It makes people realize that there is something better available. If they have any sensitivity, it makes them take a second look at an ordinary table, for example, and it challenges them as they do. For some people, a table is a table and dollars and cents are all they read in it, and that's all they ever read. But men used to come into my studio, dragged along by their wives, and you could see change in their eyes. They would realize that a simple table form is not so simple and I feel this experience made them question more when they went out to buy something, now realizing that there are options in objects.

Alison Vallance Nothing is neutral in a culture and any crafts object has a social component and certainly has a social impact of some kind. There are so many different people who call themselves craftspeople and some do work just for their own use, such as toilet roll dollies or sweaters for their children. These objects have, from my perspective, as much meaning and social value as an "elitist" object, but the latter has a different meaning. All objects have a social meaning and relevance within a community and to the person who made them, and what I find interesting about crafts is that they are exceedingly diverse. The fit for crafts goes right from practical objects in the home to more highly specialized one of a kind objects not commonly used.

Joan Chalmers A crafts object becomes part of your life and it gives you another aspect of joy when you look at it.

Susan Edgerley An object has a social impact, though it's not always seen that way, because crafts play a big part in how people live their daily lives. But people in general don't have the faith to try something different from their neighbours and that's really sad. When crafts are viewed in terms of excellence, in terms of the very best that can be made, those values are very inspiring and make people aspire to excellence. This way, objects can have a profound social impact because people really start to look beyond the standards they are accustomed to. They develop a little faith to try something different, something with the finest human values of making.

Ingrid Bachmann An object has social impact only in context with other objects, situations and people. The situation in which you put a piece, into a gallery or museum or store, or if you wear it, or if it's mass-produced, all change very much how the object is received. The object might have a different impact in each context and one object can have many contexts. There aren't fixed borders around objects and they change in relation to the situations they're put in or how they're framed, so I don't believe in the bell jar for objects since few of them can be cohesive and so complete in that isolated way. Objects can speak to people in different places at different times.

Sometimes I see a few collectors in the crowd and all of a sudden these very strong artists say, "My work doesn't mean anything. It can mean whatever you want it to mean." That speaks more about the economic realities, and I think it's lazy. Sure your work will mean anything to anyone and that's a given, but work takes so much time to make and commitment to do, and it's not an easy life. To relegate it to basically a mindless activity promotes a lot of stereotypes about the weirdness of artists, their lack of professional status, and it's also a way of collusion with the marketplace. So I get a little distressed when I hear a lazy denial of the value of making as if it's just a *lah-di-dah*.

The work I like doing best of all is related to a situation, a site, a problem, and that's where I have to respond to something. And now my work is getting bigger and harder to store, so I think audience is really important and that my work is not just not for me. You throw it out and you hope that it hits somewhere and that someone gets it and understands, since that's amazing when you have a point of contact with someone. I always like that sense of contact. When I came into crafts I was looking for a way to reach a broader audience, a way of looking at art that was much less hermetic. When I got to the craft community, it was trying to make its work like artwork and put it on podiums and pedestals. Now my work is much more in the art community, but my questions involving my own work come from my textile and craft background.

Karen Smeja How the personality of the object extends itself determines its impact, since that personality is, in truth, an extension of the craftsperson.

Donald McKinley One social result of crafts objects is that there have been people who have been hard-working volunteers and burned themselves out developing a crafts organization, while there were others who weren't willing to spend time making it happen. Some craftspeople have said that organizations shouldn't be run by volunteers because people who don't do crafts aren't sensitive to the needs of craftspeople. On the other hand, some craftspeople are so damn sensitive they're totally ineffective, while others are so competitive and try to score points within the organization.

Belabouring or Renewing Culture

Susan Edgerley Crafts do both, belabour and renew culture. By sometimes belabouring, one can renew a tradition or go beyond it and push the cultural norms. Or push the percept just the tiniest little bit further. You can't deny culture as you create, or resent it, since it's good to acknowledge what's gone before, know about it and use it.

Ingrid Bachmann A lot of artists from other cultures have adopted material from what we call a craft or decorative tradition as a way to reclaim that culture. Many women artists have also taken to working in what are considered traditional women's practices like textiles to reclaim a heritage. That's a choice one can make. If you do so, you can reinvent a tradition or, rather, translate or transform it, but, personally, I don't like nostalgia and there is a lot of nostalgia in the rhetoric around crafts. It's one thing to reclaim or remake a tradition and use a tradition to either speak to or speak against some of the dominant values, but in general the nostalgia in the debate around craft media doesn't interest me so much. I hate the romance of "the craft" and "the hand." It all makes me gag, it certainly does.

Still there is a potential for objects to bear witness and as things become more and more expedient with technology and things become ephemeral, there's a certain persistence in an object that has a potential to stake a claim and say, "I'm here and if you want to get rid of me you have to sell me, break me, destroy me, bury me, or give me away." And more and more I'm rethinking those questions. An object doesn't have a resonance innately, and it's very hard to predict an interpretation of one's work too, but there is something about the tangibility of an object, one that has the trace of an individual maker, that is very present. It is a kind of signature, to a degree, of the person who made it or the time it was made or the processes that were available.

Winn Burke Does the making of an object become or make a culture? If I make a pot here in Canada and I am of U.S. citizenship, is that pot a Canadian pot or a U.S. pot? Is the political framework part of the depiction of a culture through an object? When it was said, "I want the most beautiful tiles for this mosque in Istanbul," was that culture on demand? It probably was the creation of a culture. Can that happen now? I don't think so.

Donald Robertson Traditionally most craft objects tend to be cultural artifacts. They are the result of a long repetition with slight variations. And in the old days, most of the crafts were of necessity, and form and decoration developed over incredibly long periods of time. These utilitarian objects were made as objects unto themselves and they weren't specific to one person's ideas. They didn't possess that tremendous individualism that crafts today require that puts crafts with fine arts now. But today changes are almost obligatory and they happen every year, every six months practically. So there is a renewing in the sense of searching by craftspeople.

Jeff Goodman I used to feel awkward making objects which reflected my romantic view of other cultures, and at the same time I had a problem relating my work to my present lifestyle. At that point I began to notice that it was the effects of time on primitive works which fascinated me, rather than an affinity with their original state. In turn, I began to notice my immediate surroundings: the cracking of asphalt, the peeling layers of paint that build up over decades, the erosion and breaking up of concrete. I could no longer associate myself with another culture whose art revolved solely around religion as I monitored a TV by remote control while sitting in an air-conditioned room. I realized that my work had to reflect aspects of my own world, my own society.

Although I work in glass, I'm really a mixed-media person because the idea takes me out of glass all the time, and I work in steel, stone, and other materials. In fact, glass isn't my favourite material. It's really way too beautiful for me, and I always try to deny its inherent beauty and make it a more guttural object. I blast the objects with the coarsest sand I can to bring it down to a guttural level. In terms of material, clay is my favourite because you can be aggressive and guttural with it. Steel and stone are in the same category. The inherent beauty of glass just drives me crazy. It's not something I like at all and I'm always sandblasting it. I'm not sure if I'm belabouring or renewing anything, but I'm trying to get through that beauty to something else.

Donald McKinley I don't know anyone who belabours who is pleased they do or recognizes they do. It's not something people would choose, and only something they would see afterwards. If you're just trying to duplicate, you're being a machine, but if you're trying to improve, that is not what I would call belabouring. Sometimes people may indeed belabour and others may certainly judge them and say there's no growth or change or discovery and that it's become simply a routine. But, on the other hand, sometimes to the person engaged in an activity it may seem very much routine, and they might not be conscious of increments of improvement in quality or speed or some viewable aspect of the object. They might bemoan the fact that they haven't done anything different and not be aware of even dramatic improvement. The reverse is they might not realize just how routine the work has become. Or it may be that there is something that is becoming finer and finer and finer, something which was a nasty object in the beginning, and it still is, except it's smoother.

If I Had One Week to Live, Would I Create Anything?

Kasumi Lampitoc I wouldn't create anything but I would find the route to where my clay came from and I would touch the earth there for a long time.

Kee-hung "Eric" Wong With only one week more to live, I would create, yes, but I would be more creative with things, do some sculpture instead of the functional thing.

Sherry Pribik With one week to live, I wouldn't create anything. Absolutely not. I would absorb, I would go away and absorb rather than create.

Susan Edgerley I would make something but certainly not in my field, perhaps a video specifically for my daughter. I'd want her to know how much I cared for her and what I was and who I was. That would be my form of creation and I'd certainly make that.

Valerie Knapp I went through the death experience of a very, very close friend not long ago and I knew he would be gone in another week. It made me realize how many things there are that need to be talked about. So I don't know if I would go into a studio and start making something. Instead I would probably be more contemplative about what it is that's coming to an end and write things down. Maybe I would make things that include words. What I do continuously now is garden, write and make things, so I'd continue those, and also probably make something for myself to wear.

Barbara Walker I wouldn't spend the whole week weaving, but I'm sure I would create something.

Daniel Crichton I only have a limited time to live already and as a creative person you're always making decisions like that. Should I work an extra two hours on this piece or should I go home and spend time with the family? You're always trading off time with what you're working on with the time for doing other things in your life. It's always a compromise. People ask me about the fact that I have a family, and I teach full-time, and I have a pretty active exhibition schedule, and I say I just keep all the balls up in the air. Instead of worrying too much about it, I let my work progress at an even pace over a long period of time, instead of a fast pace. But if I had one week to live, I'd probably change my priorities a little bit. I'd probably smoke a lot of cigarettes, I don't know.

Larissa Desjardins I would attempt to create expressions of my love in pieces made of glass, wood, and clay. Glass because it looks fragile and yet it is strong. Wood and clay because each has strength in itself and each is permanent because it comes from the earth.

Robert Bowes If I created, it would be not be something that would take two weeks. But anything less would not be worth the effort for the memory I would hope to leave. Therefore, I would create a lot of smoke running to the doctor for a second opinion.

Patricia Taylor I'm always creating in my mind and in actuality. I would create a self-descriptive piece in clay and entitle it "The Undying Love of Life" so that more of me would survive than just memories and pictures that can fade in time.

Paul Pearson In my last week on earth I would make a glass representation of my soul, thus my being. This would symbolize that I would go on in some form or another.

Ingrid Bachmann A very good friend of mine just tested positive for AIDS last night, so I've been thinking about what's important. That's a hard one because it makes you look at your life. With only one week, I'd probably just tidy up and have some control over what was left. I'd try to finish up. And maybe make models or drawings that might be realized by someone else.

Wendy Mitchell-Burke I might try to gather and distribute things I'd created to people so I might live through them. I also like the ideal of creating a burial cocoon, something like the Egyptians did, and maybe make a blanket from wool to wrap me up in. Depending on time, I might make it quite creative but definitely cozy. In the process, I'd like to make a big old mess and leave it behind.

Grace Traya I would like to experiment more on ceramics and learn more about colour mixing, pattern-making, and all sorts of stuff. Most of all, I'd like to be able to make something eerie and weird that would be used in an exhibit to show how morbid an individual's mind can be.

Winn Burke Yes. I don't know what right now, because this is not the last week. But, yes! Yes!

Why Do It? — Choice or Need?

Daniel Crichton People need to work in a craft. It's not simply because they want to do it, but because it's therapeutic and they actually need to do it. Work in contemporary society is full of other people telling you what to do, and ideas are increasingly driven by corporate agendas. So to have some means of doing what is visionary in you, a means that allows none of these outer voices to penetrate, is good for a person. In turn, when creative voices are strong together, it's a way for the spirit of a people to be kept alive. People dip into the mythology we all share, participate in it, and are able to balance themselves in the midst of all the issues that come into their lives.

Robert Diemert Wood is a seductive material and I was always attracted to the colour, grain, pattern, and workability of it. It's pretty direct and you can effect change with it very quickly. It's also an organic natural material and that makes woodworking a sustainable activity. You can grow trees, use the material, and put it back into the earth by planting more trees. And I wanted to be happy doing something that wasn't destructive, I wanted to create, I wanted to use something that was existing, a natural material, to its best advantage, and to my best advantage.

I used to work at Stelco, and some people, I found, didn't give a shit and hated what they were doing. I didn't want to do that, live like that, for the rest of my life. But as a woodworker, even when you're sanding, there's enjoyment and there's a challenge there, trying to get it right. I love seeing the wood change right in front of my eyes. Mostly, I've had enough variety as a woodworker, and I've always kept looking for something more in wood. That's my nature.

Laura Donefer I went to a craft school because I wasn't breathing with my hands. After years of academia I realized that I always have to be creating something to be truly happy. It doesn't seem to matter what I use, as long as I can be expressing myself: glass, bones, sticks, leaves, stones, wire, wax, whatever. I guess my passion for creating is how I show my core to the world, it is basically just heart.

Deborah Kirkegaard Choice and need are not mutually exclusive. I had a need to create in textiles and there was a choice involved, a choice to do something I needed to do. I could have needed something and chosen not to do it and I could have chosen to do something I didn't need to do, but I chose what I needed to do.

Steven Heinemann I work in ceramics because it's my language and I have a need for communicating in the world. It's not something chosen, but rather a matter of temperament and of circumstance. I'm working with material so I can be articulate. It's a language like music and if I thought I could be more articulate in music than in the language of ceramics, then I'd probably be a musician. But so far I'm able to say what I need to say in ceramics.

Sheila Mahut I got into the craft business because when I got out of high school, I really didn't know what else to do. My family is in crafts and I felt sure that I would never do that. But after I took off a year, I decided to try ceramics and this was a choice by default. Then when I came to Sheridan College and found I really liked it, it turned out that my choice fulfilled a need.

Jim Todd Working in crafts is a combination of choice and need. I have a need to fulfil regarding wood, a need inside me that's always bugging me so I don't get much sleep and I'm never satisfied. The choice comes because working with wood is what I love to do and sometimes I feel guilty that people pay me to do what I've actually chosen to do. But I still do things without being paid for them by putting extra work into something, reworking the design or making a prototype that maybe is not necessary, just because I also have a need to get as much out of a project as possible.

Michael Fortune When I was a student from 1971 to 1974, there never was a question in my mind that furniture was an excellent career choice. If there had been a notion that it would be impossible to make a living, then I simply would have done something else. But there were a number of instructors who were working in the field and appeared to be doing fairly well, people who were industrial furniture designers as opposed to practising craftspeople. That was really my focus when I got out of school which in turn has served me quite well.

Sherry Pribik I need to do crafts and that's why I choose to be a craftsperson. I'm not making any money on it, so it's a choice I make to do something I love.

Jeff Goodman I don't know any other experience but the creative one, and if you talk to my family they'll say I'm pretty crazy. But as a kid my favourite thing to do was to go fishing. I'd get up at three o'clock in the morning, and as soon as it was light, I was in a boat. Then I got interested in golf, then in tennis, and it's always the same thing, trying to make the experience the most I possibly can. Now we have the studio and in it we have a pretty exciting environment, another challenge. I'm in the driven category of person, sure, but with craftspersons, if you're not driven, you probably won't make it.

What Exactly Does a Teacher Do?

Winn Burke The only difference between me and a student is that I have more skill experience over a longer period of time, plus the technical knowledge that can be had out of a book, if we wanted to deal with it that way. In teaching and learning, there's a "where" and then there's a lot of "how to" and we spend an inordinate amount of time on that. And then there's "why," and "why" is the toughest part of it all to stimulate in terms of a student wanting to go through the process, which is sometimes very complicated.

It's also necessary to provide some sort of perspective of where this object-making magic is in terms of its own history, especially in ceramics, which is thousands and thousands of years old and nothing really has changed. That perspective tends to offer a real comforting quality because it simplifies the complexities of where you are, doing what you are doing as a ceramics maker. It's also intimidating as hell to a student at one point because they start asking "why?" If that "why?" gets bigger and bigger, the student gets really impotent about making things. They feel they can't make it because it's already been made.

So you as a teacher have to turn them around and cause them to see that the experience is enlightening and expanding, rather than narrowing. A teacher tries to get students to see other kinds of perspectives so they can define where they themselves are and use their own thumbprint or viewpoint to create their own personal experience that, in turn, one hopes, achieves their own personal aesthetic. Students need to realize that their experience belongs to them rather than to this great historical context. And when this happens, I feel that any student of craft is really his or her own teacher. Yes, I can show someone how to throw a cylinder for weeks and weeks, but this is boring and the question of what to do next is the guts and meat of working in crafts. If I don't have some information for the student to plumb at the right time, and I can't push the right buttons, I'm dead as a teacher. And yet I have to say, in another way, I have no idea what a teacher is.

Bruce Cochrane I consider it a privilege to be teaching the very thing I have a passion for and that is making pottery. It's extremely satisfying to be involved helping students reach their potential. Being active with my own work allows me to relate to the students' needs and students keep me on my toes. The research and dialogue that go on at a craft school benefit the students' development and force me to ask questions about my own work, keeping it fresh and evolving. What I learn in turn goes back to the students.

Susan Edgerley What does a teacher do? Everything. A teacher leads, guides, shares, encourages, and helps others to discover creative areas that he or she, the teacher, may not have been.

Laura Donefer I took the enthusiasm and freedom I learned in craft school with me when I left. My teachers were helpful because they taught me basically how to properly critique my own work. When you leave your training, you have to have a language with which you can consider your own work. Even more than just actually making objects, you have to learn a language to speak about art objects, a language which teachers can provide.

Peter Fleming Certainly I realize when I'm talking about solving a particular problem or dealing with a certain aesthetic issue, that I'm forcing my own viewpoint on people. However, I hope they understand that this is my viewpoint and that they can accept it or reject it. There are specific senses of aesthetic that are appropriate to given media, and certainly the fashions that are at work within a given medium dictate how that medium is approached, but sometimes there's also a particular need of a student that is not being addressed and needs to be.

Deborah Kirkegaard As a teacher, if I can convey my love for textiles to any other person, then I've done my job well. If you love something , then the people you teach are going to see it as an honest thing and it will maybe turn on a light for them. The student will see that the teacher is doing something she loves and wonder, "Maybe that's something I would enjoy doing too." The other part of teaching is helping students learn a new language that will enable each person to express what is inside his or her mind.

Sheila Mahut As a teacher you learn an awful lot about learning through your students. You realize that some students learn things by watching and that some learn by hearing. With some students you can demonstrate a technique and they'll watch you and then go ahead and do it. They have learned to watch and now learn from watching. Then, with other students, unless you're talking to them directly and telling them why you're doing something and what exactly you're doing, there's no way they're going to get it. So ideally you decide where a student is in their development, and ideally you give them what they need when they need it. And that could be completely different for every single other student in the class.

Donald Robertson A teacher helps you find your strengths and your direction. I don't have unrealistic expectations of teachers because you often expect someone who is really good at a craft to be a really good human being too, and that's not necessarily true. But a teacher is like an important signpost on your road of development.

The Impact of Heroes and Influences

James Hollingberry An artist must obtain as many influences and ideas as possible, become submerged in work, and take on all the world as a starting point. It is after an overload of information and influences that a creative person must then forget or put aside this information and re-emerge with a clearer and more precise direction in his or her own work. Without first looking at the past, I do not think a creative person can go forward. I tend to create folk objects that will depict my surroundings and, I hope, leave a visual record of my life and inspirations.

Deborah Kirkegaard As a student it was really important to me to be exposed to people who were at their work for a long time and were successful in some important way. That gave me something to hang on, because I felt that I too could do it if I stuck with it. They weren't actually heroines, but they were role models, people who inspired me as guides or mentors, people I looked up to when I thought I couldn't do it anymore. These people, therefore, serve a real function in the creative process because it's essential to know they exist and create, it's essential to hear their stories. There are times you think, "I must be insane to be doing this," but if you have a role model you also say, " She must have come to this very same point I'm at and I wonder what made her continue."

If you personally know your heroine, you can phone her up and ask how she got through this difficulty. You can say, "I'm stuck at this point and I want to get to that point and I don't know how to get there. I've lost my way and I don't know where my direction is and I don't know what to do. How do I resolve all of this?" It is really important to have a mentor whom you can hear explain what she did at the same point of crisis, if possible, or at the very least to have their example. Words are incredibly powerful and sometimes when you read or hear something, it's like remembering part of a dream that makes you go, "Wow!" You never know what will light a fire with a person.

Sean Ledoux Influences are both good and evil. I think that I torture myself and feel envious of one of my heroes because he somehow manages to keep all the balls in the air and keeps it all together. He's obviously more disciplined than I am, or smarter at some things. Yet I think that not being your own mentor can be dangerous, because it's like comparing your physique to models and you don't measure up. So, because you might feel what you're doing is no good, there are dangers in having a hero. I therefore prefer to think of influences, and usually objects more than people. You can't design in a vacuum and I'd be lost without influences, because what keeps me from getting stagnant is having a piece by someone else strike a responsive chord in me. This in turn influences how I create my next piece. So I find that I'm constantly being influenced by things and less and less by heroes, though it is encouraging to see somebody really make it. You then think that if they can, so can you.

Jim Todd I'm influenced by any creative person. I'm also influenced a lot by music, by geometric shapes and forms inside of nature, by physics and how, say, a circle can be broken down into a magical formula. I enjoy seeing my peers make things that are fresh and new and a contribution to the pile. I sometimes feel that contributing to this pile of ideas, though we don't necessarily get to talk to one another, is a way that allows us to talk to each other, since we see each other's stuff in galleries and this creates a dialogue of sorts. I don't really have any heroes, but there is a furniture maker in the States, Wendell Castle, who to date is the most successful furniture maker of all time, at least in recent history, and I guess I can only hope my ideas will be accepted and thought about as much as his.

Peter Fleming Furniture-making is not a hero-driven occupation, and I prefer to chart my own visions. But I have connected with a lot of people over the years because their technical abilities were more ambitious.

Michael Fortune My influences are pretty much anyone I've come across, historical or contemporary. I try to be as observant as I possibly can, and I try to file away in a sort of vague way my impressions of what I'm looking at. In the contemporary field I tend to gravitate toward people who are doing things with a certain level of panache, be it from an artistic or business point of view. They are serious and they show it in their work, but it's important to also show a level of enthusiasm.

Jeff Goodman I don't agree with having glass conferences or meetings of glass craftspersons, since it shouldn't be what's currently going on in the medium that influences you and sets your direction. I've always believed you should design something in your head and then decide on the material. Mind you, that's very hard when you've got a hundred thousand dollars invested in a glass studio and you then decide you don't need the glass studio anymore and can do it out of another material.

But I usually go the library on and off for a while and start working with sketches. I try to put everything out of my mind, not thinking about materials or cost. I'll run through *National Geographics*, I'll run through historical books, I'll run through painters like Jasper Johns, and everything just to formulate something that is my own and then build it in our studio in some way.

Learning to Learn

Bruce Cochrane Becoming a competent potter is a labour-intensive process. In the learning process of ceramics, there is no substitute for practice and repetition in large quantities, initially with little attachment to the final product. As time goes on and skills evolve, then more concern is directed to quality, craftsmanship and evolution of concept. Work becomes less technically oriented and is geared more toward concept development. A student should also be encouraged to bring life experience to their work and combine this with research into historical and contemporary issues. Much of the learning is intuitive and cannot be acquired from textbooks. Developing aesthetic values and a level of skill which goes beyond mediocrity requires, all along, a tremendous amount of discipline and commitment to craft.

Robert Diemert Because I have a lot of skill, it gets in the way. It gets in the way of creativity when your skill level interferes with letting yourself go and run with something. You have to learn to not get hung up on your skills, but to trust your instincts once you've got your skill and know you can get a job done, though I always try to have some control over what I'm doing. But you learn that you're always compromising. You have to and you hate it, though you have to accept compromise eventually, be it financial or your own limitations. There's always a compromise also between what you want to do and what somebody else wants you to do. But that's also a chance to be creative.

Paul Dolsen In the furniture program at SOCAD I have been forced to shed my conventions of how furniture is designed and made. I now realize there are no conventions and no limits, and this discovery has let my thinking roam into a realm of furniture styles I once thought I would never be part of. I am being taught to see and not just to look. At first I was not comfortable, but I have learned to relax with my creativity and get through it, to my surprise, rather effectively. So I am experiencing growth and my skills are being focused.

Lisa Clarke My development has been slow. At first there would be a sudden change, a dramatic one, but actually it is a slow process. I've learned I have to organize my thoughts so my designs and pieces aren't so jumbled, to see pieces ahead of time and envision the colours and shapes and sizes before I actually do them. I've learned I have to have an open mind and try out new ideas, though sometimes this is tedious.

Janet Robson I feel sometimes like a sponge, out to soak up everything that comes into contact with me. What I'm learning is to realize the knowledge I absorb.

Jan Finamore I tend to get an idea and stick with it, but I'm learning that there are many solutions to each artistic problem. I've never been dedicated and now I'm learning to be.

Kerri Tedford In ceramics studio, with my first handbuilt pot, I slaved over it, talked to it, burnished it, loved it. It cracked because I loved it too much. Now I compromise because I realize that I will never be one hundred per cent satisfied with anything, and I'm now having fun. I can laugh at my mistakes and look with interest at others who throw much better than I do. I find that the best things I do are made really quickly, with me barely thinking about them. Could I be a little nuts?

Yukiko Nishiyama Everything at the school SOCAD is new to me, and not only the new language, English. In Japan the education system is different and everything has to be by the rules and related to textbooks. Black must be black and white must be white, but this way of thinking doesn't make sense when you are trying to create. It suppresses my mind and my creativity. At SOCAD it is easier to express my personality, though I still tend to suppress myself out of habit. I hope I shall be able to change.

Donald McKinley Makers can be quite defensive or not wish to recognize or point out the flaws because they want to feel good about what they've done and don't wish to be critical of it. They want to think it's been a good day, a good week, a good year or a good career. On the other hand, people can slam you without meaning to do anything for your benefit, since they just like to slam people. But learning to learn requires that you are willing at least to consider that your work isn't as good as it could be or that it isn't the only or best answer but only one of many alternatives. Once you acknowledge that there are almost always alternatives, that's how you learn. You need to look at a thing as if you aren't the one who made it and be objective about it as if it isn't yours.

With my own work, there are times I feel I've gained quite an insight into what's possible. But there are other times when you don't really learn as much about the situation or about yourself, since you really can't every time. You can't guarantee and deliver an increment of improvement, and learning to learn involves learning that you don't always learn. There's also the part about courage to change what you can, but it's a pendulum swing where one week you learn and next week you realize this might not be a time to set new challenges but instead one to conclude these objects and use what you've got without dismantling it again.

Turning Points and Their Impact

Winn Burke One of the hardest things for a student of crafts to go through is discovering that they have to accept subjectivity and then realize that learning comes from other sources and that they have to accept those things subjectively too. In crafts, people have this brilliant learning curve they have to connect with. No one else really has the answer, but up to a point other people do indeed have the answer. Students then have to realize that they are going to do some important things in spite of teachers and influences. I don't know when that happens, but it's magical and you get these wonderful aesthetic breakthroughs of discovery. And whether it's technical or it's aesthetic, though, is chicken or the egg, because some students have to know how to do something before they can make an aesthetic judgment. As a teacher, I will do anything to facilitate that connection, in any case, and I'll lie and cheat to make it happen.

Robert Diemert When I sold my first piece, it validated a certain amount of what I was doing and proved that there were people willing to pay me — even though the piece was indeed worth twice what I was paid. I didn't regard myself differently because of the sale, but it did give me a sense of hopefulness. Sometimes it's great to sell a piece and sometimes it's heart-wrenching because each creation is like one of your babies. It's changed in the last few years, though and now it's more, "I gotta get this done. I gotta get this done so I can pay the bills." You learn that you can love a piece to death and feel it's the best thing you've ever done, and then you just want to get rid of it because you've been working on it too long and you hate it now. You also go through a stage of being totally wrapped up in it and then you look in a book and find that it was done a hundred years ago by somebody in Europe. That kind of unintentional plagiarism happens a lot because we're so inundated visually with stuff. But when you do it, it becomes your own problem. You've done it in all honesty and it becomes another turning point because you start a process within yourself, you start questioning and rethinking.

Daniel Crichton I once had a student come to study ceramics, not glass, and she was really good at ceramics. Her mother did ceramics, taught ceramics, in fact, and ran a gallery. But this student fell in love with glass, fell head over heels for glass, and one day I heard a strange sound outside the studio. I looked around and saw her weeping her eyes out. She said, "I don't know what I'm doing, I'm so damned confused, my life is just crazy." This has happened a number of times with other students too. In any case, her turning point was when she followed her passion for glass, and subsequently she's been very influential in her field. It takes courage to follow one's instincts and commit to a new discipline.

Laura Donefer When I was raped, my strong harmony with people and with nature was destroyed, my spirit felt shattered. There are forces over which we have no control, that seem to swoop in out of nowhere and directly change our lives, and my series of standing women came out of this experience. It was titled "From the Core" and the glass was not beautiful. These faces had no eyes. The glass body parts were objects with no identity. Even though these women were round and voluptuous, they were topped with such horrid, tooth-filled mouths that no one would want to go near. They would be face to face with protesting mouths. No more silence, they are saying. The witches were silenced, but not us.

It is so important to reach that inner core and let the inside out. We all have a voice, we just have to learn to reach it. For women this has been a historical battle, because even if we have accessed our core, found our howl, we have not been allowed to show it. We are conditioned by society to be quite subservient beings and we have been taught not to delight in all aspects of who we are, the sexual side, the erotic sensual side. If women do celebrate their passion, they are branded immoral. They used to be burned at the stake. My favourite quote from the book *Hexenhammer, Hammer of Witches*, written in 1486 by two inquisitors, is "All witchcraft comes from carnal lust, which in women is insatiable." It is an ancient battle!

Deborah Kirkegaard Every turning point has an impact though perhaps it's only in retrospect that you see it, either the turning point or the impact. We all have turning points.

Sheila Mahut I've had two major turning points. The first was when I decided to continue my education at Illinois University. So I left home and went off to a school in the middle of the cornfields in Illinois. I was so very lonely and it was culturally very different as a learning environment from SOCAD, which had been very nurturing and supportive. The learning environment in Illinois was of the old school, which was highly competitive and combative. Being in competition with my peers was a complete surprise for me and I didn't know quite what to do. That taught me that the person you need to know and the person you need to develop is yourself, no matter what goes on around you.

There are other turning points as well, but the second major one was the birth of my child. I think everyone is a child until she has children, and then she becomes a parent. I feel the birth changed my whole consciousness. It also changed my work dramatically, since the work took on a real feminine aesthetic. I started a series of seed pods about the process of bearing life and caring about life, and giving, feeding, watching someone grow.

The Role of a Crafts School

Sean Martin I am not accustomed to talking about myself or expressing my feelings. This comes from my past in school, where I felt that no one was interested in things I had to say. But those people were not interested in the things I am interested in. That's why I like the crafts program at SOCAD. People have the same interests and I find it very easy to relate to what they say. I am now part of a family and I learn a lot more. So I want to learn all that I can now, all because people are interested in what I do and have to say.

Jo-Anne Trepanier Things are being asked of me that I never really considered before. I am travelling down new avenues of thought, expanding my very conservative and somewhat restricted outlook, remoulding my views. I realize that at the crafts school I am free to be creative and have an opinion that doesn't necessarily reflect my teachers. It's a very human approach at the school. I am mingling with such obviously gifted people, but I am coming to realize that I too am talented in my own way.

Lisa Hudson The most important thing I learned first semester at SOCAD is that I'm not a furniture maker. I've found that I think two-dimensionally, not three-dimensionally. I still love and appreciate furniture, but it's like music for me — I love music but I can't play a note. I'm now very happy in textiles.

Donald McKinley Not everybody needs schools of any kind, but a crafts school can make a difference in how quickly or how easily people learn. Over the years at SOCAD, people have stayed for both less and for more than three years, and some have discovered that this institution at this time is not for them and have left. For their part, schools at their most conventional feel that anyone who starts should become a graduate and that what the schools have as goals coincides with what people need and want to learn. I think that's damn presumptuous. People may not learn as quickly or as thoroughly or as completely as the school wants, but it's really a lack of coincidence between a student and what may be not a very flexible standard or goal within the school in terms of how they get along with particular students. But that's an institutional issue rather than whether there should be crafts schools.

In some ways it would be nice if, one could financially afford schools or places to learn which don't have to be called schools or have faculties as such. Still, people do need place and space with the equipment and the method of discovering skills, and that's highly desirable whatever it's called. If there's no place where people can learn, and that can be different from a place where people can be taught, then it makes it difficult for them to learn. In a broad sense, if there's no place to learn then there won't be learning. There'll be no tools or materials or communicators of some kind, since there's no place for people to do it.

Don MacLennan The craft school offers me a situation diametrically opposed to my previous life. The nature of the program dictates that I constantly produce results in a short time. I am forced to be realistic and come up with answers in a short time, though my lofty ideals sometimes must fall by the wayside. But I feel that my growth is linked to my self-esteem, and I am amazed how my positive attitude has grown in this situation. I am often told to be patient, but like a child with a new toy I still want it all right now. This program, therefore, is laying a solid foundation for the reality of my future.

Daniel Crichton When I first started as a student in glass at SOCAD, it was all guys, but things have changed a lot. Like ceramics, it's now a unique place where the input of both genders is welcome. Last year many of the best blowers were women, as far as amount of glass and technical ability and other aspects are concerned, and people in this medium, it seems, have stopped accepting gender-rooted ideas about themselves. I still try to stop these gender distinctions at the door of the glass studio, when they first come here, and keep chipping away at the whole problem of separation of the sexes by the type of studio they are in.

Moreover, creative endeavours matter only if people believe they matter, and it matters to me that people understand for instance what glass is. If there weren't three glass studios in Canada that were teaching educationally, then nobody would understand what glass is, both physically and chemically. There'd be no experimenting with it or any kind of intelligent discourse about it, and it would become a fantasy material that only experts could handle. But glass is one of the most basic materials of nature, like ceramics and fibre and wood. When you lose meaningful access to it, it limits your ability to express and feel, partly in connection with the Canadian landscape where you live.

Theresa Pankratz I want to see what my hands can do. I believe we are all created as creative beings, and in the process of my search I've come to a craft school. I want to explore the idea of craft as art and art as craft, but I am realizing that to create to the fullest of my abilities, I need skill, discipline and practice. I need to learn through experimentation and making mistakes, and I find the glass studio the most intriguing. Both wood and glass are sensual materials, but glass is much wilder, out of control and dangerous. Wood is solid and basically controlled, while glass is crazy. It's like the old eccentric aunt whom you love but fear for her unpredictability.

The Studios

Ceramics

Furniture

Textiles

Glass

Sarah Coote

This functional pitcher was thrown on the wheel and handbuilt off the wheel with thrown parts, then fired in an electric kiln with polychrome glazes to cone 10. I used this method because it reveals the natural fluid, plastic qualities of the clay, while also being an excellent means for achieving volume.

This pitcher provides a good representation of my work for several reasons. Firstly, "pouring pots" have been a large part of my investigation for some time. I am interested in the spout as an element which animates the pot through its scale and gesture. I build and alter the form of spouts off the wheel, which allows me to play with proportion and asymmetry. Secondly, by my approach to glazing, I try to achieve unity of form and surface. In other words, I do not reinforce the separation of parts, but rather glaze the pot as a whole, knitting the parts together through creation of another layer of forms and shapes by means of the glaze.

I like this pot because it has an intrinsic poetic quality: the form, function and glaze work together in a dynamic way. The direction and proportion of the spout speak of pouring, and the pot feels good, in your hand. The balance is right, the weight is good and it functions well. I also feel the pot is formally very sculptural because of its proportions and additional form brought out by the glazing.

Evaluate the piece objectively? Impossible! My response has to be subjective because it is my own work.

Sarah Coote by Winn Burke

Sarah was an unbelievably hard worker as a student, interested in lots of things, with an ability to find out because she was curious. She was also directed to specific cultural areas related to ceramics, and a lot of work back then was derivative of various cultures. But the important thing was that she wouldn't stop until she made influences her own and did them her own way. That's the most important thing about her work. She always takes her forms from a starting point and moves very far with a variation on a theme, working on the form for a very long time. The result is that the form, and not just her work, has matured.

In this piece, which is not derivative, there's a potential to say it's a classic English jug shape, a particular Chinese *mei ping* form, and the very large spout could be Hittite or Minoan, but they just belong anywhere, whatever our associations. She's divided her work physically in terms of surface, so it's not particular to any form. The big round part, the high-contrast area, is a reflection of the form, and it's divided so there's an angular sort of dynamic between the spout and the green in the centre. That takes your eye towards the negative space in the handle, so there's a big V dynamic created, but the form itself is not buried because of that oval reflection. The pot is inverted, which sets up a dynamic to cause the bulge of the piece to be emphasized, and then this piece is broken up nicely to draw your eye from the spout back to the negative space in the handle. She's very good at that in a lot of her work. She's adept and smart at looking intellectually at what can go with forms to cause you to unconsciously move around them. Sometimes you respond to a piece and you can lay a finger on why, and I don't walk away from this piece partly because of the dynamics of the form.

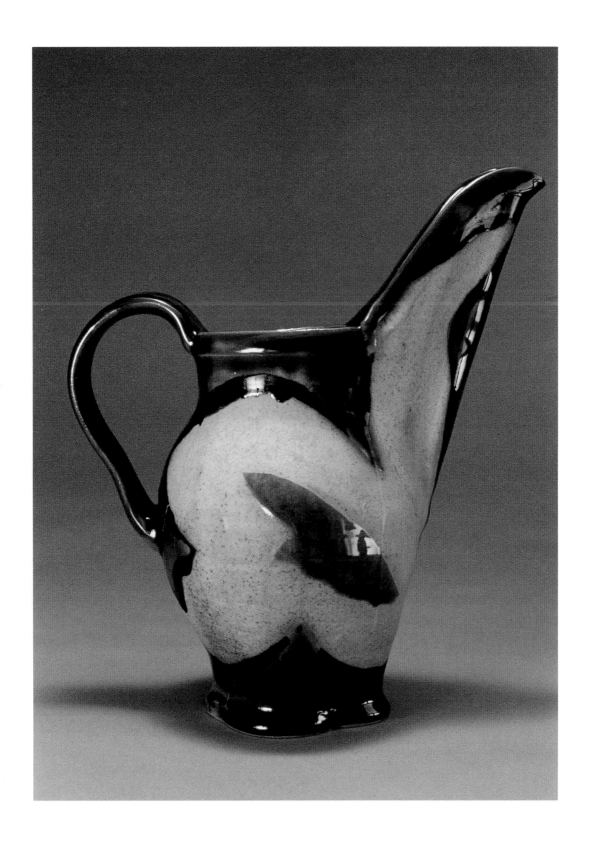

SARAH COOTE, pitcher, 1995, white stoneware, polychrome glazes, 8" wide by 12" high.

Neil Forrest

In the past several years, I have been combining tile with hand-shaped clay forms to invoke the historical relationship of ceramics and architecture. The decorative scheme of architecture was often undertaken with glazed tile. My use of patterned tiles on earthenware trivets is a way to restate the decorative relationship of ceramics to masonry, which I find fascinating in Baroque and Islamic architecture.

Trivets are now largely absent from our dining table, but I think of them as a way to elaborate upon the domestic environment. Trivets celebrate the serving of food and afterward serve to ornament the table. As this trivet is designed to remain on the table, it also signifies that the table may resume its specific function, as gathering site for eating, at any time. This trivet is a functional object, even if the shape suggests sculpture, since an appropriate definition for craft is "the sculpting of utilitarian objects."

Set into the trivets I make are glossy tiles. The tiles provide an opportunity for both colour and pattern, a way to introduce graphic ideas as a painter might, but using the grammar of craft decoration. I believe that decoration can be as subversive as much as celebratory. I make the tiles as thin slabs of patterned Egyptian paste that are electric kiln fired, then cut and mortared onto glazed stoneware reliefs, armatures if you will. The colour is articulated "structurally" or, in other words, coloured clay is inlaid as pattern in a technique not unlike the ancient Roman glass technique called *millefiori*. Egyptian paste is a unique ancient formula for self-glazing clay and yields brilliant alkaline colours.

For several years I have been making trivets, tiled wall ornaments with shallow relief and, most recently, Egyptian paste mosaics mortared into very large concrete tiles. I think of myself as a maker with two somewhat distinct trades or professions — mosaicist and modeller — but both under the shaping force of ceramist. More simply expressed, I am a decorative artist.

Neil Forrest by Bruce Cochrane

The series of trivets on which Neil is currently working implies utility in both its title, since a trivet is a short-legged ceramic plate to hold hot dishes, and its traditional format. However, I believe its primary role here is to support and frame a spectacular composition of pattern and colour rich in personal imagery and association. The trivet form, constructed in red earthenware clay, has a bold architectonic stance. Its mass floats on elevated feet visually lightened by its lyrical two-dimensional shape outlined by an articulated edge.

Neil's investigative drive has resulted in a uniquely successful marriage of terra cotta clay and Egyptian paste, a self-glazing clay capable of producing intense colour through saturation in soluble materials. His flamboyance, energy, and creative passion are naturally embodied in his work. He continues to challenge the limitations of his technology and is rewarded with innovative direction and objects of beauty and intelligence

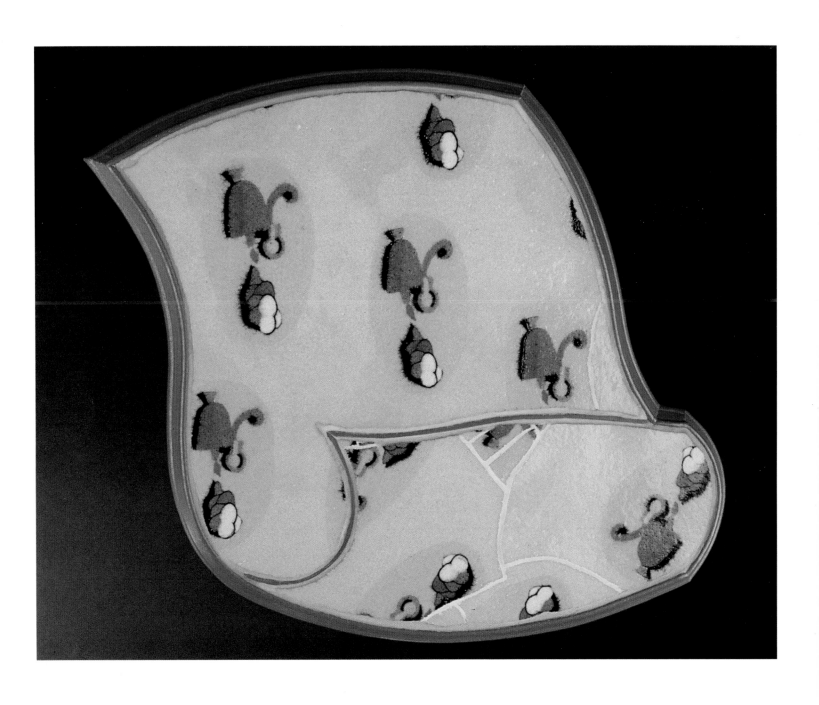

NEIL FORREST, *Trivet with Flemish Lamp Pattern*, 1994, Lantz terracotta, Egyptian paste clay, mortar, & grout, 37 cm long by 33 cm wide by 5 cm high.

Steven Heinemann

A piece that "works" — which, at this writing at least, I consider this piece to do- can never be fully accounted for or its implications undone. Like much of what I've attempted over the years, this piece evolved over several months and numerous firings; previous versions lie buried beneath the surface. In its current form, it represents a familiar problem: how to activate images on a symbolic level, images that hold a "charge" while retaining their inexplicable nature. I have neither the desire nor the ability to completely unravel that mystery for anyone.

However, here are some clues: Physically, this is a large tub-like vessel, not so much of an aesthetically beautiful or refined form, but one that suggests a life, a history, a use or purpose. Inside, at the bottom, an image is superimposed on the clay "crust." Representing a tilting vessel in the moment of spilling or pouring, it loosely resembles the form in which it exists. While entirely invented, the image recalls the detached and precise character of scientific illustration, since I'm particularly fascinated with the way in which science renders the non-visible, such as electricity.

The interior is divided equally into black and white, and this reduction to light and dark is intended to resonate with other aspects of the piece. This aspect can, I hope, be different things to different people. For me — and these thoughts are shaped in retrospect — it reflects the experiencing of fullness in relation to emptiness, time past in relation to time present, longing in relation to fulfilment.

Steven Heinemann by Bruce Cochrane

The open forms of Steve Heinemann are clearly intended as contemplative vessels, as vehicles for his viewpoint about containment, time, space, and personal experiences. The identifiable use of the bowl form make it accessible, offering the viewer interpretation on many levels. Edge, weight and subtle articulation of the slip cast form suggest a shell-like fragility evolving from a slow growth process.

Although impressive in scale, this work possesses a quiet presence and its messages are not forced but unfolded slowly and discovered with repeated viewings. Applied surface treatment is restricted to the interior, reinforcing the notion of a protective outer half-shell. A sensitive use of black and white slip/glaze combination shows a graphic ability to define or redefine the space the vessel occupies. A continuous reworking of surface through multiple firings and layering of ceramic materials provokes a sense of history in the work.

Steve Heinemann's vessels are autobiographical. They reflect the artist's intellect, personal gestures, and response to his environment.

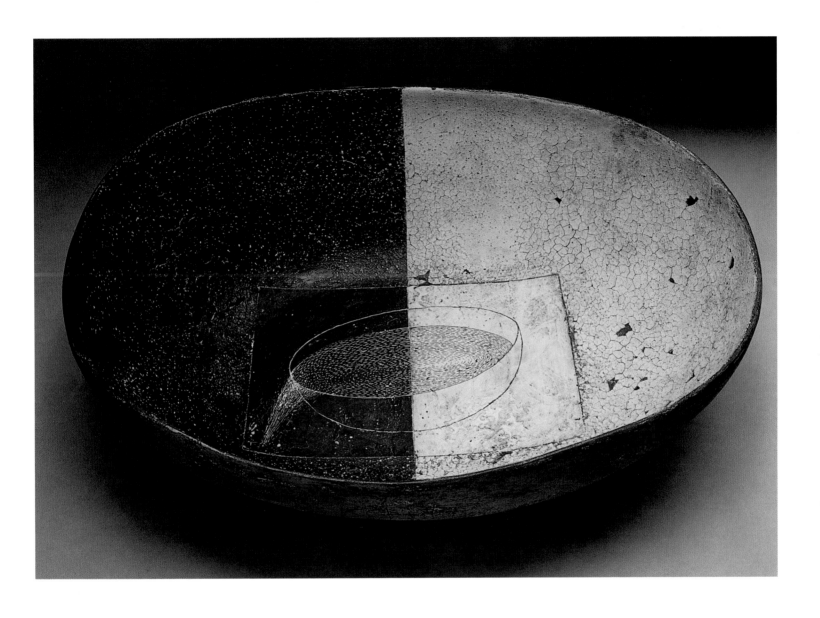

S<small>TEVEN</small> H<small>EINEMANN</small>, *Then and Now*, vessel, 1995, ceramic, multiple firings, 67 cm by 58 cm by 23 cm.

Joanne Noordhuis

This piece is made with mid-temperature cone 6 porcelain, with various colours of glossy and matte glazes. I generally use any technique that will achieve the effect I want, which, in this case includes throwing and altering press moulds, modelling, and slip-trailing. My aim here was to emphasize the fragile qualities of porcelain and exaggerate the decorative aspects of a particular style of cup and saucer which uses seashell forms in its design.

I was interested in the way various forms and decoration were applied to vessels, to the point where the decoration severely compromised the function of the object in any utilitarian sense. In other words, to the point where they were too good or delicate to use. This was particularly true of porcelain made in Britain and Europe during the eighteenth and nineteenth centuries. One manifestation of this approach was the cabinet cup, which was made expressly for looking at it, with its elaborate painting and gilding, and ornate moulding. And in the situations where a porcelain cup was actually used, the extra care given to avoid damage to the cup became an important part of the tea-drinking ritual. This paradoxical relationship between utilitarian function and decorative design is what has interested me most about porcelain vessels. It stresses the flip side of what we usually understand as form following function. In this case, decoration and fragility are necessary for the object's more important ritualistic function.

Apart from learning through trial and error — and error, and error — about a hundred different ways to torture clay into forms that it is reluctant to conform to, I became more aware while making this piece of the potential relationship between the symbolism of the representational forms I used as decoration and the function of the vessel. That is, seashells, which are considered feminine, with connections to Aphrodite, Venus, and the fertility of the sea, and the teacup, used now predominantly, if at all, by women and kept safe in the china cabinet.

In most of my work now, I like to use vessels like teacups and saucers that are more or less extinct, forms that no longer have any utilitarian relevance to our lives because of a change in technology or in social customs and rituals. These include items such as confinement tureens, which in the eighteenth century were traditionally given to women after the birth of a child, and spill vases, which were kept on the mantel over the fire and held the nineteenth century equivalent of matches. As for the cup and saucer, although we rarely use cups and saucers, we still retain the associations of the ritual, of visiting our grandmother, balancing the cup on our knee and eating a cookie without getting crumbs on the carpet, all the while chatting about our family and its history.

The size of the piece, though slightly larger than the average cup, is still small enough to relate to this intimacy, and the complexity of the decoration invites close inspection and makes the viewer consider the compromises that need to be made in order to use it.

Joanne Noordhuis by Bruce Cochrane

Joanne has chosen a variety of traditional ceramic vessel forms as a format to express her keen interest in marine life — its form, colour and texture. The cup and saucer combination here assumes the basic stance of function, but screams out, "For your viewing pleasure only." Fragile appendages, precarious balance and aggressive texture are elements Joanne exploits without having to deal with the constraints of utility.

Joanne realizes the value of input from various sources, an important one being the aesthetics of eighteenth- and nineteenth-century porcelain which are often overstated and expressive. Clever interpretation and evolution of such references have resulted in personal solutions in technique and concept, and Joanne's work illustrates clearly that she is an excellent craftsperson. She uses a porcelain-like clay fired in an electric kiln to a mid-range temperature of twelve hundred degrees centigrade. The animated and detailed forms are patiently constructed over several days, involving precise timing for each stage of the process. Such extremely complex assemblages may require multiple techniques: coiling, throwing, folding, carving, pinching, and applique.

In the end, Joanne's pieces are precious and jewel-like in scale, and one does not pass them by with a quick glance. A provoking metaphor with rich ceramic content forces one's undivided attention on these wonderful objects.

Ceramics

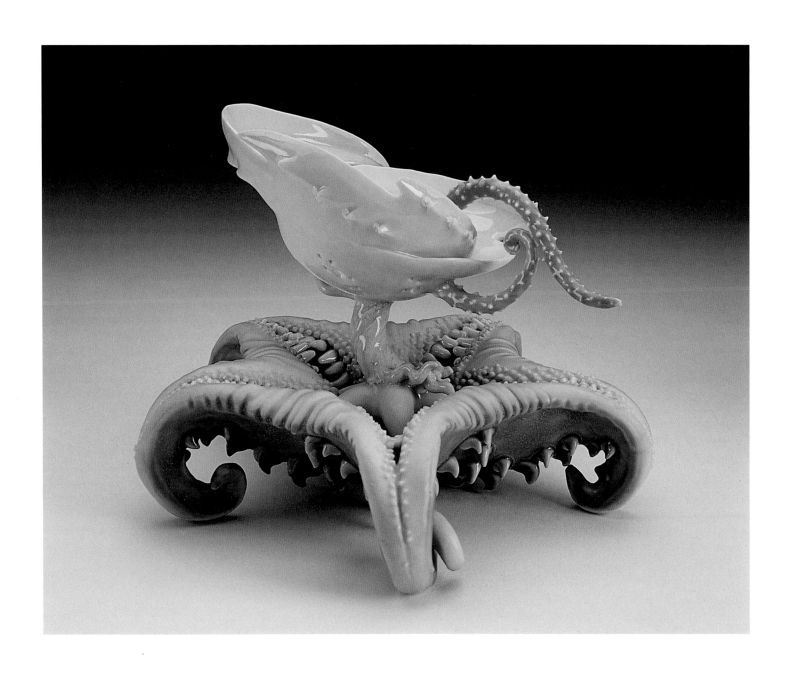

JOANNE NOORDHUIS, *Cup and Saucer*, 1993, porcelain, glossy & matte glazes, 5 1/2" by 8" by 8".

Karin Pavey

Having made a series of simpler pieces recently, I decided to venture into making something more complicated again when I was asked to produce three works for the show "Of the Garden" at Prime Gallery. At least one of them would be a vase, and the idea of taking the vase off the table and mounting it on the wall interested me. I decided to redevelop an old wall vase idea from ten years ago, and this piece is what I came up with. Besides the shapes being drastically different, my main thought was to make the piece much more functional. Thus I created two pieces as opposed to one. The actual flower holder would be separate from its decorative shelf, making it convenient to fill the vase with water.

The wall unit was inspired by a twelfth-century Romanesque capital and it was handbuilt from slabs, with some being pressed into an etched mould to create texture and contrast within the flat areas. Also, the leaves were press-moulded. A combination of decorating techniques was used to achieve variations on the surface. White slip was applied over red earthenware, then sgraffitoed through to give high-contrast lines between the slip and the dark clay body. Underglaze was brushed over the textured sections, flat and shiny glazes were used to set off each other and, finally, stains were brushed over the background, all giving a watercolour effect.

It took much more time to make than I had originally thought. Some parts of the piece started to dry before it was finished. However, now that it is completed, I'm glad I did it. There is always the hope that, because I have now completed the first one, the next may go slightly faster. From doing this wall unit, I resolved some of the technical difficulties with cracking and support structures.

Like the rest of my work, this piece is functional, and while not in use, it serves the purpose of decorating a room. Unlike most of my work, the colours here are somewhat subdued. What I like personally, about the piece is that the finished product seems to succeed as a unit. Having to work while the piece was lying horizontally all the time was not easy and I had to continually place it on a low stool to see how it was progressing. I think I chopped off the top of the vase three times before I thought it was the appropriate size for the shelf. I was also pleased with the way the colours turned out, since I purposely tried to limit my colour palate and was worried that it wouldn't be successful. So I think people can appreciate this work for its function as well as a three-dimensional decorative object for the wall, which contrasts with the flatness of a painting.

Karin Pavey by Winn Burke

Karin is disciplined and she loves working in clay. She loves doing what she does with material and has the personality to take all the time it takes, with an ingrown intuitive approach to clay. Her work shows what she's all about. She's very cavalier about things, works with what's going on, and if it's not what she's intuitively predicting or hoping will occur, she lives with it and changes it and makes it work. In her early twenties, Karin discovered she had arthritis in her hands, so for her to continue explains a lot what goes into her work. She just ignores it, it's just another thing that's come up, and she just powers through and keeps at it.

The surface here is quite lively relative to the piece, and her surfaces and form ideas have always had an integration because they're so lively. The forms move and the surfaces move because she's so involved in what she does. When Karin teaches for us at SOCAD, the life of her work is so integrated and personalized that students tend to be strongly influenced by her. What she puts into her work leaks out and people can't help but absorb. She doesn't abide by rules and conventions, so there's a liberal-minded outlook that comes from within her and into her work. She just ignores rules. Her work is very strong in use of earthenware and colour. She has committed herself to ceramics and stuck to it; the world doesn't matter and that comes out in her work.

KARIN PAVEY, wall vase unit, 1996, red earthenware, white slip, sgraffito, coloured glazes, 56 cm high x 32 cm long by 14 cm wide.

Dale Pereira

This oval platter, approximately fifteen inches in length, is made from earthenware clay that is a dark red colour when fired. The piece is formed by "pressing" a slab or sheet of clay over a simple plaster mould. The mould forms the inside of the piece, and a foot ring is made from a coil of clay and applied to the back of the platter while it is still on the mould. When the piece has become stiff or leather-hard, it is removed from the mould. The dark red clay that is the mass or structure of the platter is then disguised or obscured by pouring a thin layer of white clay or "slip" over the entire surface. This thin coating of white on red allows for the process of sgraffito, the scratching of a drawing through the white to reveal the red below. In the platter the dark outlines of the images are actually incised lines carved into the clay. After the drawing is complete, the work is bisque fired and then coated with glaze. In this particular piece, the colours that fill in the images were painted over the glaze. When the painting of the images is complete, a hot wax emulsion is applied over the entire rim area, which allows a thin wash of colour to be flooded onto the centre area of the platter.

This platter is part of a series for a show at Prime Gallery, and in this series there are some subtle changes from my previous work. My work to this point had been more complex three-dimensionally and, for example, platters were fluted and had rims. But this prevented sgraffito drawing. So for this show I made two new moulds and both were very simple oval forms. Also, previously dense heavy colour dominated my work and frequently obscured the sgraffito, so lightening the colour provided another change. As a result, I like this platter a great deal because it differs from what I was doing. I enjoy the control I have with the sgraffito, the congestion of the images and how they interact, how they touch. Sgraffito as a process provides a lot of tension and excitement, since nothing is sketched before it is cut into the surface of the clay and nothing can be erased once it is drawn. I like this thinking-on-your-feet approach and how it offers a moment in time.

Dale Pereira by Bruce Cochrane

When experiencing Pereira's work through touch and sight, one connects with the artist and his concern for meticulous craftsmanship and thoughtful attention to the formal concerns of the object. His pottery is made from red earthenware clay, covered with slips and coloured glazes and underglaze colourants. He investigates every aspect of his technology with integrity equal to and inseparable from the creative process.

Historical ceramics and traditional techniques are influential in this work, but not obvious or dominating, and Dale's functional pottery displays a confident sense of form. It is straightforward in its forming process, yet lively and animated through use of a sgraffito technique, a carving through slip, and a layering of vibrant colour and glaze. The plant and marine images are partially recognizable but exotic enough to provoke questions of origin. This quality is reinforced by his choice of colour, a visually compatible palate but again provocative in its association with the images. Visual tension is created as disparate motifs intertwine around the rim, juxtaposed to the crisp symmetry of the form.

The dynamic use of line, colour and form here provide a rich embellishment to the food and offer both functional convenience and a wonderful visual experience to the act of dining.

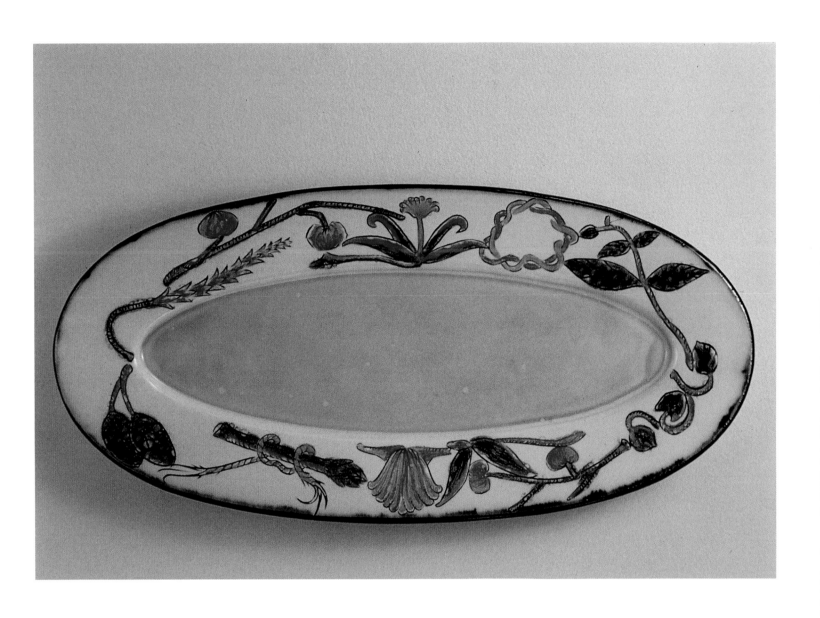

DALE PEREIRA, oval platter, 1995, earthenware clay, white slip, sgraffito, glaze, colours over, 15" long.

Mary Philpott

In this tile mural, the tiles are made from red earthenware, press-moulded and carved, with coloured slip and majolica glaze and stains painted to create the imagery. The project developed from my interest in historical majolica work from the Italian Renaissance. Specifically, Italian majolica, large open bowls and plates painted with Greek mythological and Biblical scenes, portraiture and varied border systems. Looking at these influenced how I would think about the image and subject matter for a large panel of tiles, while the border systems suggested how the space could be divided up.

My intention was to create a panel of tiles acting as a decorative object that could be found in the home, in people's living rooms or entrance halls, and therefore the subject matter I chose was a floral still life. My interests in botanical drawing and painting of the seventeenth century in northern Europe led me to develop my own style of floral painting, which is found in the tile panel. I was also interested in the tradition of having still life painting in certain rooms, such as the living room in modern homes, and wanted to approach the subject matter in a medium different from canvas, namely tile. I believe that tile can be a more accessible medium for many, because of its history of utilitarian function as well as beauty.

This tile panel was my first experience in making a large piece, and in doing so, I found that tile is an exciting and versatile medium. This piece was constructed by press-moulding the tiles from plaster moulds, and decorated by carving and glazing, which gave variety to the panel. The tile acts as a canvas in which any imagery can be depicted in relief or flat. In this way, the panel represents my work, much of which begins as flat or shallow and then is carved or pressed with pattern, painted with slips and underglazes, and finished with coloured glazes. Much of the imagery I use is botanical, and in my press-moulded work, the plates themselves resemble the flowers and leaves I carve and paint.

I find that this tile panel is one of my most successful pieces because the botanical imagery runs through the whole work, from the central vase with flowers to the leaves around the base, and through all four borders. The central image is not fighting with the pattern in the borders because the colours used become darker as the borders surround the vase and are varied by carved imagery. The tile panel may also lend itself to repetition in a series with other still-life floral imager, and my exploring colour variations and combinations as well as types of flowers.

This tile panel directed me to play more with border systems and their interaction with the central imagery. In this piece, the borders are definite and do not interact with each other, while the flowers are held within the border but only overlap in a few spaces. In my present work, platter sets and tiles, I employ the overlapping of elements in borders into the space that the border defines, while pushing elements of the image that lies inside the border out and over top of the frame.

Mary Philpott by Winn Burke

Mary is a "comer" whose work hasn't matured as yet, but it is exceptionally strong for the short period of time she's been at it. What emerges from her work is that it's going to get stronger. She has a good balance of influences and individuality. She has discipline, and she has an art history background. She comes to looking at clay objects from a long history of Moorish, Berber, Spanish, and definitely Italian majolica, and her sources are what she's all about in terms of personality. It's a natural match, a Newfoundlander trying to be Italian.

How Mary looks at historical parts that go into her work comes out of a solid discipline, from the standpoint of an artist wanting to consider the essence of different things and be strong in them, not how she interprets, but how she is affected by them. Her own aesthetic sense of colour and form are solid. She'll mature very fast and I suspect there will be details that are more individual to her in their manipulation, as opposed to the standard pottery solutions. Her use of graphic marks on forms will become more related to the forms and to her, rather than coming from without, and there'll be less distinction between making forms and what marks go on them, more of an integration. Sometimes form drives idea and sometimes ideas drive form. With Mary now they're more of a coherent thought in a blend because she's maintained an open mind.

I like the surface and the scale of this site-related work, which was designed for any place that would allow some breathing space around. it. The execution was spontaneous and she approached it without hesitation, so it comes off as an intuitive piece and the carved border doesn't look forced. The piece suggests a depth to it.

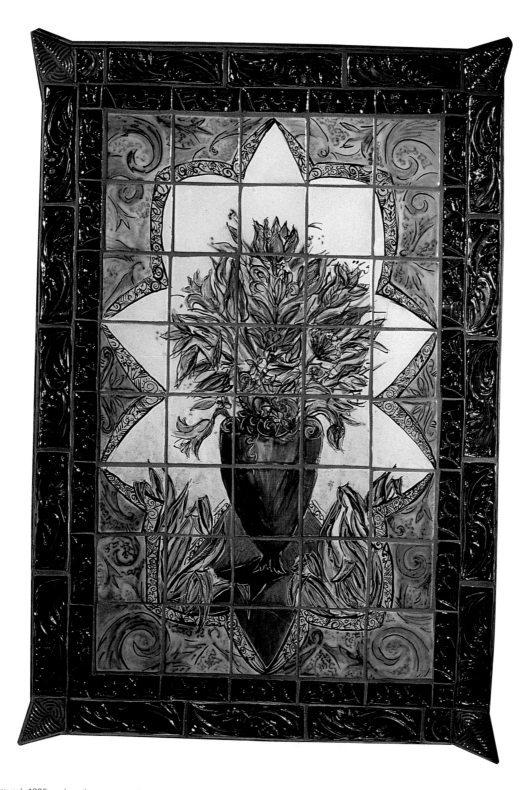

MARY PHILPOTT, tile mural, 1995, red earthenware, majolica glaze & stains, coloured slips & alkaline glaze, 150 cm by 100 cm.

Friederike Rahn

This butterdish is made of red earthenware, press-moulded and slab-built with brushed polychrome glazes over resist lines. The knob is a squiggle, carved from the leather-hard clay. The plate has four sprigged feet in the shape of gnocchi shells on thin diamond slabs. The interior of the butter dish is glazed in a cream-coloured majolica glaze with overglaze decoration in cobalt sulphate.

The piece started as a technical idea with male and female plaster moulds from which to cast a plate or lid, and a flange. I was attracted to the sculptural possibilities of this technique using a negative and positive three-dimensional space, and to the idea of building a piece around the line that separates the two parts. I wanted the form to suggest the feeling of a freighter and an oyster shell, and to give a sense of fluidity and motion. In making this shape, I've learned how to scribe a flat-sided slab form onto an organic three-dimensional base.

I have used this mould technique/idea for several other previous pieces, which include a large soup tureen and a gravy boat and saucer. This combination of slab and mould work is typical of the way I make pots. Boat shapes of various descriptions have always been present in my work. What I like best about this piece is the quiet gestural quality of the form, the fluid line that separates plate and flange, and the mottled surface of the glaze. Where I think the piece could go farther is in a more textural use of the clay surface, enhancing the qualities of the glazes.

The butter dish is best appreciated in use. Imagine, at a dinner party, asking your neighbour to pass the butter and receiving the oyster shell/freighter. As you carefully lift the lid, a single yellow stick of butter is revealed floating on a cobalt and oyster pool of glaze, all surrounded by a ruffly terra cotta edge. In fact, this piece fails as a purely utilitarian object because of its preciousness. Its scale and weight are too large to be practical for daily use, and the elevated feet and exaggerated form make it somewhat precarious. Ultimately, it is a ceremonial object, celebrating the food it contains when used, but also functioning as a sculpture/puzzle/drawing that evokes a certain feeling about marine landscape.

Friederike Rahn by Winn Burke

As a student Friederike was always concerned about where and how she was going to go with her work, probably to the point of distraction. This was maybe her gift as well as her bane. She beat herself up with her concern because she was so critical of how and where to go. When she finished the program at SOCAD, she understood that she'd done some important things and answered a lot of questions that mostly she had posed. She was better than anyone at posing the questions, the technical questions that always accompanied the issue of how to do things. It was always a challenge that she always overcame by simply doing.

Friederike was always very productive in that she never tired of doing, never gave up. The technical stuff was always a burden, but it never got in the way. The bigger issues were aesthetic and she came to grips with the need to answer the question of why earlier than most other people in their careers. Aesthetic decisions were always difficult for Friederike because she wanted answers, answers that were tough to come by. She was open-minded and had no problems with criticism, but after graduation she needed a fallow time to come to some conclusions.

Her work is very strong and she often creates a context as a driving idea for what she does with form and finish and marks. There's a high expectation on her part because she would like the context to be created out of someone responding to her piece, and that's a tough leap, but that's the way she thinks. Coming cold to the piece, and if I erase "butter dish," I come to it with a sense of geographic landscape with maybe a combination of water. So if I open this piece up and find butter, I might not respond the same way she's idealizing it. In a word, I'm responding differently, aesthetically rather than functionally, and this is personal for me. I would rather look at the piece and say, "Oh wow, look what's going on here!" and emotionally come to grips with what I'm responding to, rather than basing my aesthetic judgment on utility. If there's utility that follows, that's great, but it doesn't need to be there.

Knowledge of function can alter the aesthetic. Or the aesthetic will define the function. But I'm not necessarily wrapped up in the context she's described. Freddie has an active mind that visualizes and not only describes the context of things. She's always been like that in a delightful dreamy way that doesn't close doors, and she always realized there might be another door to open.

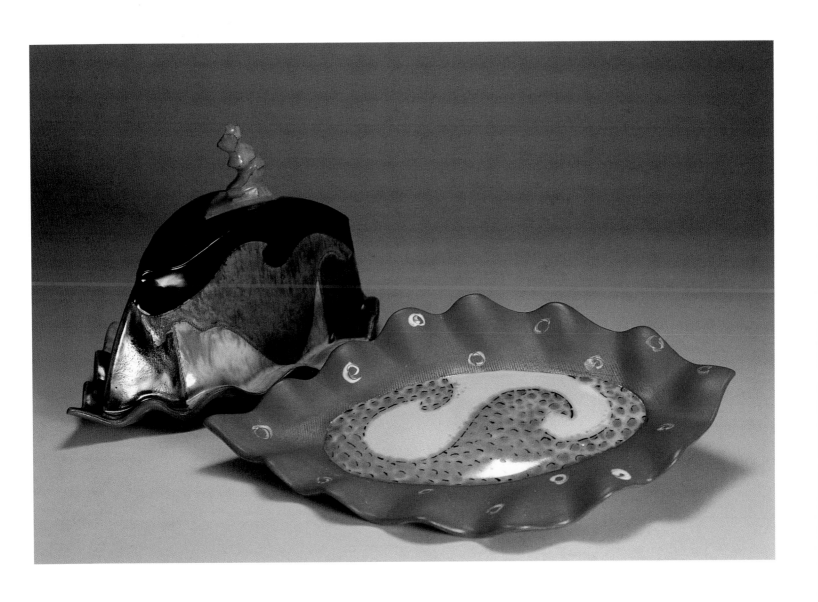

FRIEDERIKE RAHN, butterdish,1996, red earthenware, brushed polychrome glazes, 8" long by 4" wide by 7" high.

Laurie Rolland

This handbuilt piece, based on the traditional jug configuration, represents my continued interest in the jug as an expressive vehicle. The iconological relationship between birds and the female archetype informs the vessels I make. Previously they have been called pouring vessels, beaked vessels, and bird/figure vessels, depending on the implication of their form. This "handbuilt jug" has intentional bird and figure-like qualities while embodying aspects of growth with the lines and movement of water. It is handbuilt because this technique proclaims the plastic nature of the material and, like a life force, it becomes an extension of every impulse and touch.

Particularly gratifying is the assembly of the various parts that make the jug, as a form, so eloquent. Working this "tenacious, plastic earth" while it is wet and mobile, I find that a clear statement is possible and pure expression given dominance. As a result of this series, I have developed ideas for new combinations of handbuilt parts together with thrown sections. Work is always done in a series, with variations and improvements happening naturally. A sketchbook is consulted and used, but often the "seeing" must first be done with the material itself. For example, I developed the handle by working with textured pieces of clay until something suitable emerged.

I like this piece because it has the fluid, gestural quality I wanted. It is bird-like, introduces an organic element, and still maintains the integrity of being a jug. The simplicity of the form is not compromised by the more complicated handle. Although apparent enough to be interesting to the user, the spout is integral to and balances with the form. The texture of the lines and the surface treatment enhance the sense of movement and coincide with the organic intent.

I always hope that my work evokes a sense of ritual and that these objects, that could occur naturally, embody the pulsing of organic form. Studying the feminine vessel character, ancient symbols and their meaning, birds and their promise of spiritual ascent, I attempt to assimilate aspects of court and tribal art in forms that are derived from nature. The viewer becomes aware that the ability of the image to evoke memories is at once powerful and magical. The earliest making of images was part of a desire to communicate, and the universal instinct for style resulted from pushing "good enough" into something that pleased and surprised. Today's makers are continuing that tradition while reflecting a contemporary attitude that is synthesized through a rich ceramic heritage.

Laurie Rolland by Winn Burke

Laurie was always organized and had tasks and solutions which she would, with tenacity and unbelievable organizational ability, accomplish in spite of and despite anyone. This woman was driven by organization. She had ideas that were conclusive about what she would create and be damned if anything would get in the way. She seemed to take criticism, but one never really knew. I think she considered everything on her own terms and in her own terms. She always felt there was no time to be wasted and she didn't waste time. Those qualities appear in her work and I find some of it very cool and very intellectual for those reasons, but also there's always been a quality of the unexpected that sets you off balance. There's always a change, a juxtaposition, an unexpected, something about the quality of the piece to jostle you a bit and make sure you're not being complacent. It's nothing that grabs you by the throat and shakes you by the teeth, however, since it's not that extreme and inaccessible.

With this piece the first thing is the full intention for you to be moved by the surface and the gesture of the piece, and it does that. You're also caught up in the tradition of the form being utilitarian, so there's contradiction since the piece does not imply utility. That's not what it's about, though it's in the context of utilitarian form. The piece is not static. It's gestural in a way that it's a construction worker gesturing with ballet shoes on, so the contradictions of the stereotypical movements are within the piece. There's delicacy, but there's solidity. There are angular qualities to the surface that says there's a dynamic, but it's offset with something that's as subtle and perfect and fragile as the colour of a begonia. The handle has some weight to it, and the spout has some weight to it, and there's a truncated juncture between the two, a curl on the top of where the handle attaches to the two junctured spaces. That is so delicate, you're afraid for it, but the rest of it is very strong.

All of Laurie's work reveals those kinds of things. She holds opposites together in her work in a complementary manner. Her work amalgamates differences, which in turn requires the viewer to internalize the stuff. If you want a piece of Laurie's, you have to really live with it, and you can't dismiss it.

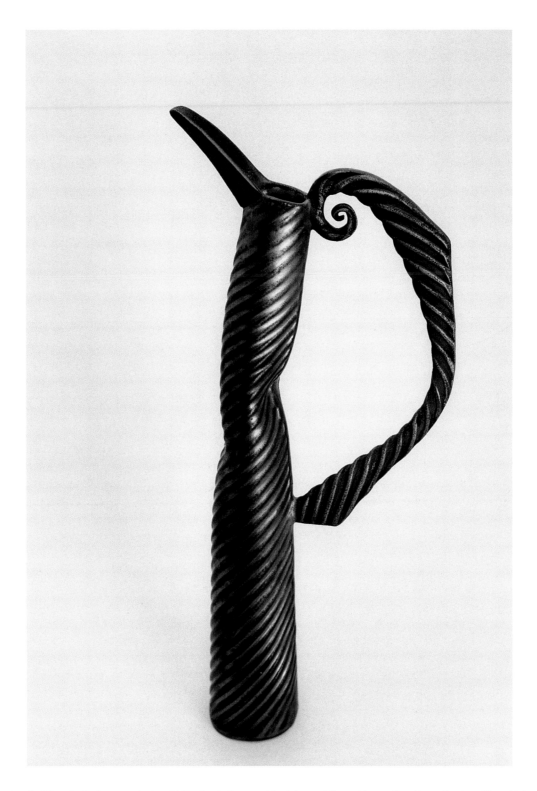

LAURIE ROLLAND, handbuilt jug, 1996, stoneware body oxidation fired, chrome oxide stain, post firing gold; spout/handle w. slip glaze, 32 cm high.

Eve Rubenzahl

This soap dish was thrown in several parts — foot, bowl, and, rim. Some parts were altered and then all were assembled. The dish is a complex structure with a cohesive form, and the way I built this object is common to many of my pieces. Most are either built in sections and then assembled, or built as a whole but divided visually. This way I can arrive at a unique final form through simpler building blocks.

I choose to make objects that have a specific function, and a specific function often entails a unique form. I'm interested in how things work and how an object's function can affect its design and character. In "The Evolution of Useful Things," Henry Petroski discusses the history of the fork and shows how its design changed from two tines to three to four tines. The aesthetic results of this "useful" evolution, the beauty in the detail of an object, interest me.

I started with teapots, which have an inherently complex form, a minimum of four parts, and also cups and saucers, candle holders, and soap dishes. All of these have structural elements unique to their function, as in the fit of a cup to a saucer or an area to catch the drip of wax. I question how these functional elements fit into a piece as design elements. The specific function of each of these objects gives me a basis for the design of a form. For example, the soap dish has a fluted area where the soap sits, which is meant to catch excess water, giving this area a specific function. The design of this area has guided the shape and surface quality of the entire piece, since, while incorporating fluting to solve a functional problem, it became apparent that fluting also acted as a decorative element in the piece. This realization allowed me to apply the same texture to other forms, but in a different context where pure decoration was removed from function altogether.

I feel this soap dish is successful because the proportions of all the separate parts result in a balanced whole. It does not read as many parts but as one piece. The form is further defined by the glaze, which is fluid and transparent, pooling into indentations to clarify the form. The various glaze colours and their placement redefine the form according to the original, separate parts. The soap dish was built in a series of steps that comprise a complex building technique. However, my aim is not to confuse, but to create a final product that is useful, unique and cohesive. I hope the soap dish is easily accessible for its user, yet interesting enough for rediscovery to occur during its use.

Eve Rubenzahl by Winn Burke

There's a clarity that I like in this piece about its purpose. It reaches out with what it's about. It's definitely Eve. In fact she says, "I do these things because they are what I'm about." This truth is what every craftsperson has to discover. Eve has done that remarkably.

Eve and her personality are what her work is. She's disciplined, she's task-oriented, she's overwhelmingly concerned about the craftsmanship of pieces. Sometimes her concern has got in the way because it's a preoccupation with everything being perfect that doesn't let discovery out of technology draw her into her work. She spends a lot of time preoccupied with not letting technology get in the way. Her work is very intellectual to the point of sometimes being stiff, rigid, unyielding but not with lack of intelligence, which is the beauty of her work. Her work is concerned with specific task-defined directions that are not intellectual, that she has internalized. So utility and the goal of reaching a utilitarian, functionally perfect object are a natural phenomenon for her, in that you do it well or else. If you don't do it well, the aesthetics are shot because it's so intellectually rooted. The physical manifestation has to realize the initial idea.

This piece is very Eve. There's movement, but intellectual movement. There are no surprises and the piece is elevated in a very predictable way. The transition between the elevation and the surface give it the softness that the whole piece has. It has a continuity of glaze that links everything together and doesn't hide or bury thesoftness. The ribbed interior of the piece is soft like the rest of the form. The ram's horns at each end are soft as well, rather than rigid and contradictory. There's a totality without surprise, but it's accessible and it's clean, and there's no question that it lifts and supports the interior surface. The utilitarian purpose or intent is without question, though you might have to personalize it as to what for, and the utilitarian function requires no guesswork. The aesthetic is made up of the function and the perfection.

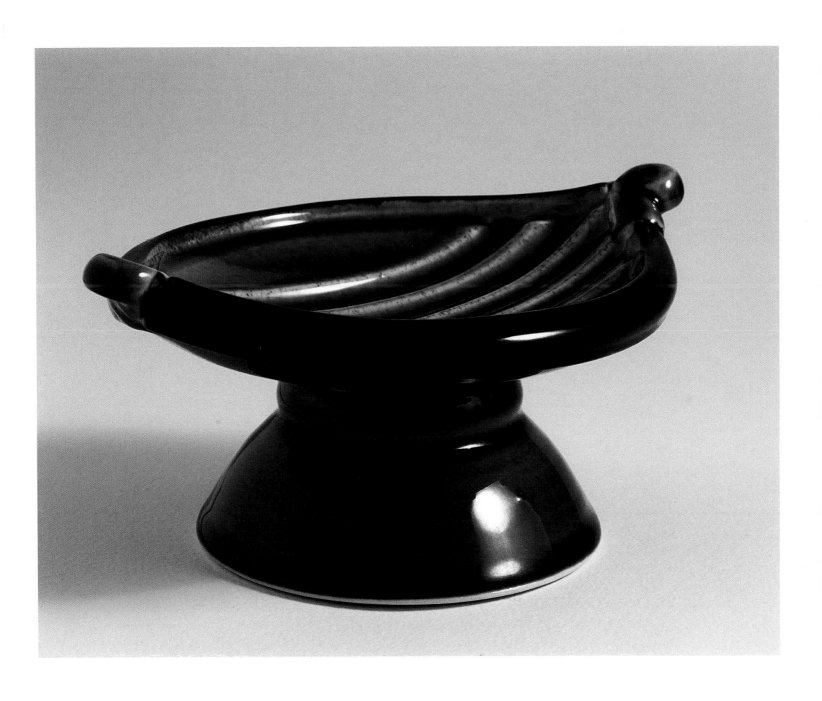

EVE RUBENZAHL, soap dish, 1996, porcelain, coloured glazes, 6 1/2" long by 5" wide by 3" high.

Kee-hung "Eric" Wong

Tea-drinking is an ancient and important custom in Chinese culture. A ceremonial ritual, tea-drinking actually allows a momentary freedom from our daily activities, allowing us relaxation, serenity and refreshment. A teapot is, therefore, a must in every Chinese family.

Making a teapot is a critical task for a potter. To me, it is a challenge of merging utilitarian and aesthetic aspects in harmony without compromise. This teapot has met these criteria and relays my message in pottery.

From a technical perspective, the form of this teapot is in good proportion. The body carries the appropriate capacity. The spout pours well without dripping. The handle provides an essential balance of weight. Although the lid, the spout and the lug were thrown and made separately, they integrate as a whole in design when assembled. The handmade rattan handle is another accent to the entire presentation of complete craftsmanship.

Besides fulfilling the function of a teapot, it is comfortable in my hands and pleasant to my eyes through the richness of the clay, the touch of the surface, the simplicity in form and intuition visible as decoration, I try to enrich the act of tea-drinking to a full enjoyment. It is only through active participation, by holding and using the teapot, that my audience can have access to my expression in this work. With this piece of handcrafted pottery, I am inviting my audience to rediscover the beauty in daily life.

Working with clay is more than a process of expressing myself. It is also a process of learning, self-evaluating and changing. During the process of throwing, I am overwhelmed with the versatility and potential of this humble and yet changeable medium — clay. I find the work of forming, glazing and firing a creative and disciplinary activity.

The outcome of my work can be satisfying, rewarding, or frustrating. I have experienced the exciting and encouraging moment, feeling contented and harmonious. I have also experienced melancholy periods. It is the emotional impact that keeps me pursuing ceramics art.

Kee-hung "Eric" Wong by Bruce Cochrane

As a maker of functional pottery, Eric Wong has developed personal ideas about form and utility influenced by the Leach–Hamada tradition Those aesthetic ideals evolved from the qualities found in the folk pottery of Far Eastern cultures, qualities of simplicity, directness and expressive use of the potter's wheel. In the absence of applied decoration, Eric relies on surface embellishment from single glaze coatings enhanced by the fire and a firm control of the kiln process. The scale of Eric's work is intimate and easily manageable in response to its intended function.

The lifestyle of a studio potter is labour intensive, but the rewards are many. Eric's sensitivity and disciplined work ethic provide us in turn with beautiful objects that offer a pleasurable experience not only through visual connections but through physical and sensual ones as well.

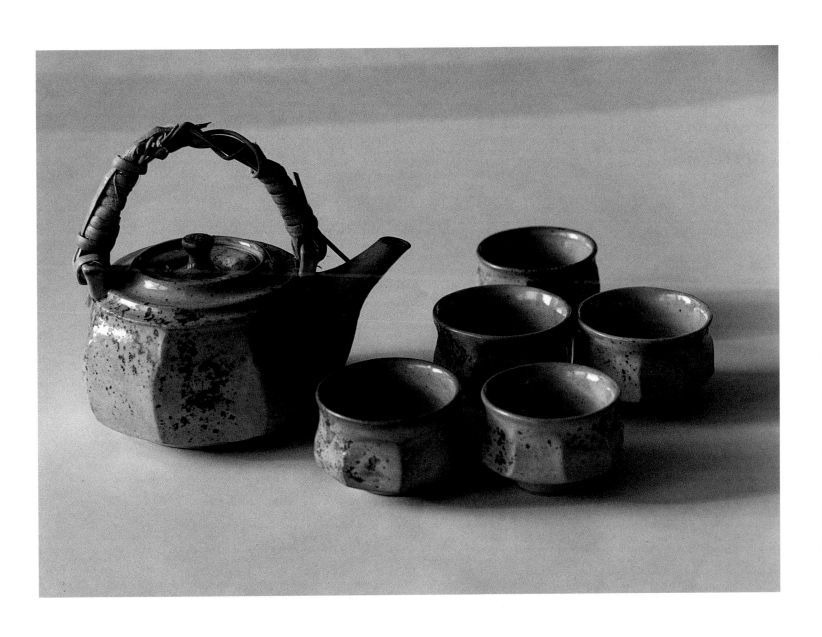

KEE-HUNG "ERIC" WONG, tea pot, 1995, stoneware, shino glaze, 5" diameter by 4" high.

Donn Zver

I have always been impressed with the clear and honest statements made by our early Canadian potters, who in their time reflected the needs of the people through their work. Pottery, unlike other media, has a permanence due to the nature of its process, and today we are still gathering information on these early cultures through the pottery made at that time. These early pots become a statement of each culture's interests and concerns.

I see myself as a potter who works in the same tradition as those early craftspeople of the past. When I work with clay, I work knowing that someone will see the merits of the piece and want to use it in their homes. From that standpoint I accept the responsibility that the piece must not only be aesthetically pleasing but that it will also fulfil a necessary function.

The vase shown here was designed with long stemmed flowers, such as gladiolas, in mind. My concern in making this piece was that it had to stand on its own merits as a pleasing statement and, when in use, had to complement the flowers it contained. The height of the piece had to be such that the long stems of the flowers could be accommodated. Because of the size of the flowers, the vase had to have a sense of stability and proportion to it, therefore the wider base fluting up to a wide opening to allow the flowers to spread out.

The rings applied to the side of the form give the feeling of weight and visual interest to the piece. Although I never intend to duplicate or copy works from other early cultures or times, ideas based on the works they produced do filter through my work. One could say that these rings have a feeling of old copper urns made in early Chinese culture. They are intended to add visual interest and again to add to the overall stability of the piece.

The vase form has endless possibilities in form, size, colour and texture. To the potter, it becomes a challenge to discover these possibilities using his or her sensitivities in creating the most pleasing solution. A friend once defined an artist or craftsperson as one who brings into being that which others can only dream of. As such, our civilization could be measured to some degree by the quality of life and the role of pottery in it. In a sense, the crafts of a nation define its progress.

Today our market has become somewhat polarized. On the one hand, pots are made for prestige, for the collectors, and on the other hand to serve a purely functional need. My work as a potter lies with the latter. I attempt to make functional works which reflect the needs of those who will use them and enjoy them in their homes.

Donn Zver by Bruce Cochrane

Donn Zver has operated a successful production pottery for over twenty-five years. His ability to produce such a high volume of work relies on a disciplined work ethic, efficient studio process, and a well-designed work space. His economical and creative sense of design reaches a broad audience without sacrificing the potter's integrity or individuality. A good example is this vase based on a classical Chinese vessel form.

Donn is making a clear statement in this vase about its intended function, about its ability to contain a full bouquet of flowers. The stoneware pot, fired to thirteen hundred degrees centigrade, is visually grounded by its bold footing and strong horizontal banding and glaze application. The dynamics occur in the vase's ability to harmoniously counter this direction with a sweeping upward curve. The rings are purely a decorative focal point providing further recall to Chinese bronze vessels.

Knowing his market well and exercising an effective business practice has allowed Donn to produce the type of pottery he likes to make and enjoy a successful lifestyle at the same time.

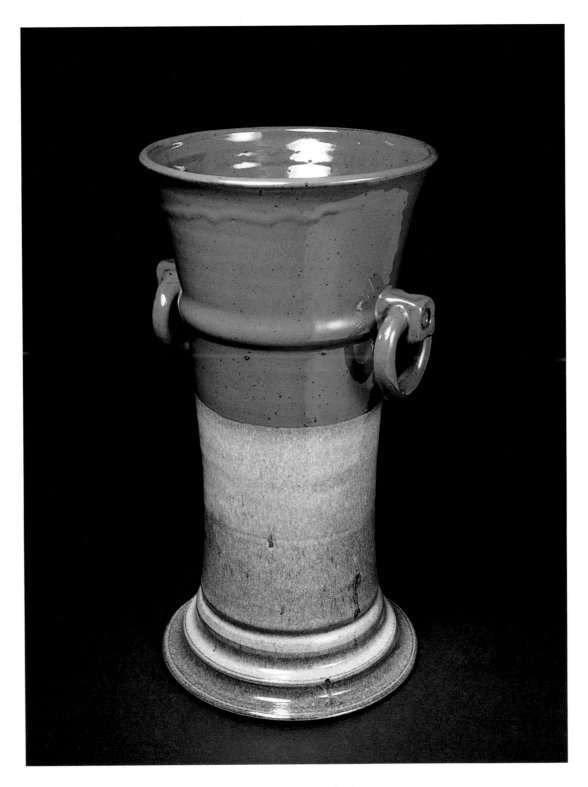

DONN ZVER, vase, 1995, stoneware reduction fired, teal glaze, opal blue glaze, 14" high by 8" wide.

Robert Diemert

Designing and making furniture is a very labour-intensive craft and it necessitates an awareness of economy which, in turn, usually translates into straight lines and right angles. However, I've long been interested in using what I term "activated" line, form, volume and negative space in my furniture through the use of curved forms.

These small end table/cabinets are made of bubinga with macassar ebony handles and, along with some other pieces that have similar volumetric qualities and curved forms, were made for a solo exhibition of my work in 1995. The challenge I set for myself was to design a cabinet that could be viewed in the round, one with an asymmetrical feel using a curved form that I had previously used in some other work. I like to see movement within a piece, either through the use of line or shape, that makes the eye travel around or through the object.

In order to really understand how this piece fits in with the rest of my work, one would simply have to see more of it within a chronological order. The curve that is used to make the sides of these cabinets was also used for the shell of a chair and the doors of an earlier cabinet. The designs for all of these pieces started out as thumbnail sketches, like everything else I design, in my sketchbook. I also did a quarter-scale model of these side cabinets, after the sketching was somewhat resolved, and added or deleted some of the final details. The design then progressed to more full-sized drawings and mock-ups.

Robert Diemert by Stefan Smeja

This work represents one of the finest craftsmen in Ontario and probably all of Canada. What sets Rob's work apart is the quality of execution. The pieces look quite fluid, with easy curves that represent considerable technical challenge, to have joints in various junctions work out as smoothly and flawlessly as they do. Rob has an absolute sense of quality of execution and his craftsmanship is just superb. The forms are intriguing because in plan view there are really no straight lines. The only straight lines occur in the vertical plane where there are junctions between the curved planes. Everything in plan view from the top is a curve and the doors are curved.

The leg detail works out particularly well, in that it flares outward nicely and supports the volume of the piece without looking stressed. In all, there's a nice fluid motion here, especially because the bottom edge undulates in and out of the door plane and up and down on the side plane. I read the pattern of the veneer in horizontal bands, which work quite well with a curved surface and support the form. The richness of the veneer works well with the curves because as you move around the curved surface there's a play with the light that activates the surface. The handles have curved elements in them that reflect the overall curves of the whole cabinet. It blows me away that someone can execute curved forms with such tight control, with such craftsmanship and attention to detail.

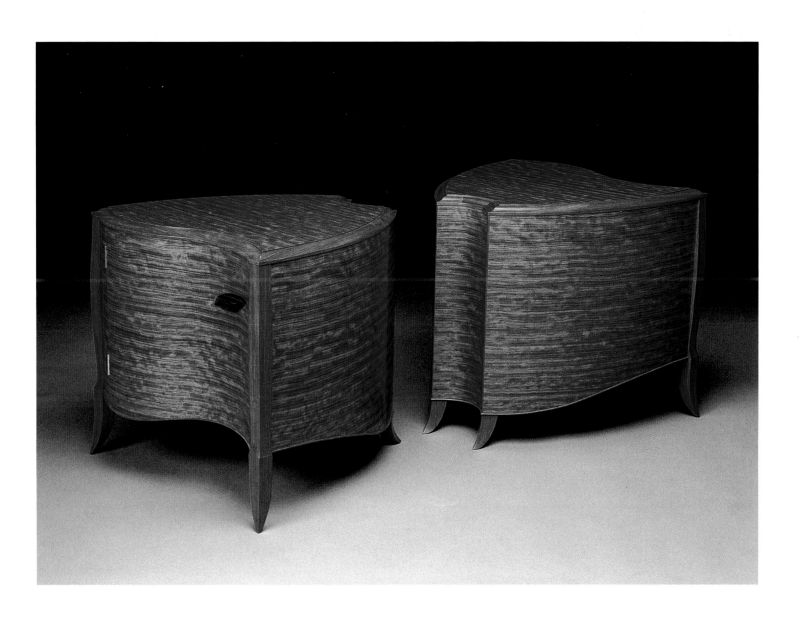

ROBERT DIEMERT, *Endtable Cabinets*, 1995, bubinga, macassar ebony, 20" high by 24" wide by 24" deep.

Peter Fleming

I design and make furniture. I draw a distinction between the two because, while the ability to do both seems ideal, the two activities can be in conflict with one another. I admit to impatience, a curious quality for a craftsman. I am driven to complete a project, to see it finished and then revel in its merits or sink in its failures. But an equal and opposite force has to be surmounted before the making can begin: I have to subdue my temptation to tinker endlessly on paper with proportion, line, colour and form. Resolving the design as fully as possible before construction is in everyone's best interests: it means the work progresses smoothly and efficiently; it means a satisfied client, a mollified bank manger and a minimum of frustration for me.

This storage unit for clothing was commissioned for a client's bedroom. Simple economics dictate that I work primarily on a commission basis since the time required to make substantial pieces of furniture on a speculative basis is prohibitive. I do occasionally make self-generated pieces for exhibition, but I find the rigours of solving someone else's problems challenging. I mostly work for residential clients because I find the intimacy of the pieces more satisfying than the scale and attention that is often required by corporate clients for their pieces. A large part of my enjoyment is in establishing relationships with people who have made an investment in my work, both financially and emotionally. Many become friends. Residential clients have to live with the pieces I design and make for them, become very involved in the design process, and care passionately about the outcome. I encourage this and find it quite satisfying, although it can be tiring on occasion.

My client had recently renovated the third floor of his Victorian house and made a large open space with sloping walls to be used as a master bedroom. There was a severe angularity to the space with little headroom where the ceiling met the walls, although the space was very deep. I proposed that we make a cabinet that was quite deep and to bring the front of the cabinet out as far as possible so that when opening it one wouldn't hit one's head on the ceiling. I curved the back of the cabinet so that it would form a contrast to the angularity of the room and also be able to be positioned at an angle to the wall, or have a variety of different placements in the room. The drawer fronts give a flat blank face to the room, which emphasizes the asymmetry of the piece and contrasts to the curve of the glass shelves and back.

Choosing materials always has visual consequences, so I try to balance the visual effect that one material has on another, thereby acknowledging an aesthetic agenda that goes hand-in-hand with functional considerations. In the case of this bureau, I chose a light-coloured wood, maple, for the main cabinet element I wanted it to have a massive but light-feeling block which housed the main storage. The legs are rosewood, and they form a link with a series of pieces that I have been working on for several years. Their form and placement give a delicacy to the support and give the piece a "perching" appearance, slightly imbalanced but still trustworthy. The sandblasted glass shelves are for display of objects and disguise the rather prosaic function of the piece, as well as terminating the rather wide end of the cabinet with a rounded and asymmetrical element.

I like this piece because I feel it is a successful marriage of functional considerations and aesthetic intent. It has a link to other pieces I have done before it, and yet expresses elements of asymmetry and balance that I have not achieved successfully until now. It is also one of the most recent pieces I have done, so I haven't gotten tired of it yet, I guess.

Peter Fleming by Robert Diemert

Peter and I shared a studio from 1983 to 1990 and in this recent piece I see a maturity in design that builds off previous stuff, like the glass shelves going off on the left that balance quite nicely with the rest of the cabinet. Considering its size, there's a lightness to it, and a quirkiness because Peter has to challenge the viewer. Peter's earlier pieces had a funky quirkiness to them, a playfulness, but this piece is more serious, more resolved, more homogenous, and as a result quite successful. The quirkiness here involves the leg hanging off the glass shelves in a tenuous looking manner. He's taken this symmetrical and balanced thing with the same two legs on either side and pushed an asymmetrical quality with the glass shelves offsetting the largeness of the cabinet. Also, normally the taper on a leg goes on the inside, whereas Peter's notion is always to turn them around and give a slanted pigeon toe feel.

Again this is fun, but the piece is truly refined and controlled too, with the back curve and the front curve playing off each other. There's movement here, but the elegance of it comes in the simplicity, the subtlety, and also the use of various materials which is quite beautiful. This is a complicated piece with many technical problems involved, and Peter makes it all look simple.

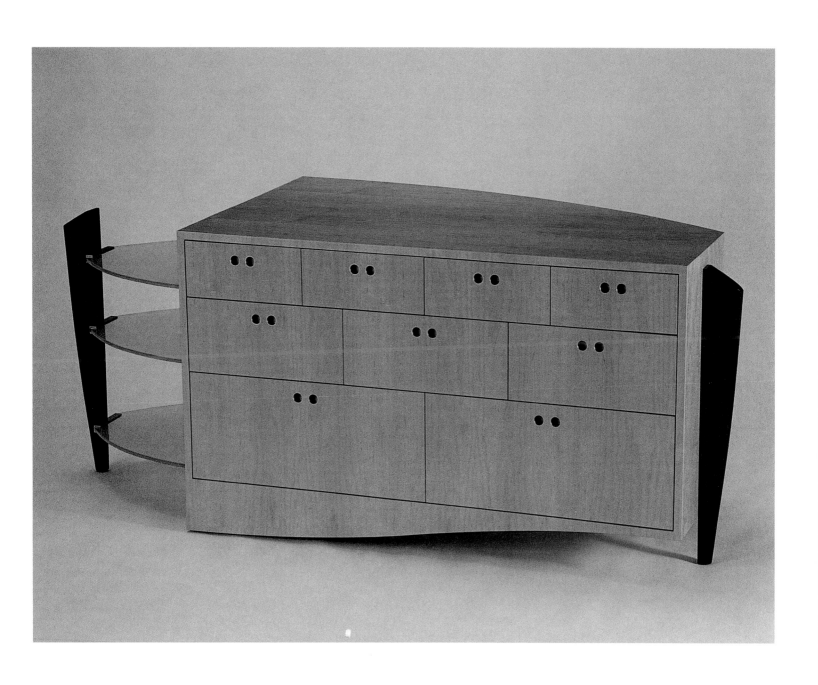

PETER FLEMING, *Caravel Bureau*, 1994, maple, sandblasted glass, rosewood, 760 mm high by 1800 mm long by 720 mm deep.

Michael Fortune

I designed this chair in 1981 in response to a commission for a dining-room suite. The clients had previously commissioned two small side-tables, a hand mirror, a wall mirror and a small box. Both individuals were climbing the corporate ladder and, although their combined income was not large at this point, they did spend some of their money on fine art. "Craft isn't too far off the mark and besides it is useful," it was said. This was my first large commission, a challenge for me and a bit of a risk for the clients.

The first prototype chair took five months of consistent effort to resolve. The set of eight chairs that followed took an additional four months to make, while the accompanying table was built over a two-month period. I went on to design a series of six different chairs, all inspired by that first commission, and I have built between 150 and 200 chairs, all in variations of that first design. The design has received some acclaim, and it has evolved into my signature piece. The first chairs sold for $565, and now a current chair with a degree of inlay sells for around $6000.

I chose to use the techniques of steam-bending and hot-pipe bending, introduced to me while I was a student at SOCAD, in the Number One Chair, and I have continued to explore these techniques over the past fifteen years. I teach regularly all over North America, with wood-bending being a topic that is frequently requested. I have recently been approached by Taunton Press, publisher of *Fine Woodworking* magazine in the United States, to write a book on wood-bending. In addition, Lee Valley Tools, based in Ottawa, manufactures bending equipment that I submitted to them. I worked with the engineers over a two-year period to develop a comprehensive system that is inexpensive and easy to use. I now receive royalties on the sale of these products.

A very important lesson was learned from that chair commission. It has opened many doors and allowed me to do what I want: have a great time, make a reasonably secure living, and make an artistic and economic contribution to Canada, to boot. Thank you to my first and all subsequent clients. It is my opinion that, over the length of one's career, one can create four or five benchmark pieces. This, I believe, is one of mine.

Michael Fortune by Donald McKinley

This is not a one-off chair. It has been well enough received that it has been reproduced a number of times and sold in quantity. The chair allows variation in wood choices and pattern choices, so there is some personalization each time as Michael creates alternatives. Initially you want simply to make a good chair and he has proceeded to work with a specific process like steam bending, using the curvilinear shape that bending allows.

It combines Michael's skills and sensitivity. He is sensitive in that it is not made out of little straight sticks and lath. Count the corners and you will find there are no corners, since it is an elliptical cross section. We are looking at the intersection of the elliptical bun and the missing heel. We never get to see the end because the end disappears into the chair. So in terms of touching it, it is cornerless and very tactile. Indeed, it is a tactile treat in which you feel the intersections and transitions.

This chair is quite comfortable. One is basically concerned about how a chair works when you are in it. At the same time, when you are not in it, you see the chair as a network and there is a sense of generosity and continuity by not having the slats stop at the seat. They could be joined there, but actually they only just brush it with a kiss. The slats really go from top to bottom as individual slats and, though that is not critical in terms of function and comfort, aesthetically it is desirable. However, if you do not want to interrupt your cat running around the house, you might as a maker say, "Let's get rid of those, so the cat can run from front to back without being made into potato chips."

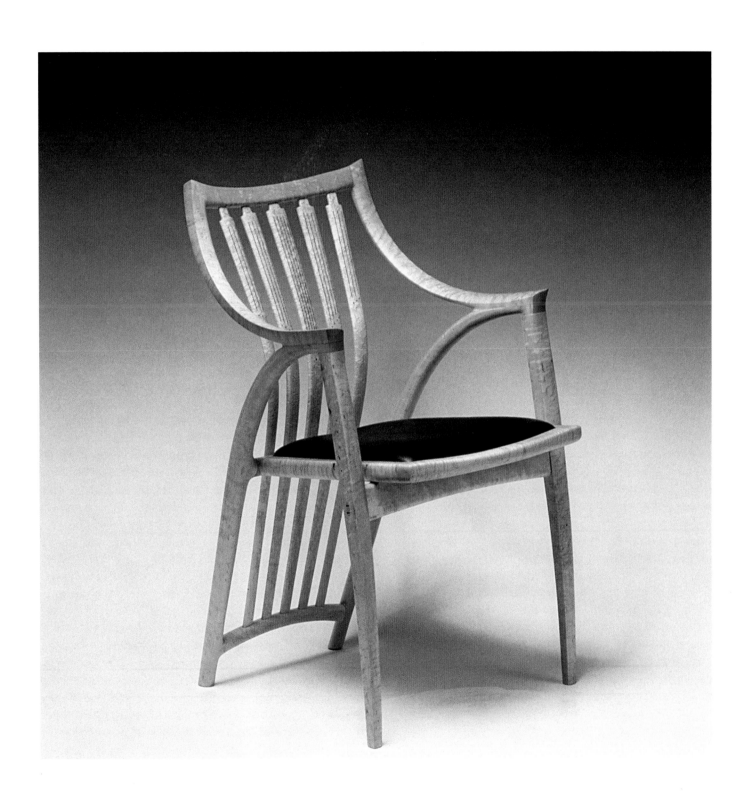

MICHAEL FORTUNE, *Number One Chair*,1990, bird's eye maple, ebony inlay, merino wool, silver, 26" wide by 26" deep by 34" high.

John Ireland

This bannister was commissioned by Joan Chalmers and Barbra Amesbury to replace an existing pseudo-Georgian bannister whose top was in a curious low-ceilinged hallway and which led down to a fairly expansive basement hallway. I wanted to create a feeling of animated flow between the two areas. The linearity of a railing invites it to be read, perhaps, as a form of progressing abstract notation. In it, I see allusions to musical notation and scripts which create a sense of rhythmic movement within a structure. The structure of this railing is also determined by the usual functional and structural requirements of a stair railing.

A railing is experienced differently from furniture-which is usually perceived as a static object in space rather than a structure to enliven and shape space. Before this commission I had built a number of pieces of furniture which alluded to stair railing forms, so this actual railing was an obvious progression for me. To give a sense of movement to the bannister, I made the handrail a sinuously curving line which was shaped to invite the hand to ride it along its roller-coaster length. The balusters are of two different types, with the newel post being a variant of one of them, and they change in length and proportion according to each span created by the curved handrail. These variegated balusters create a sense of rhythm which is punctuated and reinforced by rosettes on the stringer and underlined by a thin bead of bubinga underneath the stringer.

A successful piece must operate on several levels. Besides the obvious functional requirements, which must be fulfilled rigorously, and a high level of craftsmanship appropriate to the piece, it is essential that the piece have a coherent though not overly didactic compositional structure. It must have sensual appeal that produces both tactile and visual delight in the forms and shapes. Less easily defined and partly a result of the combination of these elements is the emotive response that must be touched by an evocative use of forms and that makes cultural history personal. All this together, while the piece still somehow manages not to take itself too outrageously seriously, and the piece is successful. This bannister is closer to success than many pieces I have made.

A postscript: the bannister was destroyed within three years because it didn't fit into the renovation plans of the home's new owner.

John Ireland by Donald McKinley

This railing has a role in a house, a subservient role, and it is there to do a job. But as you descend, you interact with it, and John's craft raises it beyond simple function. I especially enjoy the rhythm of the alternate images going up the stairs and there is much else to appreciate. Each sphere is not melted into the diagonal, for one, but it is tangential to the railing. The whole effect is almost like lacing a shoe, nicely syncopated. You have this distinct shape that is poised between the tread and the railing, and then with the next one it is almost like toffee dripping. There is also a fat upright down at its bottom, the newel post, with a nice balancing off between what is virtually an identical diameter sphere above matching that diameter down below. The different natures of the two elements is really nice.

This railing offers a minimum kind of protection. The design is not just a very light textural pattern of thin linear elements, but these things are large enough and with enough space around them that you can see a counting out of the troops going up the stairs, so there is a rank and distinction that is given to the comparatively larger newel post. According to tradition, the newel post is a major component, and this one looks like it has a corset on it and is tightened up enough to keep the fat from down below. It matches with that alternate that has this dropped bulge, but here it has been corseted with an inflated centre.

There is a relaxed look about the other parts, because like a bag full of sugar that you pick up, the sugar goes to the bottom, or the toffee you make really flows. The newel post is more military. There is a nice range of attitude about the balusters.

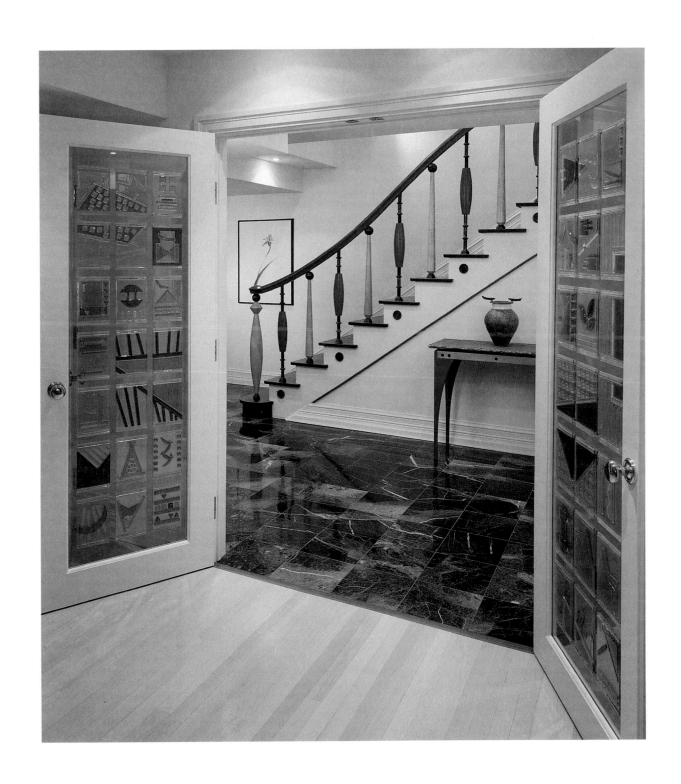

JOHN IRELAND, railing, 1991, bubinga, cast bronze, curly maple, copper, ebony, 17' long.

Randy Kerr

This piece is the mayor's desk in the council chamber in the Ottawa City Hall. I received the commission as part of the municipal art collection agency "Art in Public Spaces" competition for the Mayor's Desk and Chair, which was one of seven sites for art installation in the new Ottawa City Hall. As it turned out, three SOCAD grads were shortlisted to compete for the site.

Councillors and Mayor aside, the desk is the visual focus of the council chamber. It condenses the significant architectural details into one piece of furniture, highlighting those details with the aid of the inherent beauty of carefully chosen woods. The desk is made from curly cherry, burled walnut, walnut, and several other species of wood seen in the coat of arms marquetry. The desk is the central and focal element of a curved series of city councillor desks approximately fifteen metres in length whose arc is defined by a 7-metre radius. The space within which the desk had to fit was very specific and I could only work within that area. In plan view the space was a truncated piece of pie. The front and back of the space were defined by the two arcs, with the sides of the desk following radiating lines. The primary tool used in the construction was an adjustable seven-metre beam compass with a router mounted on it to establish all the curves and to construct all the patterns.

Ottawa City Hall was designed by Moshe Safde and built in 1992. Even after a public meeting with the architect it was difficult to understand his conceptual motivations for the juxtaposition of differing geometric forms and their relationship to the whole. Therefore, my approach to designing the desk and chair was to complement the architecture using my personal aesthetic vernacular as a woodworker.

To design the desk, I chose to rearrange some of the forms and geometry as seen within the council chamber to create a desk that was commanding in presence, detail and crafts-manship, yet not overpowering or subservient to the architecture. The bow front and the paired pillars of the desk relate to the cleaved cone and support pillars of the architecture. The 36 pieces of burled walnut and the mother of pearl relate to the repeating structural elements as seen in the roof and, of course, the two inlaid coats of arms represent the City of Ottawa. Part of my approach to the design was to limit the amount of detail and to keep what detail there is simple yet bold, because the desk when viewed from the public gallery is ten metres away. To complicate matters, the desk also had to contain a video monitor along with other electronics.

As a technical challenge, the construction of the desk was very demanding because of all the odd angles and curves as defined by the specific space allotted for the desk. As a juried design contest, the challenge was to balance the perceived aesthetics of a jury and the significant demands of the architecture with my own aesthetic sensibilities. For myself the bane of every woodworking project is the amount of time it takes to complete the piece, a period of limbo and exacting work as you wait to see whether or not the piece works. Contrawise is my love of the process, and occasionally I even like what I've made.

Randy Kerr by Robert Diemert

Randy was a natural choice to do this mayor's desk in the council chamber because of the scale of work he was getting into and how his superb craftsmanship would meet the technical challenge involved here. There are curved surfaces, inlaid mother of pearl, columns, and Randy pulls it off cleanly and effectively in a way most craftsmen could not. The desk is intended to be the room's focus of attention, and it's successful in its sense of power. A simple curve form might have worked, but it wouldn't have as much punch as Randy's desk. It is elevated with a stepped up quality and rich with detail of different woods, a burled wood that is quite busy on a curved surface with linear wood at the top and bottom. There's a very architectural feel to it, an Art Deco richness of materials with the top and bottom more post-modernist in feeling. You would discover the details in approaching the desk, and they would be a compelling discovery.

It's always a hassle for a maker to incorporate a TV monitor and here it's recessed with no indication of it being there. The desk must have been a nightmare to do because the sides are tapered and have to fit the opening, with a staircase going off the side of it. If anybody could get a nice tight fit, it would be Randy. He's also used a richness of detail while keeping it simple and without going for more shaping in the base and capital. Because he needed to fit it into the rest of the chamber's cherry paneled look, he maybe restrained himself somewhat, but he's pushed the facade out and distinguished it.

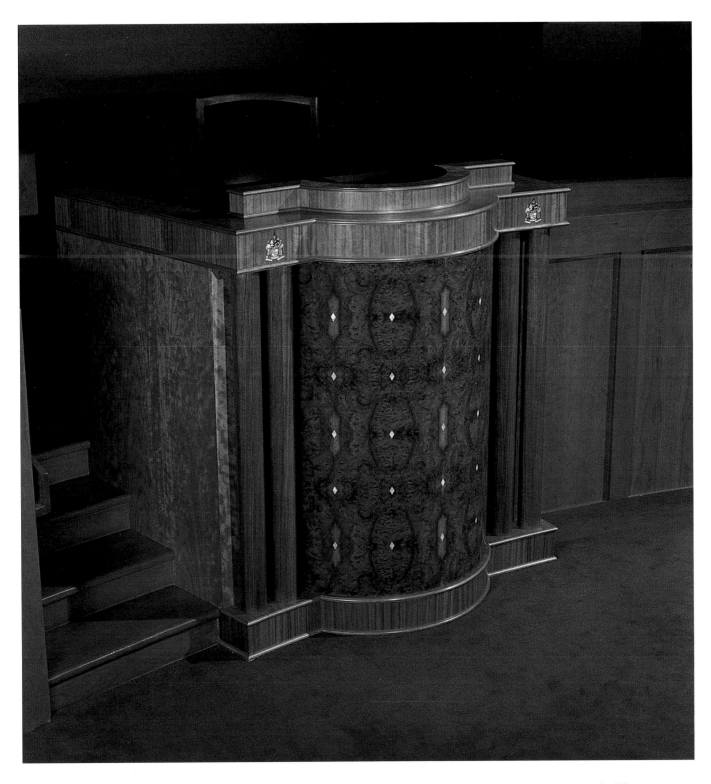

RANDY KERR, *Mayor's Council Desk*, Ottawa City Hall,1993, curly cherry, burled walnut, walnut, mother of pearl, approx. 1500 mm by 1500 mm by 950 mm.

Sean Ledoux

This chair is the 1993 evolution of the 1987 original. It is essentially a speculative prototype for limited production. In designing it, I set out to create seating for dining and the typical after-meal lounging at the table. My primary concerns were for a comfortable seat as well as a supportive and restful back upon which to lean. As with much of my recent work, my secondary concerns were to find a happy balance of machine-production methods with hand work, in order that labour cost intensity not drive the price out of reach. Lastly, considering all the work that goes into the development of a chair, I wanted a timeless design with staying power.

In making the chair, I streamlined construction by using the same curvature form for all the bent stretchers. Shaping jigs, for creating the other components, allow duplication without undue hand labour. Modifying the look of a common brass screw allowed me to easily fasten the lower ends of the seats without appearing too pedestrian. These methods save time and expense.

I like the chair because it works. In addition to a comfortable seat, the bent slats provide soothing back support and dynamic involvement with the chair/object. They are free to move in the crest rail at their upper ends, and this potential for movement offers a resiliency that accommodates varying pressures. For those who really want to kick back, the crest rail offers a modest contoured headrest. As well, the chair continues a tradition in my work of inviting tactile involvement from the user. All exposed ends are domed to create a form which is soothing to the touch. As one sits in the chair, one's hands are drawn to exploring these surfaces. The oil finish allows the texture of the wood to be realized while at the same time providing a surface treatment that wears and ages gracefully.

As I evaluate the chair after living with it for three years, I am pleased it is still very comfortable and has held up well. I believe that I will be as content to look at the chair ten years from now as when it first came to life. Unlike clothing, which can afford to be trendy due to its relative short-livedness, furniture deserves a more classic look if we are to escape the realm of disposable consumerism supported by outdated style.

If I have to be critical of this chair, I think that it could stand some surface embellishment or detailing. My original reluctance was driven by cost concerns. Perhaps, as production evolves, detailing could become another step in the overall process.

Sean Ledoux by Stefan Smeja

I like the simplicity here, the overall clarity of line. It is a straightforward chair, probably because part of his goal is to design a piece that could be made affordable to more people. That explains, for example, the joining of the backsplats to the two sets of rails at the back with brass fasteners, since this allows for expedience. From a structural standpoint, it is quite good because of the double rail system which allows, if you wish, for leaning back on two legs. The height of the upholstery gives one the feeling that it will be comfortable to sit in, and the combination of the choice of upholstery fabric and the tone of the wood is a nice match.

For me the proportions are unusual. The back is fairly high and fans out with the crest rail acting as a headrest, and although one would not be leaning all the way back, the long curvature of the backslats does provide enough resilience to make the chair quite comfortable. This chair speaks more about form than surface and material, and there is not much embellishment or decoration to the surface while in the wood itself the grain is fairly quiet. This is intended as an affordable piece and that can influence the maker toward some degree of compromise, since some aesthetic decisions are therefore driven by a desire for economy in production. It thus becomes a challenge for a designer to make a piece that does fit within a certain price bracket and is a well-designed piece of furniture. In the end, I like this chair. Based upon the criteria he has established, it is a good chair, a robust chair, and I would like to sit in it.

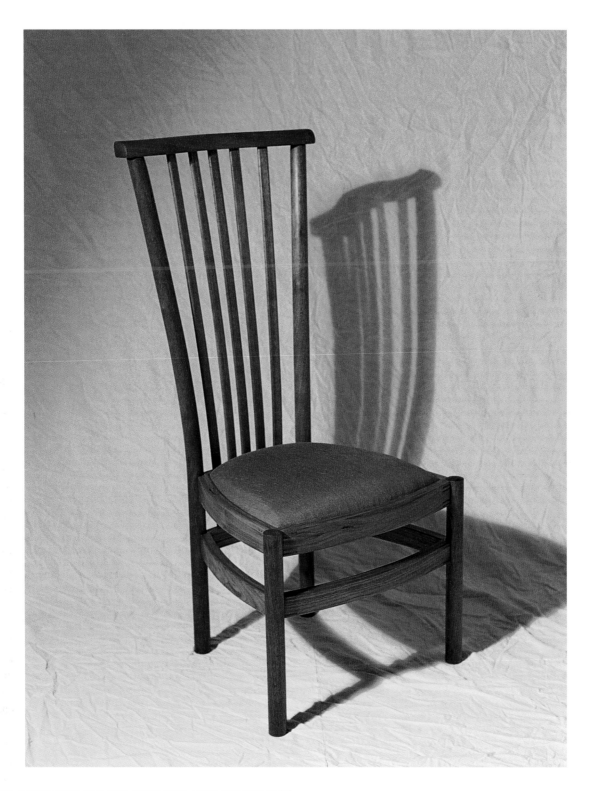

SEAN LEDOUX, dining/lounging chair, 1993, walnut, brass, cotton, 22" by 18" by 49".

Tom McKenzie

I wanted to do a writing desk because I'd never done one. You must start somewhere and when I saw a magnificent picture of a diamond-back snake, I knew I had an intriguing challenge. I wanted the desk to be petite, to fit a small person in a small place, but, as usual when I start sketching, the judge and engineer got left out of the process. No thought was given as to how it could be built or if I had the skill; I couldn't let those useless problems stop me. Then it was time to give thought to what I knew that I might use and what I didn't know. Research took me to an old reference book, the Bible, where the snake told Eve that she should eat the fruit because she would become god-like and God would not punish her. After Eve, others to come didn't like snakes; maybe it was time for people and snakes to get reintroduced. Once I had the information needed, it was time to free the mind and let the dream take over, and after many sketches I settled on a look.

The technical part of this piece proved a challenge. The gold-leaf eyes led to a 300-mile trip to Vancouver to enrol in a course in gilding. The forked tongue meant finding a lathe, a welder, and a place to anodize aluminum. The drawers would not open wide enough because the curve of the desktop made the outer side of the drawer too short, so I used a pivoting sliding dovetail drawer I'd used for another piece with the same challenge. The drawer not only pivots sideways, allowing full access, but has the added benefit of one's not having to slide back the chair to open the drawer. Another feature is the snakeskin texture, which is visible only up close. I considered a few ideas, including hand-carving the textured skin, and decided to vacuum press octagonal-patterned veil material onto six-hour-old lacquer. The result was subtle but effective. The diamond shape on top is eggshell, which I've used before on several pieces. This idea came to me from a man called Dunand, who, in the thirties, excelled at creating intricate patterns on furniture and small lacquered objects.

The thing I like about Eve is that it stands solid but looks a little precarious, as does a snake. In retrospect, I feel I should have made Eve a little more snake-like, but making this piece was a good experience, a chance to explore new and old techniques.

Tom McKenzie by Donald McKinley

This desk by Tom McKenzie, with its quality of animation, has a strong sense that there is a story being told and it is not simply a surface on which to put paper and write. At first I am not sure what the identity of the character being depicted is, but we have a pair of eyes that are somewhat mesmerizing and somewhat threatening. Without knowing it is a snake, I would still feel people would be a little nervous around it. We feel it is going to keep its eyes open, because reptiles have no lids and cannot close their eyes. The desk certainly has a face, perhaps somewhat like a frog or Ubangi with an attitude, and the legs become fangs of this serpent. It gets scarier and scarier. It also gives you four points to balance on and it becomes less threatening because it is so devoid of lower jaw that we have only bare pieces of a snake, though provocative and eerie enough to create a reaction.

Technically, it is not that obvious what is happening. The curvature above the brow probably has stack laminating and he has carved an undulating ridge; he has not built a box with just a bunch of flat surfaces. With these four elements that go from the floor up, two of them merge in the forked tongue, and then there is a single contact with the desk itself. Because the legs in the front are vertical, they do not give a bracing, though the connection at the top is fairly large, so the desk will work fine for penmanship. But with an old-fashioned typewriter womping back and forth, the desk would suffer abuse. The question, then, is if the desk can hold the poise and the pose without anything happening to it.

This head of a serpent with a poised quality to it, suggests maybe twenty-five more feet of serpent behind it, though the desk would be happiest against a wall. It is animated, with an appealing colour compatibility between the forked tongue and the writing surface. It has a reflective quality in some of the elements, and the socket that the fang is going into indicates a high level of finish, which is typical of Tom's work. He is a very good craftsman who almost always has a message, and part of the pleasure of owning this piece is to get his story line with it. He is absolutely conscious of what he is doing and he is able to share the narrative from his mind in a desk that is certainly physically present with, ultimately, a story of its own.

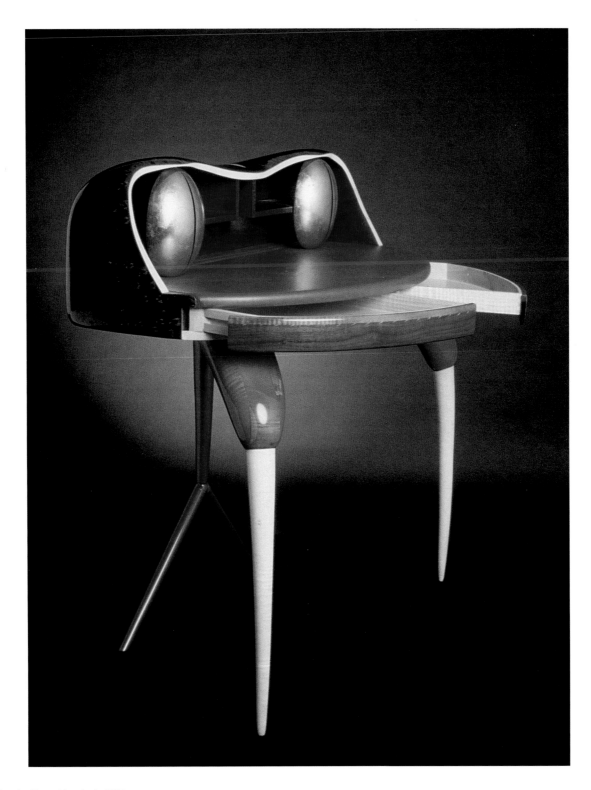

Tom McKenzie, *Eve*, writing desk, 1993,
curly maple, yellow cedar, blackwalnut, leather, anodized aluminum, quail feathers, egg shell, gold leaf, 36" high by 36" wide by 20" deep.

Sven Pavey

After fifteen years of woodworking, it is difficult to focus on one piece of furniture as exclusively illustrative of my work. However, a fireplace surround/entertainment centre constructed in 1989, two years after leaving SOCAD, does stand out as a piece that is reflective of the aesthetic and craftsmanship to which I aspire. As well, it provided a challenge.

The cabinet was constructed using a combination of curly African bubinga veneer, solid bubinga and ebonized curly maple. The woods were selected for their highly figurative grain pattern, which reinforced the serpentine motion of the upper cabinet. The use of ebonized curly maple served to both define and highlight the elaborate detailing of the piece.

The unit consists of two sets of cabinets. The lower cabinets function as a surround for a black granite fireplace and also provide concealed storage. The undulating upper cabinets house stereo equipment and drawers, all of which are situated behind tambour doors. The undulating tambours are motor driven and follow a curved path that echoes the waves of the cabinet and the curved drawer fronts. Speakers at each end are concealed behind open framed doors covered in black speaker cloth.

While at SOCAD, I concentrated on designing and building speculative furniture using organic and free-flowing lines, combining man-made and solid wood material. Subsequently set up in a Toronto-based furniture co-op, I was approached by a client who loved sailing and water, and requested me to design and build an entertainment centre for his residence. This opportunity enabled me to further develop the work I had been doing at SOCAD, but within the confines of a predetermined space and setting, in contrast to the unrestricted parameters of purely speculative work. Also, coming from a more traditional cabinet-making background, I was able to combine what I had done at SOCAD with the work I had done in previous years.

The piece was particularly enjoyable to produce, in that it challenged my ability to design furniture that had to answer to specific requirements. It had to please not only myself, but the client as well. The elaborate moulding detail and the introduction of motorized tambours challenged my technical abilities and provided a new reference to draw upon in future work. At first glance, the viewer can appreciate the attention given to detail. This piece truly reflects the objectives I strive for in my craft; it is visually pleasing for both its contemporary elements as well as its links to tradition and excellence in craftsmanship.

Sven Pavey by Robert Diemert

This is a very woody piece, but Sven has picked up on the black granite with the detailing of the large bead that travels around. It's amazing the way the tambour or door works like a roll-top desk with little segments of wood that are backed with canvas. It's all quite challenging technically with all that veneer. The wood here has a quality called a mottle effect, where the grain comes up on angles to the surface with a light and dark effect, a shimmer. This is a big piece with lots of surface where the wood can speak for itself as a rich, gorgeous material.

I like the top half better because of the curves and the resulting movement, but that's my own prejudice. At the top Sven has introduced more form and volume, which works quite well, and given the piece some texture and movement on the front. The whole wood quality is therefore broken up using that undulation. This gives the eye more to consider, a special quality to the wood because curved surfaces enhance the wood's shimmer. This piece is intended to go around a fireplace so it has weight to it, and where Sven has been gutsy is to use predominantly one wood and a thin line of accenting dark wood. He might have done the tambour in another wood, perhaps, or done something differently in the flat front surfaces, something I might expect since some of Sven's other work is pretty wild. But the curve here is pretty wild, technically very challenging, and he's done an excellent job of it.

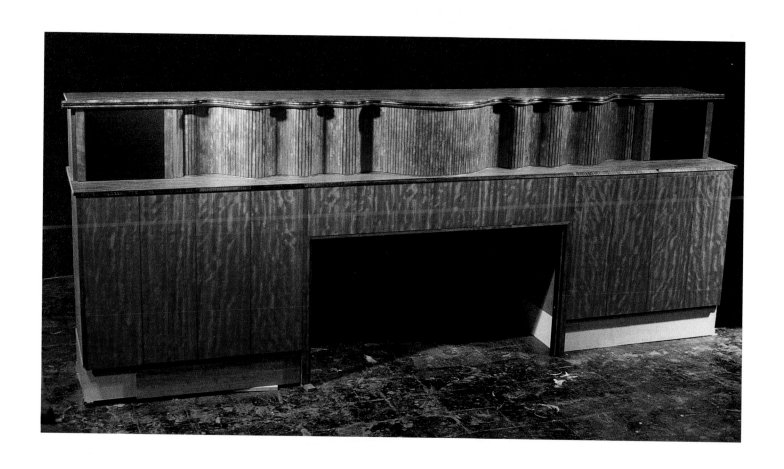

SVEN PAVEY, fireplace/entertainment centre, (before installation),1989, bubinga, curly African bubinga veneer, ebonized curly maple,12' long by 52" high by 24" deep.

Sherry Pribik

This piece of furniture is part of a series where I started with fifteen-cubic-inch plywood boxes, each having three drawers, as a base. This was the second piece in the series. The box is covered in half-inch poplar cut into two-inch squares. Most of these squares have been covered with torn maps of the world. The maps have been dyed and rubbed with earth pigments and some of the squares are painted black. The box stands on poplar legs approximately thirty inches high. The legs were shaped with a rasp and stained black.

I wanted the maps to be pieced together like a quilt, though not in a select pattern, but more like a crazy quilt. I also wanted the box to sit on as delicate legs as I could achieve without the whole thing falling over every time it was opened. I learned, while making this piece, that it always takes me longer to do something than I think it will. This is what I learn every time I make something and this is what I forget every time I start to make something else.

This piece fits in with the rest of my work in that it is part of a continuing exploration to find a randomness within a very controlled craft. Part of the difficulty with this approach is that often the randomness can only be achieved in the surface treatment. Still, I think this piece works well because the play of balance continues on the surface and through the structural elements. The skinny curved legs contrast well with the static box on top.

I really don't feel it's my place to explain to anybody my motivation or how to understand or appreciate a piece I create. I am inspired by a particular idea or concept and this helps me to define the shape, size, colour, proportions, textures of a piece of furniture. Observation is a personal experience and I can only hope that my work evokes some kind of response.

Personally I think the piece has a nice sense of balance both in colour and form and I enjoy the proportions. I like the fact that it wobbles slightly when you open the drawers, but I think some people might view that as a negative quality if you place the piece in a context of traditional terms. The materials are fragile and I wish there were more ways of attaining visually stimulating surfaces that are more durable. The top is fitted with a piece of glass to protect it and I wish that it wasn't there.

Sherry Pribik by Stefan Smeja

I respond to and appreciate Sherry's work in that she has chosen to pursue an aesthetic a bit outside that of furniture studio graduates. She deals with the manipulation of surface textures and rearranges the ordinary into something unfamiliar. The surface here involves topographic maps that have been cut and rearranged and although the piece certainly is a three-dimensional furniture form with drawers and a function to it, essentially it is about surface. This is a fun piece and I don't think it makes any pretense at being taken too seriously.

The gesture with the legs and the rails gives it a wobbly kind of visual appearance and my initial response is that the piece is having fun, therefore engaging the viewer. The legs curving up the sides of the cabinet and the rails wiggling between the legs are chosen forms that enliven the piece. If the rails and legs were straight, the whole piece would seem more static.

The collage treatment here, while typical of Sherry, would be quite a leap for most furniture makers. While Sherry was a student, she would take existing pieces of furniture and deconstruct them and then apply a surface modification to the individual parts and then reconstruct them in a way that had not much to do with the original piece. As a maker it wouldn't be in my nature to produce a work of this nature, since I'm not as bold and willing to take the risks to explore colour and pattern as Sherry does.

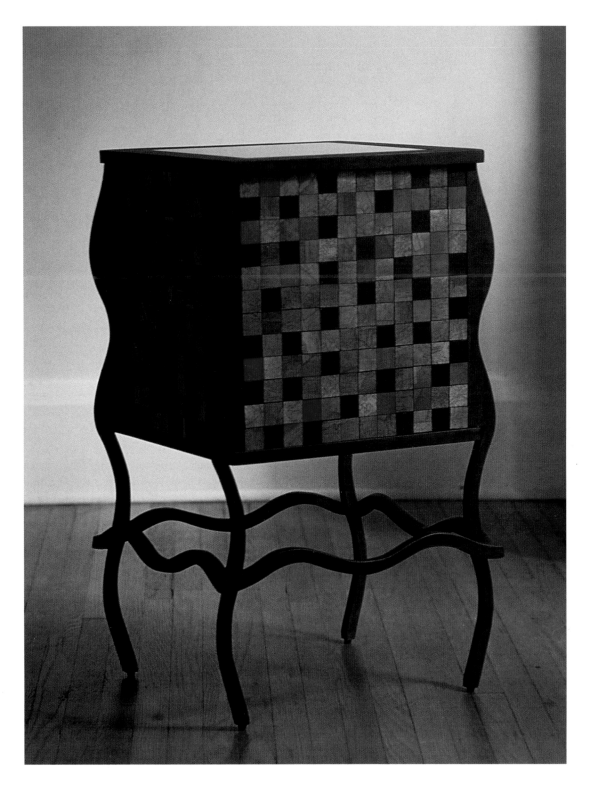

SHERRY PRIBIK, *Precarious Balance*, end table,1994, plywood, 2" poplar squares, poplar legs, dyed maps, 15" wide by 15" deep by 30" high.

Tim Rose

This armoire was made for clients who live in an old Georgian home and it was designed to be traditional without having obvious historical references. Commission work often requires reworking traditional styles for old-fashioned tastes and, as a creative designer, it is my challenge to satisfy the clients' needs, but also to be as creative as possible and to make an original piece. On this project I tried a new drawing technique where I enlarge a sketch on a photocopier to 1/8 scale. This helps me control the proportion and composition during the sketching and retain the gesture and fluidity of a small sketch in a large piece.

Armoires are large heavy cabinets. They were usually placed in the main hallway on the ground floor of the home which allowed for possible removal in case of a house fire. This cabinet posed a structural challenge because it disassembles into three pieces which on their own are structural and easily moved. The newest technical process which I learned on this piece is one of the oldest woodworking techniques and a lot of the veneering was done with hide glue, a old Egyptian technique.

I do speculative work which I show in galleries but when I work on commission the clients tastes and needs affect the design. I would rather be known as a versatile designer than for promoting a specific style or trademark in my work. To have integrity as a creative designer, I should be changing and evolving constantly, and if I get comfortable with a style, then I reduce learning opportunities. If I challenge myself with clients' specifications and my own creative speculative pieces, then I will eventually conquer any weaknesses in the creative process.

I like this armoire because, although it is a large piece, it is not imposing and doesn't overwhelm the user when it is placed in a small bedroom. By putting legs on the cabinet, floor space is occupied without being covered up, so the cabinet doesn't become an architectural component of the room. There are two hidden drawers incorporated into the skirt of the lower section. I wish I had placed the knobs slightly lower, since this would have been more functional and aesthetically pleasing. If I lowered them they would be closer to the pull height of the interior drawers and lowering them would also focus the viewers eye to the entire door and not just the knobs.

The purpose of a tree is growth and beauty. Whenever possible, I design pieces with comparison to living things, and forms and their components become metaphors for trees, people, and much else. Energy is form and the appearance of this cabinet is my interpretation of beauty and, beyond its function, the concept of the piece stresses growth and energy. The delicate yet strong legs, which are contained energy, support weight. Weight, or contained energy, also exists in the decorative skirt and hidden storage. The main storage body of the cabinet is physically light, yet opens to reveal precious contents and thus releases energy. The top, or hat, repeats detail, gesture concentration and release of energy. This is the most traditional piece I have done.

Tim Rose by Robert Diemert

Although about seven feet high and three and a half feet wide and also very deep, this massive piece has a lightness to it, partly because it's about a foot off the floor on light-coloured legs that create an uplifting effect. The combinations of wood help too, as does the flaring out of the corners. It's basically a boxy cabinet with the only curves being in the substantial legs, but the verticality also gives it a lightness. So does the light tropical wood and the straight tight grain of sympathetic lines. Nothing slows your eye down and the piece feels animated. Designing one off furniture is risky because, no matter how much you play around on paper, you don't know if something of this kind of a scale is going to work. You can anticipate quite a bit and Tim had done a few large pieces already, so his previous experience worked for him.

This piece really works and what I find interesting is that the base, the rectangular cabinet, and the crown are separate. I watched him work on it for several months and it bugged me that I never saw all the components together. When I work, I keep throwing the components together to see what they all look like together, but Tim was so confident working from a thumbnail sketch which he'd blown up into proportion. A lot of times you can lose the feeling of the piece going from the thumbnail to the full scale version, but Tim has really pulled it off. What I like most is the sense that this thing could start walking away somehow. Also it has both a traditional and a contemporary feel to it, but doesn't go to any extremes. Some of Tim's earlier work was experimental, but this piece can work in a number of settings.

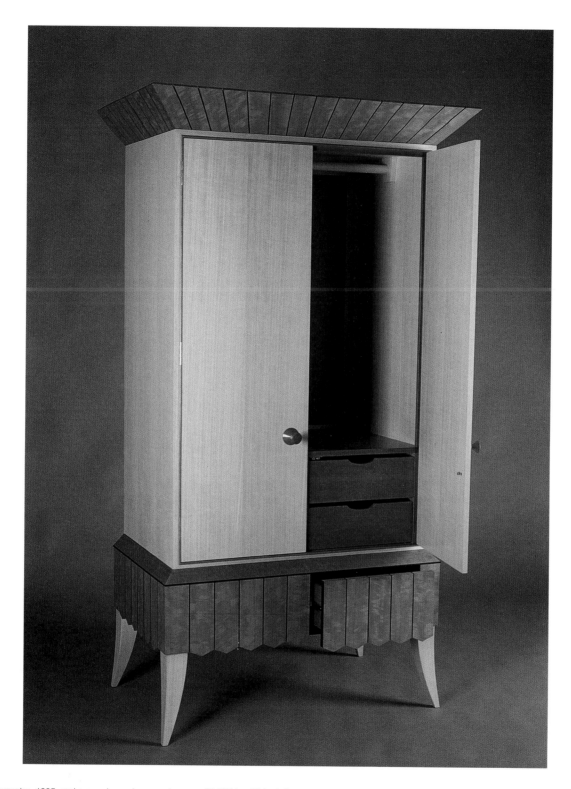

Tɪᴍ Rᴏsᴇ, armoire, 1995, makore, anigre, ebony, mahogany, 24 1/2" by 48' by 84".

Clare Scott-Taggart

Aspiring to be a maker of garden gates and decorative arbours, I was delighted to be given the opportunity six months into my career to design and make a large gate with complete creative freedom. The parameters were to design a gate that would afford some security, provide a screen of the neighbour's yard and driveway, and integrate with the smallish garden without overwhelming it. The wooden walls which created the opening were seven feet high and the gap five feet wide, so the gate is large. My priority was to make a piece that would enclose and add to the garden rather than imprisoning and barricading the space.

The design developed rapidly and simply. I had been interested in the possibilities of capturing a sense of movement using the forming abilities inherit in sheet steel. This had always been my motivation for metalworking regardless, though I usually work with steel rods to try to capture the lines of a sketch, thinking in linear rather planar terms.

The borders of a garden are often little repositories of natural chaos, no matter how finicky a gardener you are. Around large stones in a lawn, creeping along the bottom of a wall and entwined in a wire fence, there are often uncontrollable thick blades of grass for which they invented the whipper-snipper. These wide, flattish, strong stems translated easily into large twisting forms that could be hammered and woven together from sheet steel. So the basis of the design was there, but only through the making could I learn the techniques necessary and see if it would be structurally sound.

At this point I developed full-blown pneumonia, which laid me up for two months and left me weak and feeble for another three. But strength and stamina were necessary to create this gate, which was made of a series of sections drawn on 16-gauge cold-rolled sheet steel and cut out with electric nibblers. The edges were filed, and then the pieces hammered over various tinsmith's anvils, the curves moving in one direction and then inverting to keep the piece relatively flat and to give it structural integrity.

Some sections were six feet high and, while not too heavy, were extremely awkward to work. I would hammer for twenty minutes and rest for ten, slowly getting my strength back. The gate became a battleground and occasionally it would win and I would lie on my studio floor weeping in frustration, trying to think of easier and cleaner ways to make a living. But the gate wouldn't go away and neither did I.

I installed the gate sometime in November on a bitterly cold day and was dismayed to realize it wasn't high enough, though pieces loomed deceptively large in the small studio space. So, back to the shop for further adjustments and add-ons The gate was finally installed to my satisfaction in January. I am particularly pleased with the smooth, undulating forms that twist up into the sky. It is not a perfect piece, but for the amount it taught me about perseverance and risk, it is satisfying.

Clare Scott-Taggart by Stefan Smeja

The individual pieces of this intuitively-directed gate immediately capture the concept of blades of grass. In the first year of furniture at SOCAD, we do exercises primarily in wood, but in years two and three students can pursue other materials. Clare at some point decided that metal was a better medium in which to execute her ideas. In fact, she is the person responsible for us having an optional metal course. Wood involves a subtractive process where things get smaller as one works, but she now works in metal as a pliant medium that can be bent, hammered and shaped and sawn, so one can modify its shape in a way impossible with wood.

I suspect the initial concept came from sketching, and Clare worked through an intuitive process without a final form fixed in her mind. It's not that nailing a piece down before you start to work is better than an intuitive way of working, since each way has to do with the spirit of the maker, a way of working that is true to their own nature. It would be wrong to impose a way of working on a student. With this gate, I like the asymmetrical placement of the opening in a one third to two thirds relationship, the interweaving of the forms, the shadows that are created by the bent pieces, the sense of depth. There are no aggressive points, here but the gate does have a sense of armour because of the metal, and at the same time a randomness that isn't often seen in armour. Also, you can peek through portions, but at the same time it's a barrier that offers protection and keeps people out.

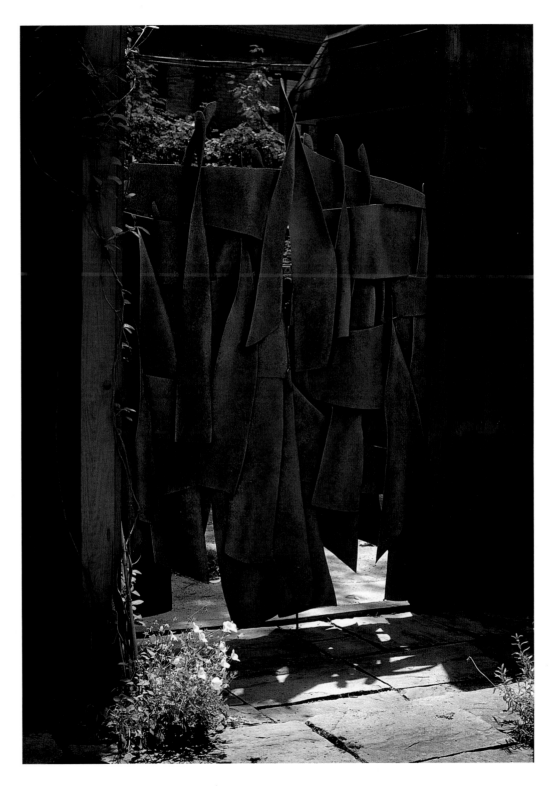

CLARE SCOTT-TAGGART, garden gate, 1996, cold rolled and cut 16 gauge sheet steel, interwoven & welded, 7' high by 5' wide.

Jim Todd

As a functional, free-standing piece of furniture, this armoire has a lower section containing nine drawers, while the upper has two compartments with adjustable shelves. As a form, its most powerful element is the subtle curve of the face, such that it would take sixteen of them side by side to form a circle. The sides are angled into the back five degrees, and the back is slightly curved as well. The whole cabinet rests on elliptical feet which I tiptoed up a bit to complement the bottom curve, giving a gentle lift to this somewhat massive piece. Technically, I wanted, first, to construct an accurate curved cabinet and, second, to orient book-matched veneers to line up with the seams between doors and drawers. Doing this perfectly was the only way to substantiate the visual simplicity. Also, the negative space of the recessed pulls had to remain an accurate twenty-degree ellipse once assembled.

This one-of-a-kind piece fits in with the rest of my work by having an optimistic, levitated personality devoid of distracting decoration on a carefully proportioned form. What I like most is that the inspiration behind the armoire's initial design concept was the spirit of the couple who asked me to create something to put their clothes in. She is a confident, gentle and elegant woman, while he is a firefighter who is building a two-seater plane from scratch. From doing this piece I learned I must stick to my instincts when designing and, also, that the personality of a piece should be the root of the design, and that the task then is to create a physical translation of the concept. It's possible to create without a preconceived notion and say, "Wow!"; but there's more satisfaction when, in the making process, I am forced to re-evaluate my progress in re-affirming my instincts and figuring out where they came from.

I must say that after all the sweat of exact reference points, handling valuable matched veneers, and moving the darn thing around my studio, it gave me incredible satisfaction. Standing in front of a large piece with such impact and graceful lift to it gives me a powerful and focused feeling of confidence. The couple who commissioned the piece have generously invited me to come by any time and visit the armoire to charge my memories and spirit.

Jim Todd by Stefan Smeja

The piece is very mysterious because there is nothing in the exterior that hints as to what might be behind. It could be an entertainment unit, it could be for clothing, so the work seems massive, holding secrets within it. However, there is virtually no difference in the tonality across the front, so I feel a little under informed, though the wood has a pronounced figure to it.

There is a line between the upper doors and the lower nine drawers. For me this line could be emphasized and thus provide more of a break than appears. The element that ties the work together is that the handles are shared between two doors and a drawer in every instance. I see the major activity happening in the lower half of the piece with the handles and the drawers, and the doors being quite spare. The elliptical shape of the feet on the ends tie in with the drawer pulls. I like the gesture of the feet, the arch between the feet that gives this piece a kind of perched quality.

The rhythm on the drawers is nice, they are not all the same size and get smaller as they go up. As the drawers get smaller, it reinforces a sense of two distinct pieces. It goes from larger drawer to middle drawer to smallest drawer to big doors, and the doors do change height as well, since they are taller in the centre and shorter at the sides.

JIM TODD, *Armoire*, 1995, solid Australian lacewood feet, lacewood veneer on medium density fibreboard and flexible plywood, maple drawers, clear acrylic lacquer, 84 1/2" high by 71 9/16 " wide by 20 1/4" deep.

Ingrid Bachmann

Fault Lines involves the simultaneous production of two cloths in two distinct locations — Montreal, Quebec, and Santa Monica, California — that records, measures and transforms information about these two sites into a woven record. Patterns for the two cloths were produced through information exchanged via the Internet during the months of October and November of 1995. Two AVL computer-assisted looms with Internet connections were set up at Galerie La Centrale in Montreal and at Side Street Projects in Santa Monica. Data consisting of seismographic waves was exchanged on a daily basis from one site to the other via modems to the computers attached to each loom. The seismic activity, transmitted daily by the Geological Survey of Canada in Ottawa and the California Institute of Technology in Pasadena, was translated by specially designed software into woven structure. Weavers at each site operated the looms each day, producing a continuous length of cloth that recorded the shifts of the earth and the gestures of the weavers.

Our objectives were the following: to experiment with newer computer technologies and combine them with traditional practices; to ground the electronic experience within the physical and the haptic; to explore new means and methods of generating pattern system; to link disparate sites through the transmission of electronic information; to reconsider boundaries, whether based on geography, philosophy, or media; to introduce digital technology and technologies to new and diverse audiences.

In much of my recent work, I have been interested in exploring the relationship between the material realm of our physical environment and the promise of the immaterial posited by digital and virtual technologies. I have also been interested in exploring new models for art-making which include a more expansive interaction between the maker and the audience. Textiles and new technologies suggest new models of interaction that are broader and more expansive than the traditional viewing gallery. I am interested in the gallery as a laboratory for ideas, as a place to initiate and stimulate dialogue.

I like this piece for many reasons. For one, it is difficult to locate where the piece exists. Does it exist in the process of weaving of the cloth? Or in the interaction and communication involving the more than eighty people who participated in the project? Or in the fifty-foot-long cloths which are now on exhibit as distinct objects? But I think this piece can best be explained through the traditional notion of landscape. "Fault Lines" is a contemporary landscape piece, a mapping of terrain that attempts to include new boundaries. Geologically, fault lines recognize no political or geographical boundaries since they run through countries and continents irrespective off national borders. The Internet also respects no geographical or traditional political borders. It has its own quite distinct, if transparent, borders and boundaries, defined largely by language, literacy and access. Fault lines also no longer adhere to the traditional view of the split between nature and culture. Seismic activity is affected by such human interventions as mine-blasting, subsonic testing, and concentrated human activity.

Ingrid Bachmann by Anne Lemieux

I've known Ingrid for over ten years and she certainly has changed her approach quite a bit. Her work used to be studio-oriented, though she was already collaborating with other people more on an individual exchange, and this is where that earlier work has taken her. When she did weaving as a student, she was influenced by Sandra Brownlee, but this present piece is more involved in a social issue. Although the piece itself is important, it's the interaction with other people that seems to be the focus, more than the finished work. It's a very different way of working, with international involvement in the actual doing of the work. Often one involves others, perhaps in a technical question of how to do a piece, but here you have to be willing to let people interact with you and not be afraid to give other people the freedom to do what they want with the piece, which is very difficult. Most people who are makers are very individualistic and making something they consider theirs. By bringing other people in, it's not all yours.

This approach of Ingrid's continues a tradition of people working together. It could be a disaster too, if people in the group do not want to interact or they don't like what someone else has already done in the process. But this way of weaving does allow for input from other people, which helps one to be creative. It's hard to work on one's own and interaction of this kind can be very helpful.

INGRID BACHMANN, *Fault Lines*, 1995, Telemedia Computer Loom project, installation with computer loom.

Deborah Kirkegaard

"In the dream her foot was thrust into the future
while her elbow nudged the past.
Mount Olympus shimmered in the distant clouds.
Her head floated amongst fiery columns in a surreal landscape.
Spirals twisted slowly into infinity."

"The Dream" is part of a body of work entitled the "Statue Series" and to date there are nine pieces in this series that tells the story of a statue who was "raised in the backyard of a downtown Toronto dwelling, where she grew to classical proportions." All of these pieces are silk-screen printed on cotton with pigment using the photo-emulsion technique in combination with paper stencilling and handpainting. I have a roster of images that make up the language of this body of work. That is to say, the images I have chosen to print with have become the "language" of the series through which each piece "speaks." Narrative, visual content, colour, image manipulation and humour are the key ingredients to understanding the "Statue Series."

"The Dream" is the seventh piece in this sequential series. It was made while I was an artist in residence at the Banff Centre for the Arts. Unbeknownst to me, I had printed the foundation for what was to become "The Dream" two months earlier but had put the cloth away due to lack of focus. Luck would have it that I decided to bring the partially printed piece with me to Banff and, when I pinned it down on the print table, it presented to me a direction of its own. This direction demanded a coming together of the statue's past, present, and future, which is told visually as well as narratively in the format of a poem.

In completing this piece I learned that printing words on cloth adds a powerful dimension to a piece and gives it more "body." Equally as important, I learned not to intellectually criticize what I was making while I was making it, but rather reserve that critical process for when the piece was completed. By one's being too critical too soon, the piece that lies in waiting may never be created. When I look at "The Dream" now, I see that its success lies in the suggestive imagery used to connote past, present and future. as well as the surreal dreamscape that exists at the bottom of the piece to snare the viewer in the web of the poem. The poem performs its function by giving the viewer the necessary clues to piece together the disparate visual elements and make sense of them as a whole story.

With this series I took faith in one hand and confidence in the other and allowed myself to work intuitively. Now I rarely use a sketchbook, as the cloth I print on has taken its place. My work tends to come about because I have a language — that is, a collection of "images on screens" that I use — and something that I want to say with that language. Although my newer work tends to involve more embellished stitching and collaging, silk-screen printing remains the foundation of, and springboard for, my work.

As I explore my role as an artist, one who is a mother of two and still makes art, I find that my "work" has become a lot more personal. My current piece-in-progress is a triptych that celebrates fecundity, pregnancy and childbirth on a personal/collective/cosmic level. In other words, it brings both microscopic and macroscopic symbols to the attention of the viewer and into the dialogue that I hope ensues.

Deborah Kirkegaard by Valerie Knapp

When approaching "The Dream" one is drawn into a drama created around the statue. The narrative is articulated through a skillful manipulation of a series of motifs with the aid of a glimpse of text. Under close inspection you will find a spiral motif peeking out from behind a column. It repeats in an upward motion and appears again subtly, in an almost monotone effect, across the top of the piece, provoking the senses to delve into the layers of printing so as not to miss any nuances of the tale.

An eloquence in Deborah's work is her use of colour. The carefully chosen colour shifts cause the viewer to move through the piece experiencing the subtleties of surface design, the text and the romance. I particularly enjoy the juxtaposition of colour and texture through the use of soft torn edges of her paper stencils, which provide dividing lines between panels of resonant colour.

Deborah works intuitively, developing the design and layout of the piece as she prints. She uses a combination of different sized screens, some with prepared images and several with open mesh, to achieve a variety of spontaneous stencil methods, such as the torn paper. The additive, contemplative process results in a thought-provoking, painterly work.

DEBORAH KIRKEGAARD, *The Dream*,1990,
silk-screen printed/pigment/acrylic paint/cotton, 60" long by 23 1/4" wide.

Valerie Knapp

"Print Studies #1-12" is a series of twelve framed pattern studies. Each study is an individual multi-media work measuring fiveinches by seven inches that is mounted on two layers of silk screen mesh. The mesh is then stretched on the custom frames to provide a floating effect. The studies incorporate sewing, printing and collaging, predominantly, using a wide variety of materials, including acetate, paper, cotton, thread, birchbark and needle-point mesh. I employed standard repeat systems such as random, stripe and grid, and limited myself to the neutral palette.

The studies began as an exploratory, freeing-up exercise to develop new work. I wanted to work in a small, intimate scale and explore new combinations of materials and techniques, so I gathered together familiar materials and tools and introduced new ones. I usually work large and fast, comfortably printing expanses of cloth, but I was craving a change of scale, hence the size limitation. I set about developing new and unexpected relation- ships among this repertoire of stuff, giving my tools and materials new use. While in this process, I intentionally travelled through personal memories and a greater history associated with textile work. I found myself calm and contemplative while layering, piercing, stitching, repeating.

As the studies began to evolve, one led to the next, or at times two or three were in process simultaneously. Ultimately, each study or maquette in this series may represent a starting point for further works. For example, I have been manipulating the pinned piece #6, printing the image in repeat on cloth as is and, by scanning the image into Photoshop, manipulating it again before printing. This initial study has evolved into printed fabrics for a variety of applications. "Print Study #3" uses clear acetate and machine stitching to create a stitched film positive which leads naturally to printing processes

Each piece has a unique resolve and can hang alone, or they may be grouped. When given the opportunity to exhibit the work in "Teachers, Mentors and Makers" in 1996, I chose twelve of the studies and grouped them closely in four rows of three. The uniformity of the framing and the diaphanous mesh mounting system present the individual works as a whole. This deliberate reference to the printing process suggests my relationship with and respect for such materials and processes.

My work is a constant search for new marks, images and relationships.

Valerie Knapp by Anne Lemieux

Most of Valerie's experience has been with printing and clothing, and this piece has a quality of a new avenue, an exploration, a start and not a complete thing. Looking at each individual square, one can see it's a study and that there's going to be development. For a craftsperson, it's necessary to do preliminary work like this, doing studies and exploring to see how far you can go. Each of these pieces could go in a specific direction and one might combine several pieces. But it's a very difficult process to introduce different elements such as the stitching and the pins, and one has to work at it through trial and error.

The good thing about a constant search is that it drives you to make choices to determine what materials work together to make the piece interesting. Sometimes you combine two techniques because you enjoy the process of each technique individually. But one might also use a process that is difficult because it might enhance the piece. Obviously Valerie is welcoming the challenge. That's where Valerie is in this piece, in the initial stage of her process of another personal route in her work.

VALERIE KNAPP, *Print Studies 1-12*, 1996, multi media, 97 1/2 cm wide by 161 cm high.

Anne Lemieux

This piece, "Paysage," is a small weaving with painted warp and that is then screenprinted and partially covered in beadwork. A combination of several processes was used in order to produce multiple subtle effects in light and texture. This effect can be seen by changing one's viewing perspective, with the result of multiple variations of this abstract landscape.

I produced this piece to demonstrate and develop unique combinations of processes for use in later commissioned works. Although similar effects could be created using much simpler processes, these complex combinations produce a depth or presence not possible to achieve otherwise. The extra time and effort put into the design and execution of the piece produces intricate yet elegantly subtle effects.

My primary artistic interest is to present an abstract view of some aspect of my life. The pieces are meticulously balanced by unequal areas of colour and/or texture. Nothing in the piece is equal, but everything is balanced directly or indirectly.

Although this piece stands well enough on its own, it is also a study for larger commissioned pieces.

Anne Lemieux by Skye Morrison

When Anne first came to SOCAD as a student, she had an equal interest in both weaving and printing. But with less prior knowledge about printing, it allowed her to do more exploration. She was always exceptional in paying attention to detail and would take on projects which would require thousands of hours of work, particularly beadwork. This piece shows her interest in metalwork and jewellery. In other words, as both a student and a staff member, Anne has raised awareness and set a standard for the completion and presentation of work in a keenly professional manner.

Anne's themes are driven not by a design mandate, but rather by her own ideas and interpretations of things. There's a tremendous sensitivity and awareness of the material and attention to technical detail here. The goldwork and beading are delicate and impressionistic, and because it appears to be a surface on a surface, you get a definite sense of the material.

Anne would never use muslin cotton, but instead shot silk or something that would bring out the texture and line in a print. Anne would never compromise on anything like material because she is very elegant, which reflects in her work.

ANNE LEMIEUX, *Paysage*, 1991, handwoven cloth with painted warp, screenprinted & beaded, 12" by 4".

Jennifer Morris

"Kaleidoscope" uses a counted cross-stitch, a traditional embroidery technique, on canvas called ada cloth. The canvas is mathematically woven with the warp and weft and has exactly the same count of threads per inch. The piece is worked with traditional motifs. I started working in the middle of the canvas and worked my way out to the edges, worked till I had covered the entire ground of white space with thread. There is one pattern in a fourth of the piece, with the other quadrates mirroring each of the others.

After I had finished the embroidery, I did not block or frame it but just put it away and started a new piece. I actually did this with all my work for about two years, and not until I got to Harbourfront did I start thinking about finishing the piece. I tried many things, but I did not want to frame it because I felt that framing would deny the work was cloth. So I chose to sew ribbons around it to keep the feeling of cloth.

In my mind I had given up textiles when I started this piece. I had been out of SOCAD for about a year and a half and I hadn't done anything of significance since my graduation. I had no studio in which to work and really no money to do anything like the work I was doing in school. In my off time from my job I was bored, so when I looked around at what I had on hand, I found I had a lot of embroidery floss and some ada cloth. I had no pressure to achieve anything, as I wasn't doing this as a "textile artist." I was just doing this piece for me. But my work and ideas began to come together when I started this piece. When I stopped worrying about what I was doing, and why, then I found my voice.

When I first created this piece I did not like it and did not look at it for about a year. Now, I can see many things about it that I like. I feel very close to it as the starting point of all my work that came after. This is the point when I became a mature "artist."

I want the viewer to metaphorically fall into the work. I want her to find more and more as she looks at the work, see more patterns and colours and see how they relate to one another. Maybe some viewers will not see what I am trying to say, but I am exploring the ideas of mathematical patternmaking as in old technology used in rugmaking, weaving and traditional counted cross-stitch. And I am influenced by computers, fractal geometry and chaos theory. When I finished this work, I worried that I wasn't making a big enough statement, since most of the art embroidery that I see is making big political statements. But I now see that my voice is as valid as any.

Jennifer Morris by Skye Morrison

Jennifer has worked primarily in embroidery and printing. She has also studied computer graphics and done all this pixilated and digitized material, and the most obvious translation would be in cross-stitch embroidery like this piece. What's she's done is look at people like William Morris, who did layered pattern and sort of transmitted this into cross-stitch embroidery and made these very small pieces with unbelievable amounts of colour and pattern. She's been working like this for the past three years, and she makes smaller pieces now because the work is just so labour intensive. Still, it's her labour of love, though there's no way of making a living at it. She does it to express a relationship between the pixilated image that appears on a computer screen and its translation into handwork, a literal translation from one area of practice to another. She's a person who loves textiles and loves the sort of tediousness and real time involved because the process of making is part of the creative experience for her. I'm drawn to her use of colour, the layers of imagery, the larger and smaller areas of concentration, the possibility for visual analogies. It's like a very intense drawing which does more for me because it's done with thread.

JENNIFER MORRIS, *Kaleidoscope* (detail), 1992, counted cross stitch embroidery, 46 cm by 33 cm.

Skye Morrison

This kite is the signature piece from the exhibition "Flying Carpets" held at the Russell Gallery in Peterborough, Ontario in 1995. The exhibition of Edo-style hand-dyed silk and nylon kites came about mainly as part of my sabbatical journey to India and on to Malaysia, Indonesia, and Japan. The theme of this kite in particular comes from a visit to St. John's, Newfoundland, in 1974, where I met folklorists, storytellers, poets, fishers, and craftspeople. The kite depicts scenes from travels in Newfoundland and is my prayer that the cod stocks will be replenished and the lives of the people of Newfoundland will be celebrated as a whole again. It is silk-dyed spinnaker nylon and uses graphlex rods.

I made my first kite as a student at the School of Crafts and Design in 1969, inspired by local kitemaker Ken Lewis known as Mr. Kite Canada. For two weeks we worked on our kites and I made an orange delta kite out of acid-dyed nylon, but my first effort looked like Swiss cheese because I miscalculated the acid in the dye bath. Persistence paid off and the final kite was the desired colour. It flew like a dream. This experience led me to make more kites as one form of expression when I attended graduate school at Cornell University. A year of teaching brought me into contact with kitemakers all over Great Britain and Europe, and to this day, kitemaking, flying, and researching have continued to be a significant part of my professional and personal life.

It is important that the kites I make fly. They offer a perfect design problem, combining the challenges of utilitarian function with the spirit of imagination. They give people a "kite smile," the pleasure of seeing something playful that works.

Skye Morrison by Anne Lemieux

Skye uses a lot of historical references and much of her work is influenced by folklorists. There's a historical point of view here, with the border and the swirl shapes, and the piece looks like a carpet because of them, while the main shape looks like the entrance to a temple. I am probably thinking of her reference system first before the piece itself, since I've known Skye and her work a long time. People continue to explore, but one eventually gets a style that always reflects in one's work. I always know if a work is Skye's just by the colours that she uses, and she usually also works within a kite format, though this shape is more like a banner. Usually she uses a lot of bright intense colours.

I wish sometimes that I could make myself do bright, cheerful colours like this. Skye mostly does silk painting, a direct application that is not very forgiving because it's a one-shot deal. You do the resist and then you paint it. You can retouch things, but retouching comes out as retouching. In the end, you have to look at this work a while to see all the details since Skye has little stories happening all over the place. She has a Ph.D. in folklore, and so the storytelling connection is definitely here.

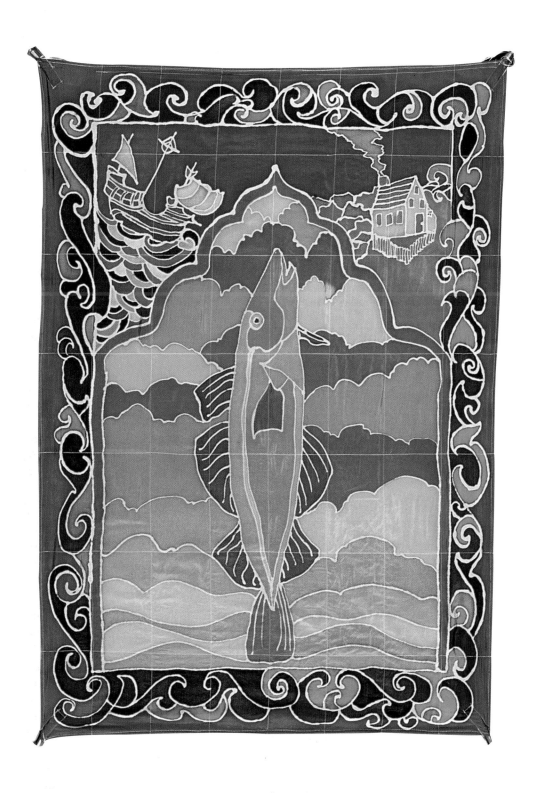

Skye Morrison, *Cod Peace, a Kite for the Fishers*, Edo style kite, 1995, resist-dyed silk laminated to spinnaker nylon, graphlex rods, 90 cm by 115 cm.

Loree Ovens

You are looking at approximately twenty-five hours of hand silkscreen printing. The texture was created through a series of intense line drawings and although the finished size of "Urban Dwelling" is nine by twelve inches, it consists of seventy separate screenings. The original colour of the cotton was white, and each colour was mixed separately as the piece developed. I used a water-based pigment system which becomes permanent when exposed to heat. "Urban Dwelling" is a wall piece intended to be viewed as one would a painting.

I view myself as a surface designer, my specialty being silk-screen printing. I enjoy working both large and small, and my work tends to have an architectural flavour combined with intricate line sketches. Often the work is full of vivid colours, other times it is very subtle. All of the work is very detailed. Often the design is developed with one pattern which is tightly placed into a narrow repeat. Other times it is over printed, creating several layers to achieve the desired effect. This practice often encourages experimental techniques.

"Urban Dwelling" is the third and most recent piece I have completed in this format. I tend to work abstractly and I am challenged by creating my own sense of imagery. Here the viewer is inspired to use her imagination to react to the work, and often I am told the piece reminds a viewer of a trip somewhere across the ocean. I find this reaction exciting, as I personally have done very little travelling — yet.

In order to print in this technique, I have spent many hours creating textures that harmonize with one another. Each of these designs has been transferred on to silk-screens. "Urban Dwellings" was created through paper-stencilling and collage techniques, and even though it has been printed, it is a one-of-a- kind piece because only the textures are registered onto screens.

Unless the work is for a specific client, the overall design before printing may only consist of general outlines and a limited colour palette. Rendering every detail ahead of time is possible; however, this is extremely labour intensive. Another difficulty is that the pigment system is based on a slightly different primary source than that of regular paint such as gouache. For example, instead of red, yellow and blue, the primaries are actually magenta, yellow and turquoise. Black works for toning as white does for tinting; however, white can also be used to block out areas, since it is extremely opaque. Colours also play on one another, and if, for example, yellow was first printed and blue was printed on top of the yellow, the area that overlapped would read as green. When pre-planning on paper, all of these issues must be taken into consideration, as they can quickly alter the aesthetics of the work.

In the end, I am fairly content with "Urban Dwelling," though there are always areas to improve in any work. I tend to be a perfectionist, but I have learned that when things aren't going well, sometimes it is best to take a short break and then complete the piece. Perhaps, when executing the next work, these weaker areas can be focused on. With this attitude, I can see the style of a piece progressing, rather than stopping altogether when problems arise. I am very inspired by this series of work and eager to see how it develops

Loree Ovens by Valerie Knapp

Loree's interpretation of the city as playful and colourful is refreshing. The work speaks of the vitality we thrive on in our urban environment rather than the depiction of decay and conflict so often made reference to by the media.

Architecture provides a theme in Loree's work, and the attention to elaborate detail in a small scale is central. The fine line work initially obtained by drawing is transferred to the silk-screen, then through many printings and colour changes the work is developed. The energy created in this concentration of pattern detail, combined with provocative colour, presents the viewer with a miniature fantasy cityscape.

Loree has achieved a sensitive balance between planning and spontaneity in this work, which is perhaps also the essence of city life.

Loree Ovens, *Urban Dwelling*, 1996, silk screen print on cotton, 9" by 12".

Sarah Quinton

I see these works as a lyric response to the language of the textile. The supple, sensual nature of cloth is expressed through darted, pleated, draped and folded configurations. Materials that can be characterized as both natural and industrial — such as wood moulding, waxed linen, woven cotton ribbons — are hand worked into abstracted "natural" forms, into sculptural shapes that are mediated by the body of the viewer. These forms have evolved from an abstraction of the human physique toward a more specific reference to the female form and a desire to be recognized as a part of the "natural" world. Works such as "Ivy," "Hazel" and "Lily" of 1990 are aimed squarely at locating these textiles, and their production, in the realm of the sensual.

Playing out certain tensions between the geometry of the structure and the organic or botanical patterning in the painted surface, "Black Tulip" of 1992 and "Acanthus," are indications of my interest in the interconnectedness of cultural and natural systems, and of nature's role in our collective search for beauty and identity. The cultivar, such as the black tulip or the blue rose, strikes me as a poignant metaphor for this search for perfection.

I see many layers of connections between plants and flowers and historical and contemporary decorative arts. Sources for my own work include William Morris's textile designs, bits of "found" lace, printed paisley motifs, wallpaper patterns, unicorn tapestries, historical design compendia, and architectural ornament. In the case of "Acanthus", the motif is derived from a fifteenth-century Italian cut velvet.

My studio work embraces cultural meanings, pure forms, and symbols that have been attributed to certain flora by way of the visual arts, sciences, applied arts, and domestic production such as garment construction, sewing, decoration and other sorts of handiwork.

Sarah Quinton by Anne Lemieux

I like this piece as an object, probably because of the wrapping with sticks she uses, making the piece more like a shield. This piece tends to contradict my expectations, but I'm attracted to the work for several reasons: the wrapping process she has used, the shape, and especially the minimal look of it. There's a subtlety of patterns here that you see when up close. This suggests a reality of the maker giving out subtle messages.

But it all depends why a person makes things and the reasons are many. One can create to sell or to give out a message or to reproduce a message in one's head in order to see it. Personally, the main thing for me is the piece itself, and if it moves me, I live with my own response rather than read the artist's statement. What I also like in Sarah's piece is that you have to indeed look at it, carefully, and study the motif to see it so that it involves you. It looks a bit African and I'm attracted to that kind of work. As well, I like the process she has used, just wrapping, wrapping, wrapping, a continuous thing.

Sarah Quinton, *Acanthus*, wallhanging, 1994, wood moulding, acrylic paint, waxed lacing tape, cotton tape, 120 cm by 55 cm by 18 cm.

Carol Sebert

This carpet is an example of work I do as a principal of Creative Matters Incorporated. Working with designers and architects, I try to match the needs and desires of the client with the creative vision of the interior designers. In the process, I consider how the room will be used, what type of traffic the carpet will be subjected to, the budget, and much else. In this case, the result is a custom, handtufted wool carpet, nine feet six inches by ten feet six inches, made in Thailand.

At the outset, the client wanted "something with a Deco feeling, yet contemporary, with soft colours." The process began with a consultation at the residence which allowed the client to look through the portfolio of past rugs we had designed and to discuss the criteria. Several colour sketches were then developed for consideration. After selecting the most appropriate design, a rendering was then painted with gouache, at a scale of 1 1/2"=1'. The paint colours were mixed accurately to reflect the wool samples, as this conveys the finished look of the carpet, and was reference for the mill to manufacture from.

Like a topographical map, on acetate over the artwork, I indicated the combinations of colours to achieve the desired graduation and overall softness of colour. As well, the techniques were specified, and in this case, most of the carpet is level-cut pile with a velvet-like finish, and carving to make clear definitions in the large pattern. The narrow blue lines are a lower loop to add a casual element to the surface. An eighteen-inch-by-twenty-four-inch sample was made at the mill in Thailand for colour and sample approval, and then carpet production commenced for twelve weeks.

I am especially pleased with this carpet because it suits the place for which it was designed so well. The effect is a carpet which is understated and which complements the other design elements in the room. My goal is always to solve the design problem with creative and practical solutions for clients, both residential and commercial, that will enrich their lives.

Carol Sebert by Valerie Knapp

Carol's rug is the strongest decorative element in the intended interior setting, and this essentially gives the room a provocative graphic design element. The client wanted a design influenced by Art Deco, but with a contemporary edge. Carol gave the traditional use of border design a modern look by using asymmetry. Part of the focal point of one corner is repeated on two opposing sides, unexpectedly. The sense of mechanical movement captured in the circles, resembling clockworks inside a watch, is reminiscent of the Deco period, of a move to modernism.

The bold scale of the motifs is challenging and demands attention. There is continuous movement in the circular shapes and the spirited points zigzagging around them. A lower loop pile was used in line work for definition, and carving gives other surfaces a three-dimensional sculpted effect.

This active and dramatic design has been skillfully toned in subtle gradations of a neutral palette in the most sumptuous pure wool, allowing the vitality to be tamed enough to rest comfortably with the client's natural furnishings.

CAROL SEBERT, carpet,1994, handtufted wool, made in Thailand, 9' 6" by 10' 6".

Larissa Swan

This detail is from a series produced for ironing board covers, which was inspired by a turn-of-the-century household management book. I chose to integrate historical and nostalgic elements with contemporary ideas to create a visually layered and functional piece. I hoped to make something that could be appreciated by both craftspeople and non-craftspeople. The use of domestic imagery and cloth, which is part of every person's life, provided a means to bridge this gap. All the imagery was produced on acetates and then shot onto screens using photo emulsion. The art work was then scraped and printed onto unbleached cotton using Remazol fibre-reactive dyes.

I approached printing the ironing boards with small screens and a collage technique. The small screens enabled me to sustain a fresh and spontaneous quality and work simultaneously on the foreground and the background. I strove to create each cover different from the last, even though they were intended as production pieces. Each ironing board cover, therefore, developed as I printed and allowed me to challenge myself through experimentation with colour and placement. Changing one or part of these elements can give the work an entirely different look.

Colour is just as important as the imagery in my work, whether it is monochromatic or bold. The ground here has been coloured and treated to create an aged quality and to simulate a stained, well-used surface. The text is faded in parts to complement the colour treatment.

I strongly believe in the functionality of art, whether it is used for utilitarian purposes or functions as a wall piece, to be enjoyed. I chose ironing board covers because the board itself is often left out in the home. Often thought of as an eyesore, this object is a visually stimulating cover that is thus elevated to part of the home decor. My objective was to create something to satisfy one's visual senses in the performance of daily ritual, as opposed to something that is precious and only appears on special occasions.

Larissa Swann by Skye Morrison

Larissa uses narrative literally, with lots of words and imagery in juxtaposition, which I've always enjoyed. It reminds one of collage work from the twenties, when people were using newspapers and bits of cloth together. Larissa has studied fashion design and has a strong sensitivity to the materials she uses. She always uses the appropriate material or chooses a job that relates to a specific fabric. Her type of sensitivity and awareness is not just at the graphic level, but at a visceral level where she understands how the material will behave. It's not a quality that is necessary for everyone, but it is helpful when you get the piece right graphically and also have it augmented by the fact that you've used the appropriate communication tool. When we had a sale at SOCAD, Larissa's ironing board covers were bought mostly by other textile people, who really like them, and that means a lot about her work.

The year 1995 was Larissa's indigo year. She was madly in love with indigo, but I never sensed at all that she was making reproduction Japanese indigo textiles. She's a person who can take all different kinds of information and sort it out and put it down in her own way, rather than trying simply to be different. She's not a follower of rules or bounded by rules. The materials and processes may come from a number of traditions, but Larissa's work comes from her own experience. I respond to her work because it has content that is driven by meaning as well as craftsmanship.

brushing it at the same time with a soft brus
look as nice as new.

Wrinkled Silk.—Wrinkled silk may be rende
beautiful as when new, by sponging the surface
solution of gum-arabic or white glue; then
wrong side.

To Make Cloth Water-Proof.—In a pail of s
half a pound of sugar of lead, half a pound
this at intervals until it becomes cool; then p
other pail and put the garment therein, and l
twenty-four hours, and then hang it up to
wringing it.

To Color Kid Gloves.—Put a handful of
bowl, cover with alcohol, and let it soak until
—one day, perhaps. Put one glove on the han
woolen cloth or sponge into the liquid, wet
over, rub it dry and hard until it shines, and it

LARISSA SWAN, ironing board cover (detail),1995, unbleached cotton, screenprinted, fibre-reactive Remazol dyes, 16" by 11.5".

Christina Swerdlow

Demands of a fast-changing industry, rapidly expanding technology, and the constant increase in commercial competition challenge today's textile artist, however specialized, beyond the pleasure of creative expression and presentation of visually attractive patterns. The chosen field of volume-oriented design assumes the artist's acceptance that the individual work, although complete in itself, is but a component of a much larger, complex creative process whose interrelated base objective is the success of the final product. In today's business world success is controlled by sales and profit.

Future fashion direction is dictated one to two years in advance, and research of future trends is an integral part of a designer's responsibilities. I have learned that a truly successful commercial print relies on the artist's ability to combine fashionable stylistic tendencies with originality, visual sensitivity to colour and elements, as well as professional consideration of form and proportion as a unity resulting in strong commercial appeal.

My pattern "China Beach" fills all these requirements. It outsold most of my designs and it became the catalogue cover print for Christina Swimwear. It generated high sales for my customer, which in turn generated many repeat orders for my company.

My appreciation of "China Beach" lies in the print's relationship to pattern, colour, and garment form, all of which are responsible for complementing the female body shape, which is "China Beach's" fundamental task in its end use.

Christina Swerdlow by Skye Morrison

Christina's direction was clear from the start when she came to SOCAD: she wanted to be an industrial textile designer, and she worked doggedly at it. She has since learned the industry from the ground up and has become the top industrial designer graduate of our textile program. For seven years at Go Indigo, a textile converting company in Montreal, she has organized and supervised designers, maybe done some designing and colouring herself, and then taken the work to the factories to have it reproduced and then delivered to the company. Her company has opened an office and studio in New York, she travels to Paris several times a year, and her role is to coordinate and facilitate and buy textile designs for various clients.

Christina never wanted to be a craftsperson working in her studio and selling at crafts fairs. And though crafts students sometimes say they don't want to, for example, do Teenage Mutant Ninja Turtle bed sheets, she says she wants to get exactly the right green and it doesn't matter if it's on a Ninja Turtle or on a leaf of a beautiful flower, since both are part of being a good designer. This work is floral and not geometric in any way, a swimwear design. These are the four colour ways and also an example of the fabric, which is a print on swimwear material. It's lively and cheerful and appropriate to its use, and the pattern's not too large. It demonstrates a confidence and understanding of all aspects of surface design.

This work is creative, with really specific boundaries, since it was taken out of her hands so a printer, a colourist, a chemist, and a finisher all worked on it. It's not Christina's in a signature way like a painting, yet she's had input at all stages of its production and they are going to print over ten thousand metres of the stuff. So Christina's work affects the design world and is something we encounter on a daily basis.

CHRISTINA SWERDLOW, *China Beach*, 1994, textile print on cotton (82%) & lycra (18%) material.

Barbara Walker

After spending a year at the Banff Centre, three years at SOCAD and a number of years trying to survive in the craft/art world, I at times tire of the critical atmosphere that governs this particular environment. I often find people pay more attention to the intent behind a work, rather than the work itself, and rely on theoretical objectives to explain their work. I also get frustrated with the pressure to validate my work with theory, rather than the work being accepted on its own strengths.

In 1987 I saw a concert by Texan singer-songwriter Guy Clark, and the impact stayed with me long after the performance. He sang a song entitled "Home Grown Tomatoes" and both the performance and the song held tremendous resonance for me. It was simple, sincere and honest, and lacked the pretense, arrogance and artifice that is sometimes so prevalent elsewhere. His voice and his songs have a purity and honesty about them. His issues are often simple and straightforward, but there is such clarity in his sentiments. In making this piece I hoped to emulate the directness of Guy Clark's performance.

I also used the image of home-grown tomatoes as a literal inspiration for this piece. A garden is a rich and complex domain of many greens, with splashes of alternate colours interspersed here and there. A garden is full of textures and much detail and, like weaving, gardening is meditative and creative. Like a garden, a work of weaving grows slowly.

In my work I try to create depth and movement through the composition and interaction of layers of lines, marks, textures and colour. For me weaving is a form of drawing. I use the formal elements of the weave to develop my vocabulary of "markmaking," and do much of my designing while at the loom.

The nature of my weaving is that only six to eight linear inches are visible at any one time. By the time the weaving is complete, I usually have extremely high expectations for it, and with all my work, my initial reaction when first taking a piece off the loom is disappointment. After my initial letdown, I live with the work for a while and gradually soften and see its successes.

With "Home Grown Tomatoes" I really like the variety of movement and play of line in the piece. I find many of its small details very successful, partly because they are balanced effectively with the stronger composition of the piece. Detail is always very important to me and the borders, the quality of line, the finishing are all aspects that add to the complexity and integrity of a piece, and help to make it complete.

I finished this piece over nine years ago and still see it on occasion. Like the performance that inspired it, this piece has a directness of spirit that still resonates for me

Barbara Walker by Valerie Knapp

The analogy with cultivation is really played out in the patterning and the layout of this piece. Carefully divided, reminiscent of the patchwork quilt, or as farmers' fields in the countryside, the weaving presents us the land. The shades of green resonate of growth, and the subtle hints of waves moving through are very musical-like sound waves. As I take my time travelling through the depths of colour shading, exploring the curvaceous lines, I pause at the bright strokes that energize and enliven, I feel refreshed and almost transported to the garden.

Sensitive colours and weave selections within each isolated area present the viewer with a variety of surface effects and a richness one can only achieve through the weaving process. At the same time the deliberateness of line and shading reveal her weaving as a form of drawing.

Barbara's work is technically masterful and it speaks to me of a concern for, and the importance of, the natural world.

Barbara Walker, *Home Grown Tomatoes*, 1987, hand dyed linen & cotton, 70" by 40".

Brad Copping

The wooden element is made of eastern white cedar from my family home near Dunsford, Ontario. The piece of wood was taken from a spot in the tree where the trunk divided into two, creating a natural split. The wood has been carved into a spherical form, split into two, and hollowed out. Wherever a glass element sits, a hole has been drilled through the surface. The interior has been burned, and sealed with urethane both inside and out, and the two parts reconnected.

The glass elements were formed in several steps. Hot glass was gathered onto a solid metal rod and elongated and manipulated into a "root" form. More hot glass was then gathered on the end of that root and was inserted into a graphite mould to create the "house" form. The combined form was then annealed. Once cooled, the root end of the glass element was carved using a diamond saw blade mounted on a water-fed brick saw. A wire brush wheel-mounted on a bench grinder was used to clean the carved glass. The glass elements were arranged so that the roots pointed into the centre and were siliconed into place.

"Rooted" questions the permanence of our attachment to place, the fragility of the place itself and the fragility of the manifestations of our attachment. It points to common desires that can bind and/or destroy. This piece fits in with the rest of my work in its material composition, as well as dealing with ideas about change and our relationship to the natural world. In creating "Rooted" I learned something about using glass to construct a base or support structure which is integral to the piece as a whole. While it appears to have an orientation, it not only denies the labels front and back, but also top and bottom. The piece might be understood and appreciated on a formal level or by examining the various elements and their interrelationships. It's a good piece.

Brad Copping by Rosalyn Morrison

Brad Copping has successfully developed two distinct approaches to his work. The first is influenced by where he lives, in a highly wooded part of the province, and by his lifestyle, spending a great deal of time in this wilderness. The second comes from an extraordinary talent for making highly stylized domestic objects with an urbane sense of design.

"Rooted" is part of a series inspired by the aesthetic of SOCAD instructor Kevin Lockau. Gathering ideas and materials from his surroundings, Copping explores the theme of change and our relationship to the natural world, sensitively creating pieces which reflect both cautious optimism and growing anxiety. This compelling piece is part of the d'Amour collection of the Musée des Arts Décoratifs de Montréal.

Copping's functional items are reminiscent of Art Deco, especially the work of Rene Lalique, in their line, form, and surface treatment. He produces a striking line of vases, goblets, bottles, and candlesticks which are blown then carved and sandblasted. A very contemporary look is achieved through his choice of densely saturated colours — magenta, lime-green, deep purple — and in the exaggerated scale of some of his designs.

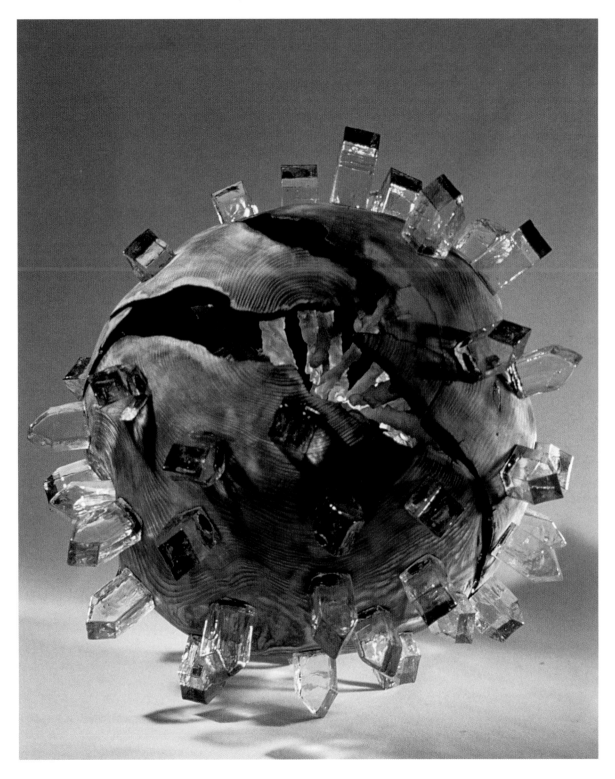

BRAD COPPING, *Rooted*, 1994, cedar, hot worked and carved glass, 21" diameter.

Daniel Crichton

Over the years, my work has continually made reference to the natural beauty of the earth's minerals, their forms, as well as the processes which combine to create their reactive patterning. As vessels, they are intended to be simply self-referential; that is, they are neither symbolic nor conceptual in nature. I see them as being closely identified with the Earth, in that the same chemical and physical forces have been working on them, artificially on a small scale. I often feel like an intermediary in this process, translating from nature's palate. However, I would like the end result to be a cause for reflection and contemplation of our existential condition, not transcendence or escape into fantasy.

My work as a vessel-maker has not been driven by new trends or technical virtuosity, but by a search for an inner voice, a place of equilibrium in an increasingly opaque and paradoxical world. Arriving at a personal understanding of the complexities of the opposition forces of hard/soft, light/dark, interior/exterior, base/closure is an essential point in the development of the art of the vessel-maker.

I have always experienced the vessel form itself, regardless of the medium, as a symbol of warmth and compassion, primarily in consideration of its ongoing association with the everyday affairs of humankind. On a higher level of refinement, the painterly, sculptural and textural qualities of the vessel merge with its historical functionality, affording an accessible and often more intimate aesthetic to the participant. To this end I have focused on forms and surfaces with ancient roots, as far back as the Egyptian and later Roman glassmakers, and as recent as the modern revival in early twentiethth-century glass, the crucible and the core form amphora.

As opposed to the exuberance and virtuosity of Venetian vessels, the amphora, as a vehicle of essences, was an unaffected and understated form. Its translucent or opaque surface, often rich with multi-coloured pattern, made reference to precious stones and minerals of the land. These simple forms have a presence which is free from the world of interpretation and illusion, perhaps offering a kind of symbolism at a subliminal level, layered within the folds of the coloured glasses.

In like manner, my pieces, while gathered from the furnace clear and brilliant, are taken off the puntil in dense opaque and translucent colours and geological textures. I tend to use glass like a precipitate or solvent, as a material which naturally bonds with and, in some cases, dissolves metals, minerals and oxides. Mediating the natural forces, I layer the wall of the vessel, then erode it.

Daniel Crichton by Rosalyn Morrison

As head of the glass studio at SOCAD since 1979, Daniel Crichton has been instrumental in developing a comprehensive educational program for the glass arts in Canada. The current curriculum includes twenty courses ranging from architectural casting to glass history. Crichton has also been responsible for the planning and development of the school's internationally recognized glassmaking facility.

In 1988, during his participation in a touring exhibition and workshop in Finland, Crichton instigated a student exchange program between SOCAD and the University of Art and Design, Helsinki which, by facilitating over 30 year-long exchanges, has enriched the program and possibilities for his students. Crichton has also liased with his gallery connections in Montreal, Toronto and Boston, thus providing third year students with an important introduction to professional practice.

One of Crichton's most valuable contributions to the glass arts community has been his role as mentor. He has nurtured the talents and ambitions of a diverse group of students who have become leaders in their field. The late François Houdé established Espace Verre, the Montreal glass school. Laura Donefer, who has lectured in many countries, acts as an international ambassador for Canadian glasswork. Alumnus Jeff Goodman has led the way in developing long-term collaborations with architects and interior designers.

Since winning the prestigious Prix Saidye Bronfman Award in 1994 for excellence in the crafts, Crichton's commitment to his own work has taken on a renewed energy. This recent body of work, with its finely honed forms, impressive increase in scale, and a refined handling of colour and surface texture, is a masterful collection. His work is in many public and corporate institutions, including the Canadian Museum of Civilization, Musée des Arts Décoratifs de Montréal, Winnipeg Art Gallery, Musée du Québec, Imperial Oil, and Alcan Aluminum.

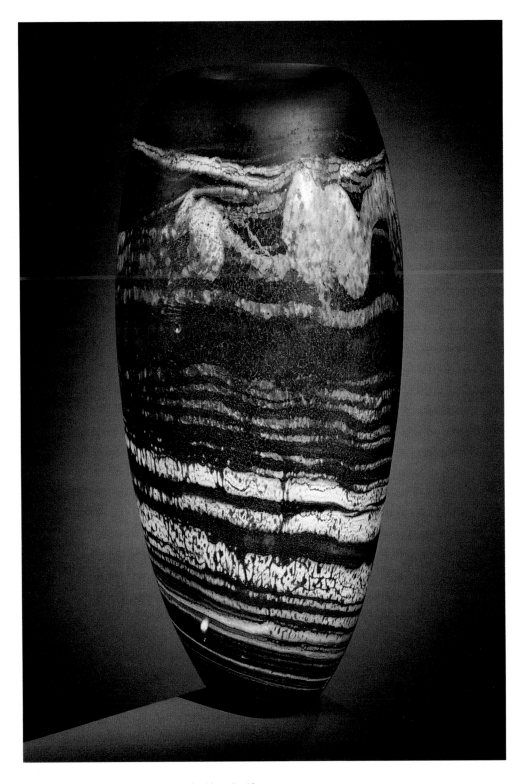

DANIEL CRICHTON, *Metamorphic Vessel*, 1996, rose quartz, 44 cm by 19 cm by 19 cm.

Laura Donefer

In the late '80s I worked on a series of shields, and my favourite is "Kali-Black Mother Time." Normally, a shield is what we use to separate and protect ourselves from something undesirable, but mine are reversed. They represent what is locked up inside our core, what we keep separate from others because we have been conditioned not to reveal, or even accept, all aspects of ourselves. With these pieces I was protesting women being perceived as merely the sum total of their body parts, thinking to get away from this stereotype we have to deny our sexuality and our sensuality, an integral part of our makeup.

I wanted these shields quite large and up on the wall, so that the viewer had to have the glass body parts in their faces as part of the experience of confronting the issues that I was exploring. "Kali" is five feet by five feet and the largest shield. "Hexenhammer Thrown" was ten feet by eight feet, so size was important. But I had to learn to work quietly because my landlady in Toronto worked below me and every time I used my jigsaw or hammered, she would yell up through the floor, "Laura, VAT are YOU doink NOW?" I learned you could up the scale of your work as long as you had the desire and a place to do it in. Now I live in the country and make all the noise I want because I have a huge messy space to make big work in, if I want to.

My work concerns the unification of the earth-spirit with the human inner core, the marriage of molten glass interiors cooled to take on the vibrant colours of the life-force. The search is for the primal voice that begs to tear itself out of the body and howl. While making my work I seem to involve my entire physical self, and "Kali" was no exception. I remember rubbing tears and blood into it. I remember getting myself covered in paint and rubbing my whole coloured body onto the surface to add colour. I interact on many levels with what I am creating, and I think that is why I love this piece so much: a good chunk of my own inner core is incorporated into this piece.

I work with found natural material that I integrate with the glass components, and this particular piece uses bones, dried kelp, sticks and dried raffia, as well as glass, the glass body parts, all bound onto a gauged and painted board. It is difficult for me to be really objective about this piece because too much of me is in it. I'd like to tell people to hold this shield up tight to their body and show the world their hidden secrets.

Laura Donefer by Daniel Crichton

In the realm of multi-sculpture, Laura Donefer is one of the best in Canada using glass as a primary medium. Laura takes a provocative and often emotive point of view in her work, challenging the stereotypical perceptions of a woman's body and spirit. The shield is an expression of her anger, and her conviction to say what she wants to say, to be who she wants to be without the stifling social norms that have been largely developed by men. The colour treatment is dramatic and energetic, the work being grounded in a primitive anthropology that comes from the core, from the wild and vital root of basic instincts.

You start to look at the details here and quickly realize that the piece is meant to confront you, even jolt you into a response and a questioning. Laura's use of media is personal. I know that there is glass here, though the uninitiated might look at it and ask about what materials have gone into the piece. They'll recognize the pigment, the bones and sticks, but they wouldn't necessarily know that there's blown glass here, layered in molten colour and texture.

There's so much raw power in this work that it's difficult to take it in all at once. One has to look at it for a while and then return again repeatedly. Viewing it this way, I reflected on Laura's words about women's control over their lives and ownership of their bodies. In this piece I feel that she's demonstrating how this power can be reclaimed by works of art that are rooted in a sensuality and mystery, not just in intellectual essays.

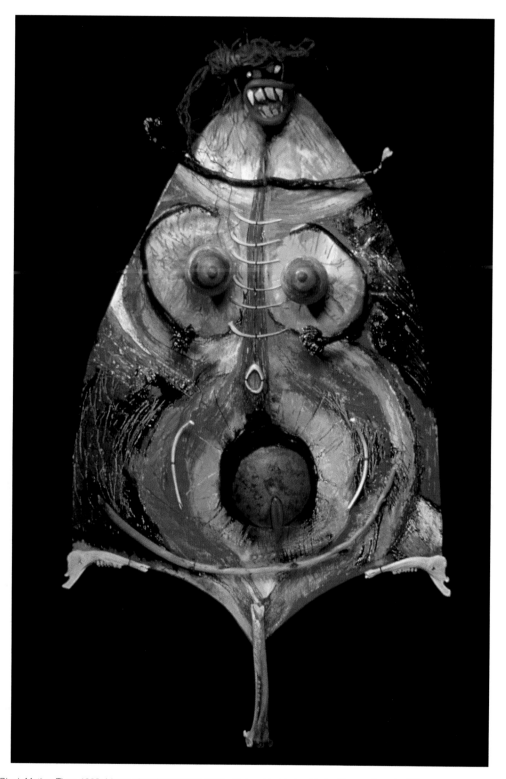

LAURA DONEFER, *Kali-Black Mother Time*, 1989, blown glass body parts, bone, sticks, dried kelp, dried raffia, acrylic paint 5' by 5'.

Susan Edgerley

Between 1988 and 1993 I created and realized a series of large-scale sculptures entitled "Scarecrows" which relate to the complexity, interpretation, and understanding of the human condition. "Nest/Flight/Bird/Me" from 1988 is a mixed-media work from that series. With these pieces, the form, scale, materials, and approaches were chosen to reference, through metaphor, the many human states of being. In "Nest/Flight/Bird/Me," the piece is poised for flight. The apparent fragility, precariousness, and ethereal qualities offered a contrast to the rusted metal barbed-wire, wound and caught, which keeps the work both physically and emotionally grounded. It is a poignant autobiographical piece which contrasts dreams and desires with realities lived and faced.

The development of these sculptures took about a year of reflection, drawing, writing, and reading, to allow me to be able to explore the richness of the theme's potential and imbue the works with layered meaning. The ongoing need to express the incredible complexity of the human experience was the spark which began this voyage, and all the choices and decisions made followed that moment. "Nest/Flight/Bird/Me" was and is a pivotal piece for me in many ways and taught me a lot about scale, visual balance, the relevance of every detail to the whole, the rich dialogue of materials and history, and particularly about creative courage, risk-taking, and trust. This piece fits in consistently and perfectly with all the rest of my work, yet, at the same time, stands out because of its impact on my own creative development and personal relationship with my work.

"The Scarecrow Series" was a great adventure, a very ambitious undertaking. Having never worked in a large scale before, and with so many new and different materials, my capabilities were stretched and challenged. To realize many of the elements of these sculptures, I worked for the first time with another artist, Donald Robertson, and this was a most enriching collaboration, one which benefits me still. But it is always alone, in the silence of the studio late at night and carefully deciding on the appropriateness of a detail, that my sense of connectedness and well-being with my work becomes my most cherished moment as a visual artist/craftsperson. In "Nest/Flight/Bird/Me" my relationship with the piece was so direct that, once the work was realized, it was as if the piece had made itself, and I felt as light as a feather.

Sometimes beauty is found not in what is evident, but in what is hidden underneath. When people talk to me about my work, they always mention how it reminds them of something they have felt, experienced, or even imagined. I like when this happens because, at the edge of every association, it is confirmed that there is an element of truth in my reason for making what I make. And now we have been able to share something which is important to us both.

Susan Edgerley by Daniel Crichton

In approaching Susan's mixed-media work you will see paper that looks like glass, glass that resembles ice or stone, and metal that could be either. There's a definite sense that all are chosen very carefully and then fully integrated into the piece. Susan has been successful because she has the ability of a poet to draw out the essential qualities of these materials while representing her feelings and thoughts clearly and with depth.

Perhaps it is the ambiguity about materials which attracts me initially, but it's the subtle handling of the metaphor of the journey and flight in this sculpture from the *Scarecrow Series* which holds my attention. The understated sensibility which is characteristic of Susan's work allows for discussion and encourages the exploration and participation of the viewer. Meanwhile the scale and balance of the form are challenging and would have certainly presented difficulties in assembly.

It is often the best artists, however, who are able to draw simplicity out of complexity. Susan's balanced use of materials invariably results in her pieces resonating with one clear voice. Perhaps all good art works because of the ability of the artist to provide the right sort of visual and tactile information, i.e., forms, surfaces and imagery that connect with the imagination and lived experience of the viewer.

The figure of the scarecrow, with its precariously balanced, asymmetrical human dimension exists on the boundary of the material and the ethereal. In the final analysis, there is a spiritual and deeply human quality about this work that moves me and speaks in a gentle voice that I can nonetheless hear clearly.

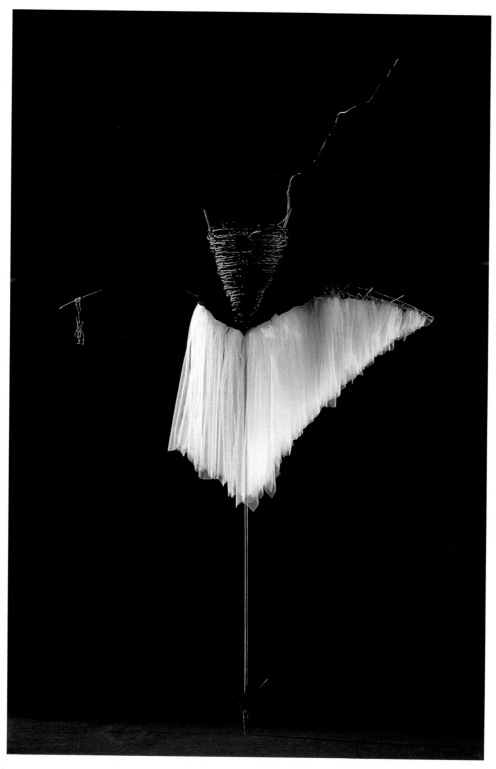

Susan Edgerley, *Nest/Flight/Bird/Me*, 1988, gauze, copper, barbed wire, steel, 216 cm by 127 cm by 27 cm.

Ian Forbes

This piece is actually representative of a body of work and, although the work is dated 1992, I feel it is the best work I have done to date. It is simply a bottle, one which deals with the relationship of form and colour. The technique used in making this piece is called *incalmo*, which requires the assistance of a skilled glassblower. Two separate pieces are made and while still hot they are joined open end to open end to form a single vessel. During my time "training" as a student, I envied the ceramic student who could make different components and then assemble the pieces to make complicated forms. Also as a student, which I certainly still am, I always lusted after the creations of the Muranese masters. Their work embodied technical expertise beyond comprehension, ranging from the bold and garish to works of simplicity and pure form. By attending a few workshops with a Muranese master and some like-trained Americans, I was exposed to the techniques I needed to assemble my work. A new door had opened.

The process also brought another element of complication to my work, that involving the need of another's hands. Up to this point I had always commanded a solo performance of myself, even rejecting the help of others, feeling it would somehow taint my work, make it less worthy. As I see it now, there is a place for both ways of working. There is still a great deal of satisfaction in completing a solo piece, but there is also a major feeling of accomplishment when I complete something, with help, that would have been impossible to make on my own. This process has taught me the importance of clear concise communication mixed with a dollop of perfect timing, and has re-established a little bit of the notion that no man stands alone.

This particular piece is, I feel, the best I have ever done. In my entire career as a glassblower, I recall maybe five or six pieces that I feel were good ones, where everything seemed to work, and this one for me sings. It is technically as close to perfect as I have come and, aesthetically, it embodies all the elements of the relationships of form and colour that I was trying to achieve. Also, I think with this piece the viewer finds the work easily accessible and is able to relate to its qualities with little effort. I see this bottle as a timeless object, without reference to a specific culture or point in time. It is fashionless.

Ian Forbes by Daniel Crichton

Ian's blowing is very much about form in glass, with particular reference to Venetian vessel forms. They are often very delicate, very difficult technically, and highly refined forms. Lino Tagliopetra, the Italian master glassblower, is one of his big heroes, and I know that Ian aspires to that level of virtuosity in forms and surfaces.

Ian has chosen to work in one of the most challenging approaches to glassblowing, and to make the work his own by evolving the forms, patterns and colours. In his "Incalmo Bottle" he offers a fine balance of these elements, with multiple bubbles connected in the hot state in a final perfect symmetry. One has to be a perfectionist to attempt this demanding work, since the hot and fluid glass forms must be precise in fit and scale.

Ian has never been keen to pursue the overtly expressive side of glass art, but rather he has focused on the subtle integration of the vessel form. He's a craftsman's craftsman, if you like, who wouldn't offer what isn't well made. Along the way he has acquired a taste for a period of glass in European history, and he pushes it hard, exploring the field, drawing out some beauty and clarity and deftly combining it with his own warmth and humanity.

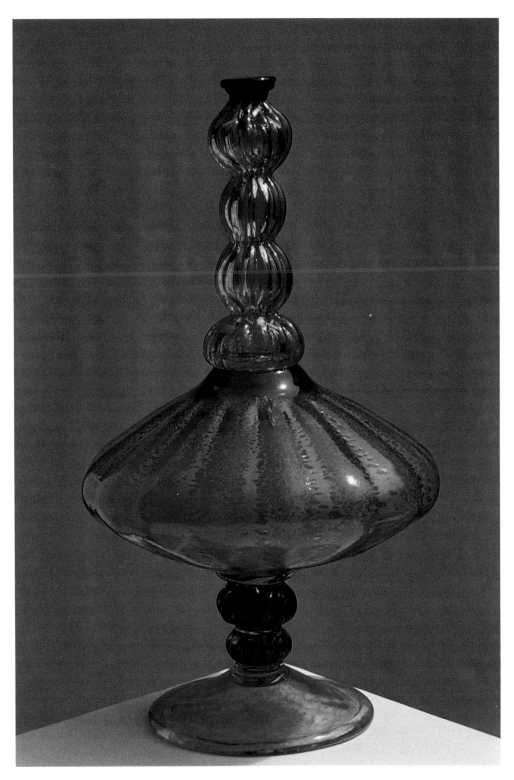

IAN FORBES, *Incalmo Bottle*, 1992, blown glass, hot fused during blowing, 38 cm high.

Jeff Goodman

This compass bowl is a hand-blown glass bowl using cobalt-blue glass as the colouring, generally fourteen inches in diameter and eight inches tall. Etched very deeply on the exterior, about a quarter-inch deep, are the four compass points equidistant from each other around the top rim. I have always loved the look of type, the look of type even more than the concept of type. Also, I used to be a fishing guide on the west coast and we'd be fogged out in the boat, so the compass was our lifeline. So using a compass from a young age was a matter of life and death, since you could head out the wrong way into the ocean. The compass was always important to me, therefore. Also, I always thought it would interesting to have a compass bowl on a table because you could then set the points and people would know which direction they were facing. I've always loved that idea, and the bowl is definitely decorative.

I have no problem if people put things into the bowl, since everything I do is functionally based, though not necessarily intended to be functional. I love the idea of a functional inspiration of a object, with a history and simplicity of function to it, and also the history of craftspeople making things for function. But I always like to make that a conceptual point so the piece isn't actually that functional, but more it's about the maker of functional things and the idea of the piece and the history of vessels. So I do a lot of furniture too, but it's sculptural first and functional second. I guess that's the way I look at everything. Everything has a functional basis, but it's concept first.

We've made about five hundred of these bowls now, and it's been the most successful piece I've done, since it's sold all over the world. I blow lots of things — vases, really large lighting fixtures- but I never tire of blowing bowls. I don't know why, though there's a reverence for bowls and the simplicity of form and it's a very, very difficult form to get the proportions right on, much more difficult than a vase or other shapes. Still, for some reason I am drawn to the making of bowls. Part of it is the process. When we open them up to make each one an open form, it's a hit or miss thing, since we get them very, very hot and the forming of them is with newspaper in your hand and it all happens in about thirty seconds. You either hit it or you don't, and you don't heat it up again and shape it back. It either happens or it doesn't, and that's an exciting process. On the other hand, we lose only one in ten in a day.

These bowls are consistent with how I work. I'll take any functional object and put it through my personal grinder and spit out an object that's based on function with conceptual overtones. I'm very form driven. The form is most important, then the text, then the coloration. The use of letters doesn't run counter to the form if it's integrated properly. With the compass bowl you can see the letters from all angles and through the glass you can see an opposing letter. I've been doing compass-oriented pieces for eight years now and haven't come up with something more compelling to me.

Jeff Goodman by Rosalyn Morrison

Jeff Goodman is clearly one of the most ambitious glassmakers to have studied at SOCAD. With entrepreneurial gusto, he has managed to position himself in several different markets: gallery presentation, interior design, architectural applications, and public art installations.

This achievement has been possible, in part, because of Goodman's diverse body of work, a diversity that reflects several areas of current craft practice. The high level of quality in each area is not usually found in one craftsperson's repertoire.

Born in Vancouver, he has been influenced by the duality of that city, a highly urbanized centre situated in some of the most inspiring natural landscape in the world. This streamlined "Directional Vessel" he produces for upscale design stores is aesthetically miles away from the rugged cement, steel, and cast-glass totems and boats that he has presented in his gallery work.

Goodman's business savvy has led him to his most recent calculated risk, the opening of a 450-square-metre glass studio in downtown Toronto. The curriculum at SOCAD and his experience as a Harbourfront glass studio resident provided training not only in the design and production of beautiful work, but also in the building and management of a working studio. Like some of the most successful studios in Italy and America, his new studio draws potential clients to view the work-in-progress and to experience the theatrical performance of glassblowing.

G l a s s

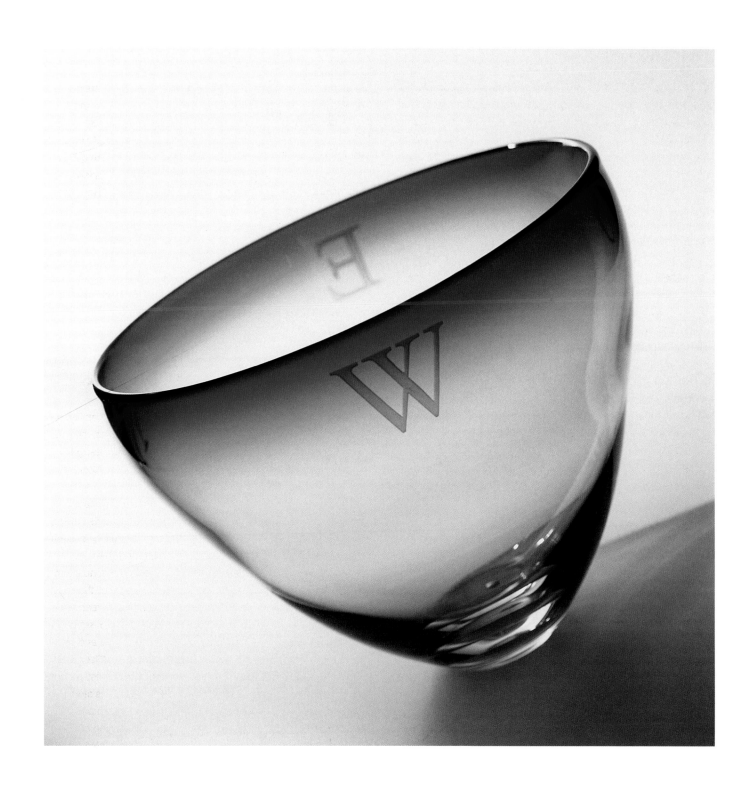

JEFF GOODMAN, *Compass Bowl*, 1995, handblown glass, etched letters, 14" diameter by 8" high.

Andrew Kuntz

This piece was originally intended as an element of a larger structure with repeating elements, and was inspired by the work of M. C. Escher. For many years I have been interested in the themes carried in Escher's work and especially how simple, recognizable shapes tell a story or evoke a feeling when interlocked with other singular shapes that harmonize to tell an even larger story. "The Conversation" is a series of six cast elements depicting three people, one talking and two listening. I have used this particular design work to create a woodcut, painting, glass and steel construction, and over a number of years have been sandcasting different coloured elements of this piece to create a wall unit.

An aspect of this piece that intrigues me, and intrigues me about glass in general, is the effect of light, especially natural light, transmitted through a textured surface. I like how the dynamic of the work is changed with changing light sources. Unlike clear glass, or plate glass, which offers us the ability to see through, textured glass stops our eye at its surface. By diffusing and refracting, it creates a greater interaction between the light source and the piece. When you add to this situation the element of colour, you have an ever-changing array of form, tone, and texture.

Andrew Kuntz by Rosalyn Morrison

One of the most skilled glassblowers in the country, Kuntz has created a body of work which has been especially influenced by Art Nouveau and Art Deco periods. An innately curious and inventive person, he was the first Canadian glassmaker to explore a myriad of creative possibilities found in the technique of sandcasting.

This constructed piece entitled "The Conversation" is part of an ongoing series using simple, strong, repeated shapes that are integrated into a large work. The subtle imagery of people talking or listening comes alive with the light that is captured in the sandcasted forms.

Kuntz's seminal sandcasting work, the "Milestone Series" begun in 1983, presented an exploration of the transmission of light through textured surfaces. "The Conversation" continues his study of the effect of a changing light source on the surface of cast glass. Rather than seeing clearly through the piece, the eye stops at the surface and is guided over the form, following the complex texture.

Through his teaching at the Alberta College of Art and SOCAD, Andrew Kuntz has influenced a new generation of glassmakers

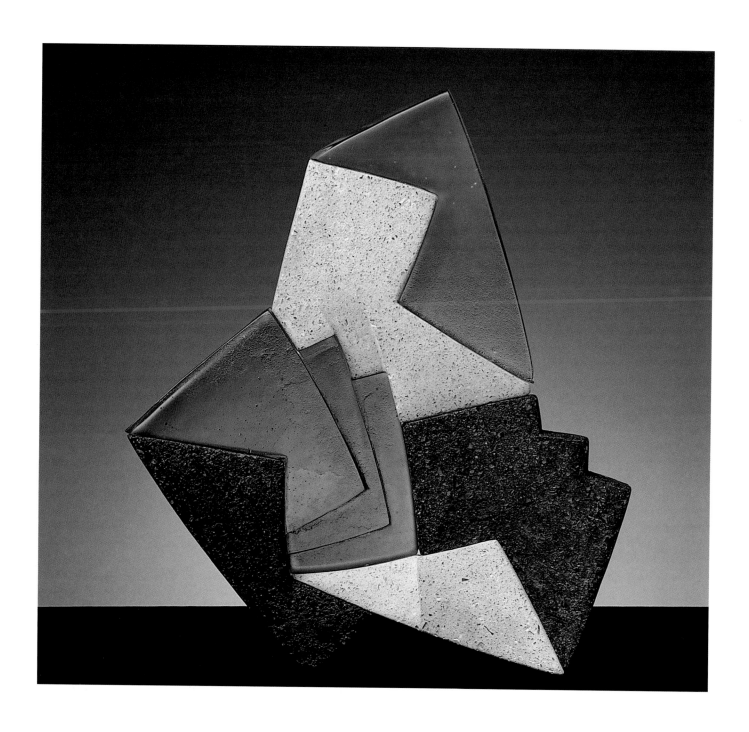

ANDREW KUNTZ, *The Conversation*, 1985/86, sandcast glass, white portland cement, cement fondue, silicone, 50 cm high.

Sheila Mahut

Shortly after the birth of my first child, I was searching for a completely new creative direction to coincide with the dramatic change my life had taken. The experience of pregnancy and childbirth nudged me toward the familiar direction of using nature as a source of inspiration. Since I had been, in a sense, a large seed pod and I had just produced a remarkable bud which is continuing to bloom in the most miraculous way, I felt the connection was too good to pass up. So I called an avid gardening friend of mine and asked her if she would be interested in working together again, this time on fanciful flora. Deborah responded enthusiastically and we met in her sun-filled dining room overlooking her glorious gardens. With plenty of coffee, the previous year's seed pods, and a gardening book or two, we set about a familiar exchange of ideas and sketches. Deborah Cardinal Rhyason and I have worked together on two other series, and I find it rewarding to work with someone whose aesthetic interests and imagination complement my own. Being a painter and mixed-media artist, she sees glass with a certain objectivity.

We both agreed that we did not want to reproduce seeds, flowers and plants exactly as they are in nature. We wanted, instead, for nature to be abstracted by the process involved in blown glass. Since the work was meant to suggest growth and the eventual bursting forth of seed or flower, we decided to sketch forms while paying little attention to the mechanics of construction. Consequently, we found ourselves somewhat baffled when it came to making the forms in glass. The versatility of a two-piece perfume bottle became the incentive for these forms as a vessel with a stopper. We could combine the volume of a blown form with the practically limitless possibilities of hot-forming the tops, the stoppers, in a sculptured way.

We were able to make design decisions while forming the piece in the glass studio; after the pieces were cooled, we mixed and matched tops and bottoms, thus sparking new ideas and directions. In this example, the place where the top and bottom join is practically invisible. Similarly the line between our individual contributions to the finished work is hard to discern since our individual aesthetics are often so in tune that the work appears to have been made by a single person.

We collaborate from designing to making. I am the glass-blower; she is my assistant. We design by passing the pen back and forth until we come up with a working sketch. Other aspects, such as selling, promotion and the ultimate direction of the work, are my responsibility. Deborah and I have continued to work on this series, with a brief hiatus when she moved away for a time and I had my second child. Now the plants are blooming again and we share the transitional process of discovery and development.

In my own career I have been drawn to the thrill of discovery, striving to create, with whatever technique was applicable, whatever my imagination cooked up. Then, once the challenge has been met, I am eager to move on to other things. This example is from 1994, when the forms and ideas were about a sense of growth involving seeds, womb and birth. The series has now moved toward flowering, the culmination of growth and reproduction, thus mirroring for me the wondrous growth of my two sons.

Sheila Mahut by Daniel Crichton

There's a kind of duet here. A traditional bottle has a stopper to keep the contents form evaporation or spoiling, yet with Sheila the bottle itself is an integrated natural form. It makes reference to the early growth stage of an organic living thing and arises out of her experience of having and raising children. So the idea itself has grown and evolved.

Sheila is a natural glassblower who clearly understands both idea and process, having her feet firmly planted in both worlds. This sculptural and asymmetrical "Seed Pod" bottle must balance, stand and function, and that's a complex problem to solve. Fortunately, glass is like a chameleon, extremely good at imitating other materials, be they organic or inorganic. In this work Sheila is using the plastic qualities of glass combined with its inclination to absorb vitreous colours when dusted on the hot surface during the blowing process. Thus she developed a transition from one colour to another with the faded and textured organic subtleties of flora. She transforms the glass by not limiting herself to its obvious qualities. Sheila's pod bottles are a compelling vehicle for metaphor, exemplifying both the process of growth in nature and the evolution of an idea in the vessel.

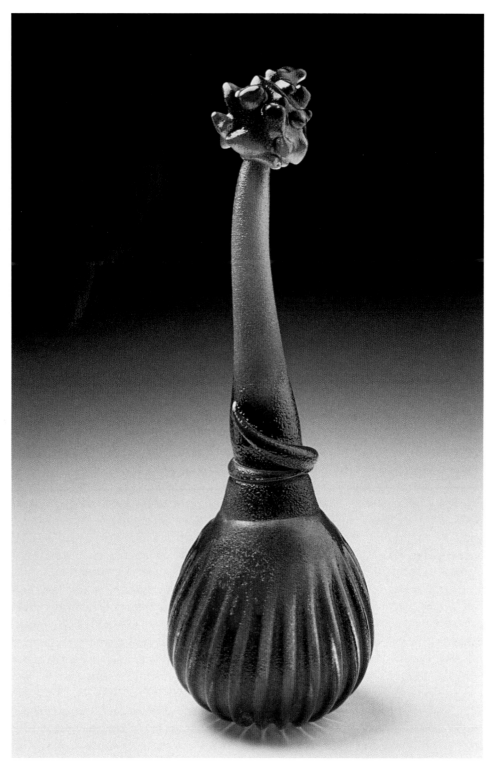

SHEILA MAHUT, *Seed Pod*, vessel & stopper, 1994, blown glass bottom, solid formed glass stopper, powdered, 14" high by 5" diameter.

Claire Maunsell

My freeblown bowl has vivid colour on the inside while the outside is solid black on the edge and speckled grey. I always wished for an intensity and detail of design in my glass pieces, but most pieces that I made as a student had very blurred colour because of the dilution of colour which occurs as the piece is blown out and becomes bigger, since most colour application techniques occur at the beginning of the creation of the piece. However, I evolved a method for applying the colour at a very late stage, which preserves the original intensity of the colour. This is done by applying glass powders, finely ground, to the surface and building up successive layers, much as a painter would apply layers of transparent and opaque colour to canvas. It is, in essence, a reverse painting on glass: as you look in the bowl, you are looking through a layer of clear glass which also magnifies and intensifies the colours, so it's rather like looking at beautiful stones under clear water.

I always learn from making each piece. Mainly, I learn from bowl-making to remain humble, because bowls are so difficult to do. I can never execute them perfectly. This piece is very representative of my ongoing interest in colour and form, and although I now make many different forms, I believe you have to always attempt the masking of a "pure" form which interests you- and eludes you! This keeps life interesting. The colour is vivid, gestural and hidden within the interior of a form that requires you to look closely into it, to interact closely with it.

I like this piece for its success in form and colour application according to my aesthetic judgement. The viewer in turn should first appreciate the simple hemispherical bowl form from afar, and then approach closely and look into it to appreciate the colour trapped under clear glass. It almost has the appearance of layers of coloured sediment laid down over time.

This piece achieves the objective that I set out, for my bowls particularly. It is an object that inspires interest and yet does not dominate one's environment. It is not huge and does not demand attention. It is an object that one can live with and rediscover periodically, as one would a painting, for intimate contemplation. It is decorative art as I define it. But I can't really believe one can accept the makers of objects to be objective about their work. A lot of the time you hate everything you make, and once in a while you like something. Neither view is real or objective.

Claire Maunsell by Rosalyn Morrison

The work of Claire Maunsell demands a close look. The lively gestural graphics embedded in the intense colour fields found in her impressive plate forms attract the viewer into the interior space. The richness of her colour combinations is magnified by a layer of clear glass which creates an impression of gazing through a pool of clear water.

Maunsell continues the craft tradition espoused by SOCAD instructor Daniel Crichton. Her work is inspired by the process of making and the desire to create the perfect form. Though her repertoire of forms is broad, including highly original essence bottles, it is the open vessel or plate to which she comes back in her search for a "pure form."

Maunsell voices her interest in producing objects that "one could live with," domestic in scale but complex enough in design so that each piece can be constantly "rediscovered for contemplation." She makes her living by creating these objects — paperweights, bowls, plates, and vases — for distribution across Canada and the United States.

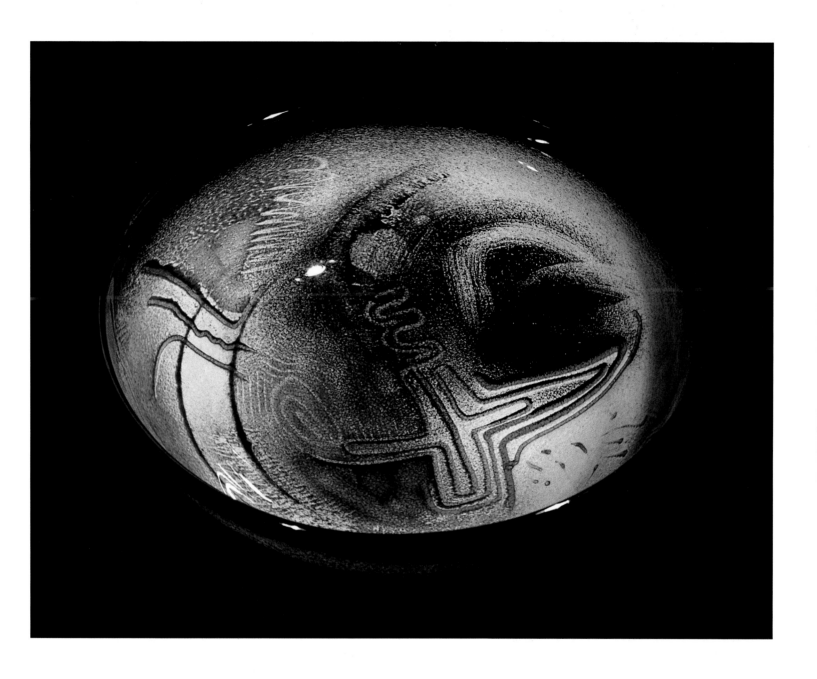

CLAIRE MAUNSELL, bowl, 1991, freeblown glass, coloured w. glass powders, coloured canes & propane torch, 4" high by 9" wide.

Susan Rankin

First the flowers are made by gathering molten glass and rolling it in the desired coloured glass powder. This is heated and made into the flower centre, and the petals are formed by snipping a small amount off another bit of glass brought by an assistant. In this way, the flower is constructed petal by petal, as the temperature of the glass is maintained by reheating after each new petal. When the flower is complete, it is placed in a small kiln and kept warm until the vessel is ready for the flowers to be attached while still on the pipe.

The vessel begins by picking up colour and gathering more clear glass around the colour, and as a bubble is blown, the vessel is formed. The forming process involves several reheats and blows. Next, the base vines are individually attached to the bottom of the vessel. The vines are solid glass that has been gathered and rolled in colour, reheated and brought by my assistant, at which point I snip the glass from his rod and pull, stretch, and flip it onto the vessel. The resulting effect is very fluent. Once the legs have been completed, the vessel is transferred from the blow pipe onto the punty rod attached between the legs. The blow pipe, now removed, allows the bubble to be opened up to the vessel shape. The open vessel is now distressed into its final folded shape and the vines of solid glass are pulled and stretched up the sides of the form. Each vine is attached separately from a fresh hot bit of solid glass. Once the tendrils have been applied, I add the leaves by snipping a hot bit from my assistant and tweezering the bit into the shape of the leaf.

We are now ready for the final step, that of attaching the flowers. My assistant brings a small hot bit of glass, which I snip off the pipe, and the flower is pressed into the bit attaching the flower to the vessel surface. Keep in mind that throughout the process the viscous glass has to be constantly rotated to hold its shape against the forces of gravity and constantly reheated to make it workable and consistent with the heat of the attachment, and that temperature has to be controlled precisely so that things do not get to hot and melt or too cool and crack off.

Once completed, the piece is removed from the punty rod and placed in an annealing oven at approximately 930 degrees Fahrenheit, and slowly, over twelve hours, it is brought down to room temperature. Once cooled, the vessel is then sandblasted, enamelled, refired in a kiln, and painted to add detail and texture. The form of the vessel, entwined with vines and stems and leaves, is sensually creased and dinted, as if the plant-like material is dictating the shape. The surface of this particular form has been enamelled with tracing black to give the impression of texture, the silhouette of growth, and the vines, leaves and flowers have been coloured with pencil crayon and oil pastel to give texture and depth to enhance the control they have over the form. The root-like feet lift and give life and gesture to the form. The subtle interaction of human and natural forces encouraged in wild gardens is captured by the tension created between surface and form in these living vessels.

This work is the result of the evolution of an idea from winged vessel through vine vessel and that now blossoms into the "Flowering Vessel." It reflects my obsession with growing things, life, gardening, exotic flowers, common flowers, a garden by my own design. The evolution mirrors my own migration from living in the city to a move to wilderness country, where I now reside.

Susan Rankin by Rosalyn Morrison

Sue Rankin is one of a new generation of women who have made a successful career in glassblowing, a physically demanding field which has until recently been dominated by men.

Since graduating from SOCAD in 1989, she has developed a highly skilled, technically complex method of creating fantastical compositions that have been inspired by her passion for gardening and things exotic. Rankin, like many of SOCAD's most promising glass graduates, continued her education as a Harbourfront Craft Studio resident and later at the Pilchuck Glass School in Washington State. At Pilchuck, she met Flora Mace, a power-house glassblower who is part of a two-person artistic team. Mace's glassblowing practice had a profound impact on the goals Rankin was to set for herself.

Following a line of glassmakers with an interest in the natural world and a passion for detail such as Galle, the Blaschkas, and Chihuly, Rankin creates intricate piece-worked florals from hot glass, petal by petal. She applies these to impressively blown vessels that often have been manipulated in their semi-liquid state, using gravity and handtools, into a gestural form.

These floral-themed works and Rankin's winged vessels are sensual delights that draw the viewer into their rich colours, animated form, and detailed textures.

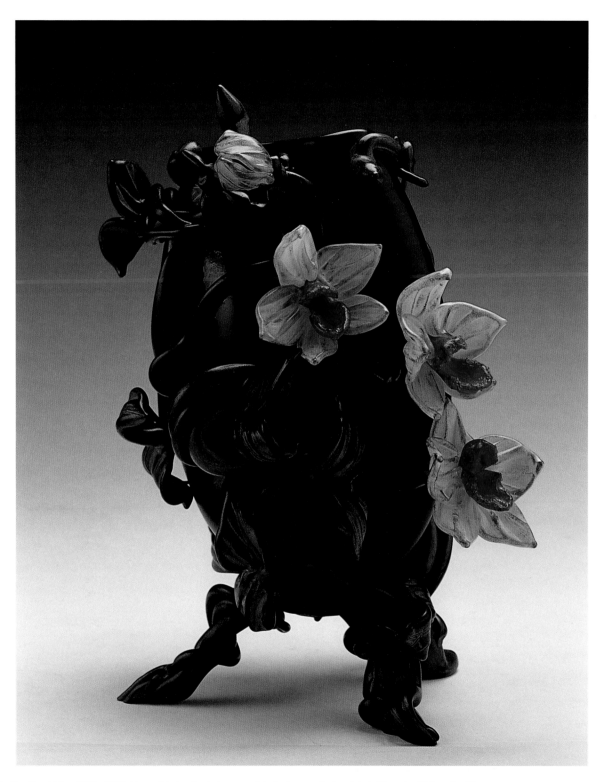

Susan Rankin, *Cymbidium White*, 1996, blown & hotworked glass, sandblasted, enamelled, painted, 28 cm by 21.5 cm by 19 cm.

Donald Robertson

"The Charge" is a cast glass crystal and copper sculpture from my "Warrior" series. This series involves the paradox of man placing his greatest efforts of science and creativity into his devices of war and destruction. The use of fragile transparent crystal in this sculpture represents what is, for me, the fundamental folly of using the fruits of civilization to bring the downfall of others — and, more often than not, oneself.

The design for this helmet originates in the Greek archaic period, when history helped fuel the romantic myths of war in European culture, while the copper horses on top reference Bronze Age technology. As an artist, my interest lies in revealing links between the universe of ideas and their visible manifestations, transitional moments of balance of energy and matter or thought and action. These I express through the visual power of materials and form, using mythological themes, historical references, or figurative elements as keys to unlock their meaning.

Although I work with many media, the qualities of glass that range from fluid, insubstantial transparency to solid brittle opaqueness serve well to express my ideas. I view glass, man's first synthetic, as a material of alchemy in its ability to retain one form yet reveal another at the same time through the transmission of light. Most of my objects are created using the lost wax method of casting to achieve the primary form which is later modified by cutting, grinding, polishing and assembling with other materials. Making these pieces by the lost wax method reflects the principles of alchemy through transmutation of idea and materials by earth, water, air and fire.

I like "The Charge" because it ties my aesthetic ideas and craftsmanship together in an object that I feel can stand independently on its own visual and tactile merits.

Donald Robertson by Daniel Crichton

Nobody I know casts glass better than Donald Robertson does. He is a sculptor with a broad set of material skills in glass and a variety of metals. Coming from such a strong material allegiance and intimacy with process has not limited Donald, but rather has provided him with the skills necessary to experiment with the complexity of three-dimensional cast forms in glass while exploring and evolving his ideas.

In Donald's *Warrior* series he's combined the archaic form of the helmet with the fragility and translucency of glass in order to articulate a paradox that characterizes human nature — the misdirection of the gifts of knowledge and technology toward organized violence and war. Though helmets are made to protect, the one he has cast for "The Charge" is as fragile as an egg. This contradiction suggests that the use of science and material technology to manufacture things that are defensive or aggressive is an illusion and doomed to failure. In the end, Donald's work successfully references our historic hubris and our struggle with rationality through his synthetic and alchemical glass sculptures.

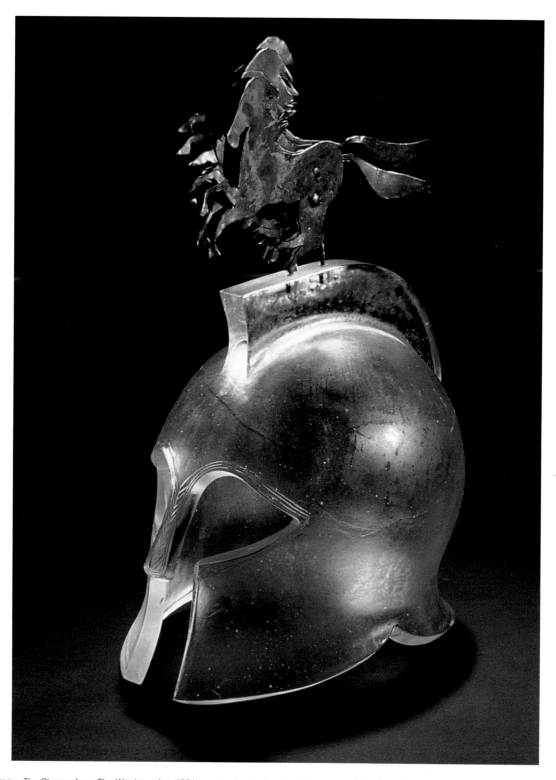

Donald Robertson, *The Charge*, from *The Warrior* series, 1991, cast and cut optical crystal, copper, steel, 39 cm by 27 cm by 18 cm.

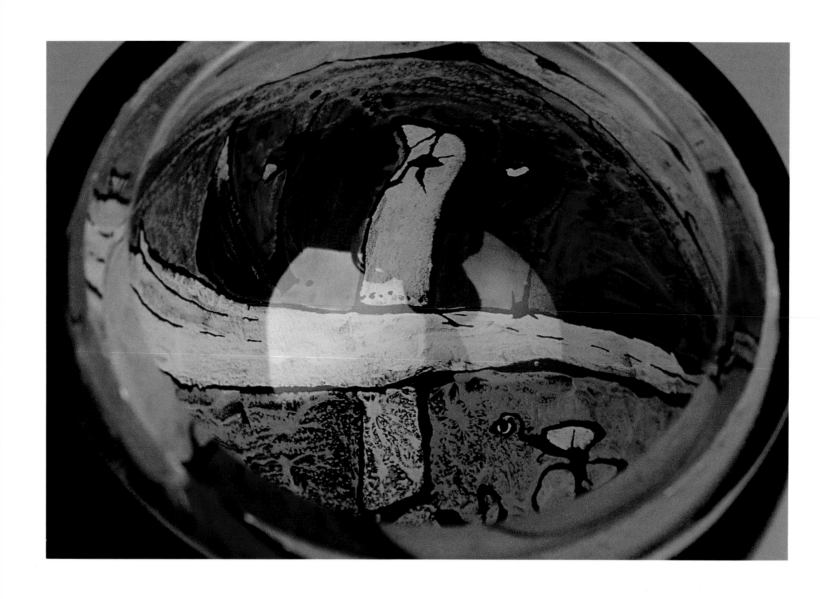

MORNA TUDOR, *Dulce et Decorum Est*, from the *Sphere Series*, 1991, blown glass, reverse painted w. paradise paints, cut & polished, 14 cm by 14 cm by 12 cm.

Morna Tudor

This piece represents all the work I've done with high-temperature enamels, paradise paints, over the past five years. Of all the painted pieces, the sphere series is closest to my heart. I feel that this work transcends both painting and "the vessel" form to become sculptural. The scale is small-size to fit your two hands, and it offers a very intimate experience since only one person can interact with the piece at one time.

But interaction has been a strong aspect of this series. When the viewer approaches the piece, she is not enticed toward it by any outward showing of colour and texture — probably contributing to their sluggish sales — but if someone gets close enough to touch it, she can see a colourful and enigmatic interior and enticing glassy optics. If she overcomes the museum taboo of not touching the "artwork" and reaches out to the piece, it responds by rocking, since there is no flat bottom and the piece is weighted to sit straight in repose but move freely when bumped. If the bold observer decides to actually pick the piece up, she can feel the smooth surface and the pleasing weight of it. It is only now that the painting can be fully seen, but because it covers the entire surface of the interior, the whole painting can never be viewed at once.

"Dulce et Decorum est" is from the heart series of imagery that has only appeared in the spheres. This imagery usually has involved something which affected me at a gut level but remained enigmatic even to me. In retrospect, I see that this piece is a lot like me — kinda unapproachable on the outside but actually quite gooey, if mysterious, on the inside. I love these pieces and I figure they're my best bid for immortality so far. They have taught me a lot about human nature, at least the buying public segment of it, and its mostly negative response. So I began to separate humanity into two groups, those who loved the sphere series and those who did not. All the artists loved them, but car salesmen were indifferent. Actually now that I think about it, I was getting quite bitter for a while, so it's probably good I quit making them when I did. I should mention that the recurring theme of inside/outside has been a part of all of my work since school and that the title of the piece comes from one of those archetypal war poems we did in grade eight. There has been quite a lot of stuff written about these pieces, including some embarrassingly glowing reviews.

Morna Tudor by Daniel Crichton

With Morna Tudor's "Dulce et Decorum Est," the spherical bowl form provides the vehicle for a painterly expression. The interior is layered with vitreous enamels in what's called the graal technique which essentially involves the application of a thick reverse painting on a clear blank of glass, working from the specific details to the background. The piece is then placed in an electric kiln, brought up gradually to above its annealing temperature, and attached to a hot blowpipe once again. It is then covered with layers of clear glass, encasing the painted imagery in the clear wall of the bubble.

A dark layer of colour is then applied to the exterior of the bubble and it's blow into the spherical bowl form. While this multiple processing is a demanding technique, Morna's emphasis is more on the vitreous image that floats on the interior surface of the open form. The focus of the viewer is drawn to this curved painting, which creates an ambience, an atmosphere that is dissolved in saturated colours. It does this because light rattles around the void within the bowl, refracting and magnifying the imagery. You have to look at this bowl in the right light, as if you are standing on the top of a hill peering down into a valley when the sun is shining on it. That's the nature of the bowl form; it's receptive and it's accessible, yet intimate. In a sense, this piece is filled with nutrients for the spirit, filled with a shared vision of beauty.

Do We Ever Get It Right?

Kee-hung "Eric" Wong I sometimes feel that a piece of myself goes into my work, but not every time. I'm working hard for that result, but it's not easy to achieve. In fact, it takes a life's work. So I stick to one form and repeat it again and again until I feel comfortable with it. Eventually, I don't know why, it will belong to me and be my own thing, it will have a sense of me to it. But I'm still learning, because I'm a late-blooming guy who will keep learning until the day he dies. If a person doesn't feel this way, he has stopped learning and is useless. It is a life's work to keep learning more.

Jeff Burnette It's never perfect. The day I make a perfect piece of glass is the day I'll quit blowing glass. It'll never happen, though. Glass involves constant learning and you always find out something new. That's a great thing, really.

Sean Ledoux It takes a lot of perseverance and a lot of proactivity, and it's pretty easy to give up. That is why a lot of people don't work in crafts or they have second jobs. But this is my career, my living, and I don't have much choice but to get it right eventually. I'm forced to get it right, and if it's not working, I try another way until it seems right.

Sheila Mahut When you make stuff, it's a high. Well, at least it can be, I should say, but it's always very positive, very energizing as an experience. There's something very engrossing about creating with your hands. On the other hand, it can sometimes be very depressing as a process. Of a hundred pieces in a series, it's usually one piece in a series that you get right, though there are varying degrees of rightness. Usually it's one or two pieces that are singing while the other ones are perfectly acceptable. The perfect piece is the one that's closest to what I envisioned when I thought up the series, what I was striving for. But it's exciting and rewarding even if you don't get most of it right, since I don't really know too many people who really love their work as much as I do. I really love my work and I love teaching too.

Michael Fortune My approach to design is evolutionary rather than revolutionary. I learn to work in a fairly effective and efficient manner on, say, a particular detail or technique and once I master that, I might switch to another, and this keeps me working at a steady pace. But you never can be satisfied at any level of achievement since, for me at least, there's always going to be a critical eye for the subtlety of what I'm doing, either aesthetically or technically in anything I make.

Jim Todd I've kept some of the pieces I've made. In SOCAD I had the luxury of spending ten weeks on a liquor cabinet, though if I were to do it now it would take three weeks. At the time I was hoping to get $3,200 for it, but now there would another digit in front of it if I had to make another one. But I might sell it one day when I'm at a status where people are seeing my stuff as more than materials and labour and shop overhead. Some pieces I've kept because I couldn't be paid enough for their success or some I've given to family or friends because I know then I can go see them forever. There are other pieces I've kept because there's some sort of hesitation in the design, or I was immature in my thinking, and this makes me smile now, but I don't want anybody to see these pieces incomplete as they are. Other pieces that didn't turn out well enough, I've turned into scrap. You don't always get things right.

Terry Craig At first it was going to be either ceramics or glass for me, but with the instant results of glass I was hooked. I realized I was too impatient for ceramics, and I saw that possibilities with glass are just endless. I realized I can go anywhere with glass and do anything I want, though I don't think anyone has ever taken glass as far as they can.

Donald McKinley Yes, we sometimes do get it right. You can pass through getting it right, but if it stays right, then something is wrong. Wendell Castle has pointed out that if you always hit the bull's eye, then you're too close to the target. So if you always get it right, then you're not trying enough. Right changes, of course, because, as you develop your skills, you can start hitting the bull's eye from that new, more distant position and to keep yourself challenged, you always try for greater distance of some kind. In effect, you up the stakes, and if you've upped the stakes enough, you're not going to get it right immediately because it ought to be something where you're seeking some kind of control. And betting bigger, therefore, doesn't mean you have a chance of winning, even if you want to win more.

So we do get it right, but that's a transitory stage. Getting it right means that it feels good, that it meets the objectives that you've set, and you need to be sure that you don't state objectives that are too easily achieved. That's to stay challenged, mind you, but if you want to make a living from it, you can't always do it on a challenge basis and you have to deliver what you've promised on time, which in a way is also getting it right. But getting it right can become a bore too.

Stefan Smeja What makes some objects valuable is that they are not universally appreciated in the same way and they promote discussion of words back and forth. Thus people's perceptions about objects, and what is right about the objects, can be altered.

The Creative Life Isn't All Creative

Peter Fleming I can't help but look at things primarily as a producer. I regard what I do as a profession, as a way to make a living, but what motivates me primarily as well is the thought that whatever I bring into being has not existed and won't unless I take time and energy to ensure its production. When you leave a crafts school, you may be a quarter of the way down the road of having the level of success you imagine and very few people have the abilities that are required to be successful.

Of course, you need technical abilities and the sense of how far to take something, when to deal with appropriate technical abilities, and when, say, not to sand something beyond recognition for no other reason than feeling it's appropriate. So you need to be a fine craftsperson, a competent and aware designer with a good visual vocabulary and a knowledge of history. But you also need to be a good self-promoter and have very good personal skills, be able to talk about the work you've done and be able to reason through each individual's concerns or complaints about a particular piece. You need to have a good business sense and an understanding of how to market yourself. It's a huge range of skills that's required above just being able to put two pieces of wood together.

Essentially, it takes a particular odd mixture of skills to be successfu,l and the first one is curiosity, curiosity as to how the world works, and an ability to learn from any kind of experience and extract the most from it. You need to be able to transcend your immediate surrounding, even your revulsion of it, and be chameleonesque in your dealings with people or situations and be able to make responsible decisions based on the information you acquire. There's also a knowledge of language and the ability to talk to individuals in ways that they can appreciate and understand on a number of different levels. You need to build up a whole sense of what individuals are, so you can serve them better and make their lives easier.

Sean Ledoux I still get to call my own shots, but it's so rare that I actually get to sit down with pen and paper and be a person in the process. I spend half of my time in the office just trying to keep the business going and being creative is a small percentage of my life. However, you do tend to be creative in every aspect of your business, though there's never enough of the true creativity in designing and doing the craft. Recently I took on an architect's design because I had to pay the bills, so it was just work.

Sheila Mahut Quite a bit of my life involves writing resumes and selling my work, though sometimes that can be pretty exciting. Also, there are more mundane things than the actual making, not at the high end of the creative process, that involve finishing the piece, grinding and polishing it, putting things together. So my life is a mixture since there's a lot of it that's not creative, but there certainly is enough that is creative, and I love it.

Michael Fortune I tend to work only on things that I find interesting to begin with. So I'm willing to work at a certain level of intensity in order to be able to do that. What that means is I work on at least one piece that will allow me a cash flow, which is extremely important and something someone should have mentioned when I was a student. With that cash flow coming into the studio, I'm allowed to do a project that's a little on the risky side,. aesthetically or technically. I may lose my shirt on this piece because it takes longer, but the cash flow items are paying for the time it takes as I become familiar with what the piece requires to make. That's very important.

Joan Chalmers When I first got active in the Craft Guild and was accepting things for exhibitions, there were craftspeople who would say, "I'm a craftsperson and I don't need to study English or Business Practice." The fact is, however, that you still need to write a letter, to design a form and business cards, and you also need business moxy to stay in business. You need to know how to wrap your pieces properly so they won't break and get the pieces in for the deadline. All of these are very boring but very practical. If you want to be in business, you've got to be businesslike, and that should not inhibit or affect your creativity. If you want to be paid on time, you need to get your work in on time, with the right price and properly wrapped.

Also, too many craftspersons are apologetic about prices, but I remember when Dan Crichton first came out of school years ago and charged $275 for a vase. My reaction was, "My God, this guy knows he's good and he's pricing his things at what they're worth." On the other hand, a lot of craftspeople don't know what it costs to produce something, how much time plus the telephone and the packing, and they don't price accordingly. Craftspeople have got to know the business world.

Barbara Walker You have to find a medium you can speak in and one that the monotonous parts don't drive you crazy, like the sanding and finishing or the threading. I don't mind threading, however, though it is boring.

Robert Diemert Producing a work is only half the battle. How we choose to promote and market it becomes a determining factor in what we produce. One ends up attracting the kind of work that one exhibits, so an exhibition is basically a promotional and a marketing tool that presents our work, our ideas and ourselves to the general public for scrutiny and ultimately for profit.

This Keeps Me Going

Kevin Lockau I make things for myself and if other people enjoy them that's great. This attitude makes for a smaller audience, but when you finally connect with someone in the audience, you almost feel that you know them. You can then talk about places you've been, and you get invited to their homes.

Deborah Kirkegaard I am very very happy when I'm working in the studio, so what keeps me going is joy and happiness in terms of what I do. Even if I'm doing something I'm not happy with, that does not mean that in time I won't do something I am happy with, so I just keep working. I no longer sketch on paper, but instead I now treat cloth like a sketchbook. I just put cloth down and start to work. The way that I work is very intuitive as I work out ideas, and I tend to be in a private world on my own terms with my own thoughts and my own focus, all of which keeps me going. There's always a desire in me to do more and also I always have ideas kicking around in my head, or an image or some other kind of inspiration. It's that clear point of inspiration that makes me want to see if the idea I have is a truly great idea, or maybe if it's a jumping-off point for a great idea. This is all on the level of inward motivation.

Steven Heinemann I'm always learning how to get myself to the next level, to get myself up on it, from here to there. That's definitely an ongoing question, to be aware of what you have, what you're starting from and what you want to be. You've got to be, aware that you want to be in another place and conscious of the next level. Hopefully you surprise yourself in finding whatever your dream may be and I'd say I've surprised myself not so much in terms of public recognition, but in feeling that I can say something or express something that I've harboured and carried with my life, and suddenly I can say something I could never get out before.

It's simply about me recognizing and following the core of design and trying to get it in tangible form. So I always need to be open to the fact that my work continues to make me someone else, because I'm in touch with my identity and persona and retain the fluent freedom to become another person. I have an ongoing desire to bring my internal values externally into the public world, to have access to the public with my field of vision. There's a longevity in this desire to bring something not present in your world into reality.

Jeff Goodman I sold a few large lamp pieces, which made it possible for me to afford a glass studio with my partner, and we bought equipment together, so sales do help you along.

Sean Ledoux It's sometimes hard to convey to my wife why I'm still working in wood when it's not as financially rewarding as

perhaps something else. I guess I have a vision, a vision of where I see myself with a product, and I have all kinds of ideas of things I'd like to make. I think the world would be a better place for having the things I wish to make and also what keeps me going is that I really believe I'm going to get there. It's a simple belief in myself and what I'm making, certainly it's not the money, and I wouldn't be doing what I do without this belief.

Also, I always consider where I have the greatest opportunity for learning. If you accept a system or situation and don't choose to effect a change in it, but rather choose to let it affect you, you stifle your learning because you're saying you have all you need to know. I choose to be proactive and keep learning every day. And learning continues to amaze me. But you have to let yourself learn and be willing to accept that there's always going to be another discovery until the day you die. After college you learn very quickly in the real world that you have to keep on learning. This comes with maturity, knowing that you have to always keep an open mind and learn how to learn.

Skye Morrison The idea of making keeps me going, more from a spiritual and intellectual perspective. You always need enough ideas to last a couple of years, things you wish you'd done, because if you don't, then you stop making, you stop doing.

Michael Fortune What keeps me going? Money. Furniture is what I do as a living and I have no alternative income, since my income comes from my ability to design and make furniture. I have to be able to draw on my ideas and speak with my clients in a particular way, I have to build different pieces out of some budget and deliver them on time. So there's no mystery to this whole thing. I see it as an absolutely wonderful profession, and that's just what it, is -a profession. Unfortunately, in the school experience they're not really good at getting this truth across. If you're not able to make an income from a chosen profession, you'll just end up burning yourself out. You have to commit yourself to it and have an eye for longevity. It's not really necessary to struggle, is what it amounts to, as long as there's a certain level of panache.

Barbara Walker I needed to make. After I had my first child, I went through months not making anything and was really frustrated. Then I made a dress for her and got so much pleasure from making one little dress and it dawned on me that I'm a maker and I have to make. It's an outlet and I have to keep being creative, making something. Also, I feed off recognition for what I do from the public. This boosts my spirits and my ego, and for me that's part of it. I'm a harsh judge of my work and have to feel good about it, but praise goes a long way.

Early Blooming, Late Blooming and In Between

Deborah Kirkegaard I'm a late bloomer. Instead of making the decision to go to an arts school at eighteen, I did it at thirty, and that's because I was so scared and it took me that long to have confidence to actually do something. Now when I talk to the people I teach, I find that a lot are very afraid when they do something the first time because they feel they are not good enough or they won't be able to do the work. So I always say to them that we all start at the same point and that point is where you haven't done this before and you really want to do it. You're motivated because you're interested, but there's always that fear of a blank piece of paper or the beginning, the fear whether or not you're good enough to create.

So what makes bloomers of any kind bloom is that they get over that fear at last. With the creative life or creative soul, it's not that there's a beginning, middle and end and that's that. There are always beginnings, middles, and ends, and although you are not always blooming, you are always growing. The growth has different stages and it's very much like growing a garden because there's always something coming up, there's always something being planted, there's always something being pruned, and there's always something that you dig up to give way to something else. There's always something being moved to the shade or into the sun or being weeded out. So gardening is a very appropriate analogy for the blooming that takes place in a creative life. I can't say I'm always blooming, but I am always growing the way a garden grows.

Sean Ledoux Blooming as a craftsperson doesn't happen in moments of brilliancy. At least what happens for me is that I go along and things don't seem great and suddenly I pull off a great project or I hit some revelation, and that to me is a bloom. It's a burst of energy, a moment of epiphany, and this sort of thing happens all along in your creative life. In the last few years I feel that my skills as a designer and problem-solver and maker have really come together as a whole and I feel for the first time in a very long time a greater satisfaction because it's not such a struggle to make things. This feeling is like a kind of blooming and it's actually like a shedding of skin, a metamorphosis. But also there are all the little moments of blooming where you're struggling, struggling, struggling and you're trying and trying to get something and suddenly it happens in a bigger bloom. These bigger blooms have to happen every couple of months or there isn't anything sustaining about your life. I don't like calling this a career, since it's more a lifestyle, a way of living.

Jim Todd I refer to myself as constantly blooming. I would never say that I've come into bloom because that would probably mean I'm complacent. Since I'm in a learning process, its a good feeling to know that I've got more coming. Every year I look back to where I was a year ago and realize what I've learned and consider myself the year before as a real greenhorn. It's a healthy attitude, though it's a little down on myself and a little pessimistic in some ways. Yet, in the long run, it tells me I always need to do better and learn more so that, by learning more, I'll have more ideas and more of a pool to draw on in the future. I'll never run out of ideas because that would mean I'm done and retired and finished so that I don't have to think about making anymore. I cannot see myself not thinking about furniture anymore.

Valerie Knapp All along I've realized that my life hinges on development and growth. My mother was a phenomenal gardener and I grew up in a growing environment, so renewal and growth are what inspire me in terms of my own work. I start off with the newness of a piece and a nervousness about something new and uncertain, and with a fear of the unknown I start building up my own methodology for what hasn't been done before. Thus I'm free of habits and ways of working and certain restrictions that one puts on their own creativity. The newness of what I do gives me inspiration and the freedom to continue and develop. Often you're working within a specific time framework, but at the same time you give yourself lots of nurturing and freedom to be creative. It's been this way all my life.

Peter Fleming First and foremost it's an issue of quality. I'm very conscious of quality in the work I do. It's an issue related to market-driven concerns and how much money people have to spend. There's also a desire to control material and to control someone's experience, so perhaps manufactured objects allow much greater sense of freedom of use because they're not so use-specific and don't guide one in a particular direction. Another issue I have is the one of utility, that I'd like the object I make to perform the function intended. As well, I used to have more interest in the emotive power of my work and whether it had shock value and could tweak people's sensibilities. I was more interested in being provocative and now I've mellowed and matured to a point where I'm more concerned with the subtlety of the way forms relate and how things function, plus the longevity of the piece.

It took some years to get a grounding and understand the way I wanted to conduct my life with a particular aesthetic vision, in other words, to hit my stride. You have to connect with both use and aesthetic to make something successful, since they are both utilities in fact. I'm not saying that my taste is either a panacea or that it's universally accepted and I wouldn't want it to be, but my taste has changed over time because I've continued to make things, often on commission.

The Studio Experience: Community and Solitude

Deborah Kirkegaard I really make use of my time in the studio because that's all the time I've got and I've got to make the most of it. I don't go to the studio to socialize or to talk on the phone or to interact with the outside world, because I welcome the solitude. It's the solitude that allows me to focus on the work as opposed to other things or other people in my life who are demanding my attention. My life doesn't revolve around my art and my life is not my art, but instead my art is part of the wholeness of my life. Holistic life is my big thing. So I want to have my family and to have what that brings and what I can give it. I want to have my art and what that brings and what I can give it. There are lots of elements in my life that are important to living and balancing all of it is the hard part.

I've always enjoyed solitude because it allows me to do certain things. But I also say, "Thank God, there is also a community." It's been important in the sense of support because a community provides a network of ideas and inspiration. I have a community as a textile artist and a community as part of my family, but they're different and they offer me different things. I gave a lecture recently in which I told a group of textile students, "Hook into the community of people who are doing what you want to do or who are doing what you are doing. You can't live and work in a vacuum." A creative person needs resources and many things have happened to me because I knew someone in the community.

Steven Heinemann It's a concrete fact that I operate in solitude, in a private sphere where I'm unsure if my work will become public. You have to have a need and a faith in such a situation. You must have the faith to work it through, especially because the early years are hard and because you have to make some payoffs, which means a lot of bad work. But you suffer through your learning process and try to achieve some level of maturity. That's a very private part of the life. This private part is not social at all, but eventually you find your niche in the world, a niche that is generated in private but which allows you to voice your inner self to the world. By your own temperament you can learn to deal with this situation and for me it comes fairly easily because I try to balance my solitude with teaching. I alternate between the two worlds of private studio and public teaching because I couldn't do just one. I need both, each to support the other, and I often translate my solo experience into the public because I recognize in my own life a link like a bridge that works well in the community.

Donald McKinley As I'm working on my own I don't necessarily identify myself moment by moment with a craft community, since my greatest consciousness is of the process and material at hand, and not what people will think of what I'm doing. If there is community, though, people can refer to it in some way and some people lose out without a community.

Jim Todd The life of a craftsperson is hard and usually unrewarding in terms of recognition and monetary value, but obviously people keep doing this and they're doing it for other reasons. Solitude is something I know because I live and work in my studio by myself and sometimes I don't get to see anybody for days. So I'll check out the girl at the food market, since she's the first person I have contact with, or a supplier on the phone or somebody like that. And then out of the blue somebody will phone me up and say that they've seen one of my pieces and want to buy one, and when they do, they're happy to have it as they take it away. So the reward for solitude is that when the item leaves the nest, it is making somebody else happy. That reminds me that every single thing I'm working on, every little piece of life I've got in my hands when I'm making it, is going to leave here and make somebody else happy, even though it's like selling off your children. But you get to watch your children evolve and grow up and it's fun in your solitude.

Skye Morrison I don't mind working in public spaces, though I know some people find that very disruptive or disturbing. Once at the Ontario Science Centre we made ten thousand kites in a week and I had a staff of forty-five. But when I work on my own stuff, I really enjoy that I don't have to have other people around. For my first show in about ten years recently, I had only one other person, a friend from India, working with me, and in that big house there was enough room for us to have our own space. That was heaven, a chance just to calm down and get on with it. So I like that, too, working on my own things when I don't really need or want other people around.

Helen Beswick I've travelled coast to coast visiting crafts-people who are always listening to CBC programs, so I know I'm not alone as a potter in my studio. I'll hear a creative person on *Morningside* and they'll talk about their approach to their work and I'll realize that's how I also feel about things. I had another kind of connection when I met a Japanese master potter. While he spoke very little, it was his inner peace that affected me, and whenever I feel all the pressures in my life, I just think of this pacific man who just sat there like a Buddha and these beautiful pots came away from his hands, so I stop for a while.

I've had a lot of mentors I keep in touch with and I also feel a connection with wonderful studios I've been privileged to visit in my travels. I'll also go to workshops, not so I can learn some new tricks, but because I want to be part of the pottery world again, I want to witness someone talking and doing the thing I love in a slightly different way. This makes me feel part of a community that has a wisdom, that has a continuity for thousands of years, and it gives me a rooted feeling as I feel part of these potters. I feel the immortality of it all.

If I Could Do It All Over Again

Deborah Kirkegaard I went to art school at the age of thirty because one day I asked myself, "Are you going to regret not doing this when you are fifty and you look at your life and that window of opportunity that you didn't take?" My answer was, "Yeah, I am going to regret it." So I did it. My father thought I was absolutely crazy for giving up a well-paying job, a really good career in arts administration, but I said, "Nope, this is what I want to do." So, yes, I would do it all over again, even though it's a difficult thing to do because the society in Canada is not one that is too supportive of a person who wants to pursue a creative life. You don't get paid for it and you don't get any major brownie points unless you're a big mover, and there are very few big movers.

If you are big in the arts, it still doesn't mean that you can lead the kind of lifestyle that you could as a CEO. You make a lot of compromises, but the reason I'd do it over is because it offers something spiritually, and if you can get a grip onto that spiritual dimension, the life of a creative person is far superior. You learn about yourself and who you are, and when you put yourself into a work and you put yourself on the line in terms of your work and express yourself and your concerns, you put it out there for people to see and comment on. This is so important because it's all coming from a deep place inside you. In turn, this makes you a happier person because you like what you are doing, and you get a great sense of satisfaction and fulfilment. Sure there are compromises and things you would change in retrospect, but overall you are becoming a more aware human being.

Helen Beswick I maybe would have defied my mother at twenty and gone to art school.

Steven Heinemann I can't think of anything else that would unfold my purpose more than ceramics. I have found a kind of fulfilment and ongoing purpose that I wouldn't have known in the early years when I was in the dark. It was tough, it's still tough, and it doesn't get any easier, but it helps in having a small audience, people who are receptive and interested. Sure, when you create something from within you, that puts you in a vulnerable place and you need a strong sense of self, but if I had to do it over again, I would, only this time with a stronger sense of purpose. You always come back to fulfilling your own notions as you move to realize your purpose with more clarity.

Skye Morrison I would live in India, but not all the time, since I still want to live in Canada too. There are things I would have liked finished sooner in my life, but you can't do it all so I'm still plugging away one thing at a time. I'd have gotten involved in writing and publishing and research a lot sooner, and tried to connect them with my teaching at Sheridan, since our current culture does not include

research and publication. But I can't think of too many things I wouldn't do over again.

Michael Fortune I'm specific to furniture and I can't think of a better absolutely ideal career choice. I absolutely love being self-employed since I'm probably incapable of being an employee, having been self-employed for twenty years. My natural inclination is to be the boss, so this is an ideal situation.

Jim Todd If I could do it all over I would find some millionaire to invest in me, because I started with absolutely nothing in my parents' basement, with a file and chisel basically. There's a lot of machinery you need and you have a constant overhead battling you, so if somebody had given me a huge break in the beginning, I might have come along faster. However, necessity is the mother of invention, as they say, and I needed to pay the rent, establish myself, and be really good to survive. I realized I had to put out a lot and sell a lot because the money end of creativity is pretty ugly, though it sure spurs you on. If I hadn't been in tight situations, I wouldn't have realized I had to do something substantial.

I'm generally happy with the way things have gone since I knew at the beginning that things were going to be hard, that it would take a lot of time and energy and money. I didn't want to fall on my face right off the bat, so I had to start off as small as possible and keep things as concise as possible. Constant growth is what I've been doing and it certainly hasn't been fast. Some of my friends went to university and they got a corporate job, a house and kids and the whole bit, so I feel like I'm on a much slower path. But I'm happy on my gradual path.

Donald McKinley To indulge in this question, you need to think that life is built in such a way that you can do it again, but for me it's too hypothetical. Personally, I wouldn't change much about my life as a craftsperson because there's a lot of flexibility and adjustment that can be made with room for movement within it. So I wouldn't have to do it all over again to make some changes, since I already do. I have no regrets as a craftsperson, but I guess if you've failed enough getting it right, then you would think about doing it over.

Karen Smeja I would have continued my craft education after SOCAD, to investigate my art form more. In the environment of being with instructors and fellow students, the creativity really flowed, but once you're out in the real world, it's not as wide open for exploration since you have to make a buck then.

Machines Do What Better?

Haakon Bakken Machines don't create, but they can take instructions, just like computers. The result is an opportunity for a designer or craftsman to develop products, useful products, for a broad audience and at a price which many people can afford, rather than today's craft objects, which usually reach a very limited audience.

Bruce Cochrane In this fast-paced high-tech society, I feel a growing number of people, the general public, are feeling the need to possess articles — whether it's a ceramic teapot, a glass vase, a handmade chair — that are aesthetically tangible, have personality, have individual expression and a connection to the maker. These are contemplative objects that provide some relief in the anonymous clutter of mass production.

Anne Lemieux Weaving may teach you to be patient and also to respect how cloth is made, even if it's made by machines. If you see something that's handmade, handwoven, then your appreciation of it is greater than somebody who doesn't understand what the making process is. It makes a really big difference, to understand something that's handmade instead of by machine. That doesn't mean that if it's handmade it's good, because there are a lot of things handmade that are just horrible, but something handmade does have a different look, a different feel to it. It doesn't look like it's mass-produced. It's nice to have things that are still handmade because there is so little of that going on.

Alison Vallance Machines do regular work with an absolutely clean surface and with an absolutely straight corner. For an undifferentiated view expressed over and over again, go to machines because machines do that. But some people feel that the value of craft lies in irregularities that actually differentiate one piece from another.

Barbara Walker Machines can't do what craftspeople do, but machines are tools and, especially in woodworking, it's not necessary to do everything by hand. They speed up the process and allow us to do more.

Donald McKinley Machines do better with things to be done in quantity, things to be done accurately, things to be done endlessly. They're good with mindless stuff because they don't have a mind. For the things that are irritating if you've got a mind, you have a machine to do them instead.

Donald Robertson You still have to know the craft and the materials to run any technology.

Daniel Crichton When I was at a conference at MIT in Boston, they showed us a 3D printing process whereby you could send the image of an object from a CAD program on computer to an experimental 3D, printer which would build it in three dimensions and in any one of ceramics, glass, or stainless steel. I don't know where it's going to go, and it scares the hell out of me and delights me. In glass we're using technology that's two to three thousand years old and we're also using digital technology. I'm not against technology but what I'm interested in is appropriate small-level technology that allows people to have access, allows them to have creative ownership of the technology. Otherwise you end up with only corporate heads having a say, and workers at the bottom who, even though they are the most skilled, have no real say in what comes out the other end. This situation creates boring things and there are enough boring things out there in the world already.

Ingrid Bachmann Machines can be completely indispensable, wonderful and useful if they're put to the service of people instead of people being at the service of them. So it's an active relationship with machines that's desirable. How can they enhance your work? How can you build machines that will help you do the work you do? A lot of things machines do better and they're faster. A table saw is pretty handy, a drill is handy, a computer to rough out sketches and to do colour ways is handy. To do everything by hand, you wouldn't go through the same possibilities.

So I think of machines and technology as wonderful intermediary tools. What you do with your hands, with a hammer, with a pencil is as much a technological process as what you do with a table saw. If you approach electronic and mechanical and electric technology in that way, you have a different relationship with it right away that says you are more in control of it, you are using it to shape what you want to do. Obviously different tools shape the user, and it's equally obvious that we need not distinguish in the end between hand and electrical technologies.

Susan Warner Keene We constantly adjust our attitude to technology and we always have done. Of course technology can duplicate pretty well anything, but this fact helps us to refocus the value of handmade objects. Handmaking of crafts at one point was technology. Then machines took over a lot of the labour and the work of the actual craftsperson shifted toward the initial concept of the object to be made. This left the field wide open and crafts took on a dimension that was metaphorical, saying something about the way we are in the world. Machines can turn out all the basic stuff, so what becomes interesting is the notion of a handmade object as something more, the way cultural practice can still have meaning in the dimension of ritual.

Crafts In a Changing World

Alison Vallance As the world changes, crafts provide some kind of sustaining values because they make reference back to earliest kinds of work, the earliest kinds of relationship between the human and the material world.

Ingrid Bachmann Crafts have an enormous impact in that they provide an alternative to mass-produced goods, so there's a sense of choice for the consumer to buy something that hasn't been predicted and prefaced for them by the media. Crafts go outside the dominant culture as a resistance, an alternative to consumer mentality, partly in an ecological sense, with an awareness of the environment, which involves having fewer things and only things that you value. There's a place for things that you don't throw out because they don't go out of fashion, and in some ways crafts can be quite revolutionary because they go against so much of what is thrown at us. Also they have potential to engage and I really wish craftspeople would design things like fridge covers and computer covers, because why does everything have to be beige or grey or plastic non-colour?

Crafts really do bear witness to an individual's process, they suggest an individual among all this mass-production, mass-everything in transit, and that's an alternative. They allow a choice to act differently, to function differently, to make choices outside of what you've been scripted to or pushed to do by popular media. There also can be a generosity in craft work in that it can pay tribute to functional tradition and provide an entranceway that isn't unfamiliar, allowing a sense of familiarity for an audience that is alienated from art and creativity. However, when the crafts are not very good, they can become a living porridge that says, "There, there, feel better, everything's okay again." I feel there are opportunities in crafts that haven't been pushed nearly far enough, though, yes, crafts can provide a comfort zone of nostalgia for people who are intimidated by this ever-changing world.

Personally, I want to be part of the world in which I live and I don't want to be part of a museum culture looking back. I'm interested in living culture and I'm interested in work that has a stake in it. If there's any criticism of the crafts community, it's that there needs to be a much broader openness to the various potentials of craft. Often work that remains in a craft situation like a gallery is discussed only on formal grounds. There's a protectionism in crafts that I find really uninteresting too, the notion that crafts and hand production are really a lost nation state that has to be fossilized. Once you do that to a practice, it's dead. So there's an inevitable amount of loss if a craft is going to continue living, but that doesn't mean wholesale abandonment of traditions or of values or of aesthetics. I simply think that work does need to partake of the world in which it's living and that's where there's been an almost protectionist mentality that is simply not useful.

Winn Burke If crafts can enrich anyone's life, crafts can do so whether the world is changing or not. I personally believe that crafts can enrich lives. However, conditions exist that determine whether or not people buy these crafts.

Sherry Pribik Crafts fit into the world because they offer an alternative to technology.

Susan Edgerley In a changing world I just change along too. But the world is changing so fast, and I hope that crafts will survive as things get so information-oriented and so machine-oriented and less focused on human actions. I'm concerned that making something yourself with your hands is going to be considered foreign. Although we have all this information with everything hooked up, at the same time there's a real need for a sense of human contact and touch, and crafts might as a easily have a humongous boom.

There has to be a strong understanding in the educational system and government to set priorities on art and craft making, on the creative aspects of life. All this cutting of arts that enrich people's lives enormously is extremely short-sighted. Once arts are cut, people who have no exposure to them won't be interested. I'm hoping for the other alternative, which, because things are changing so fast, involves human touch and contact returning as a priority. I find a lot of people are more interested in expressing their individuality and that more and more are not frightened by the fact that someone is an artist. I find with the computer age, people are in touch but they've lost touch.

Barbara Walker Crafts have a more important role now than ever in our technology-oriented world. There's something really basic and wonderful about making something with your hands no matter how creative you are, just a physical way of actually producing something. People have too much trust in technology, and people spend so much time with computers, and yes they can be creative, but it's a different language. In crafts you put your own mark on things. But there's just so much fast food around and everything is made for you and there's less and less creativity even in cooking.

Skye Morrison Personally, I think that if we don't find energizing words to describe craft, then craft will become invisible. The powerful forces in our society still want intellectual elitism to be part of justifying or crediting something, but most academics don't have a clue how things are made and are just observing a work as an object in the culture. Improvement in talking about crafts will come when crafts students take the academic subjects of their discipline more seriously. You have to have a historically validated connection between your work and other groups of people, especially in this changing world.

If I Don't Understand It, What Good Is It?

Winn Burke Understanding an object and the worth of the object are two different things. Some people reject living with an object because they don't understand it, but that doesn't equal a rejection either.

Haakon Bakken Many craftsmen today have put personal expression before the fundamental rationale for craft objects, which is function. In a very real sense, these people are no longer craftsmen; rather, they are would-be artists. The rest fall into the crack between two different human endeavours. So, if you don't understand it, it might be "art," but it certainly isn't craft.

Ingrid Bachmann It all depends on what you expect work to do. We are an instant-gratification, ten-second-attention span culture and if you don't immediately get a work and it still engages you to figure it out and explore it and consider why decisions were made, then it actually is doing a tremendous amount. It's making you think, making you look more closely, making you observe. If an object makes you behave that way, you take that awareness to a whole range of other situations and that heightened observation is a tremendous gift. Pleasure and beauty are incredibly underrated values in craft work, and that potential of giving pleasure and beauty really has a lot of power.

But I think not getting it is not so bad. Some work is one-liner and maybe you'll get it another time. Maybe it's too obscure. Maybe the creator wanted people to go back or maybe she wanted that point of bafflement. Whatever the case, all good work is interactive, whether it's an object or whether it's electronic, and it demands some sense of relationship. The object really is a kind of repository at the beginning of a dialogue or exchange, and sometimes that seems very dull and sometimes it doesn't connect, but all good work is very active and very living, and that's what characterizes good work for me. That sense of relationship for me is absolutely crucial and that is one property that is inherent in a craft tradition and one that maybe got thrown out a little too quickly in this desire for validation within an art dialogue.

Rachel Young If something is not understood, it motivates us to learn. Without learning we stop growing. Moreover, things and their value cannot be judged overall just by their relevance to one person's life.

Dalley Wark I don't believe that I can understand everything. There are things that are beyond me. But just because I don't understand a work doesn't make the work any less valid. I always feel that if two out of five hundred people understand what you mean, you've done your job as a craftsperson. Sometimes I am just not one of the two.

Susan Warner Keene I was in the back storage area of the Museum of Civilization recently and found all kinds of farm equipment and tools for jobs that don't get done anymore and aren't even understood. So I again realized that craftspeople have to think about living in their own time. Still, even if handmade objects connect with only some people, the work is important. Craftspeople are creating visual references they want to see in the world, creating a visual metaphor for something that they value.

It's unfortunate that many people don't actually see crafts objects up close, because these can help an audience to enlarge its realm of understanding. To the extent that people are willing to look and really see what's there, people can grow through the experience of crafts. But I don't see the education system at the moment as very helpful in encouraging people toward craft experience. Emphasis on computer technology alone limits the kinds of qualities people might develop and their lives may become much narrower and more impoverished. We do need a balance. We need a widening of the range of experience. We need people to take a personal leap toward other kinds of understanding.

Safana Kassam I have recently discovered, to my surprise, that my point of view isn't shared by everyone. So if I don't understand a work, maybe someone else will. Or maybe it's not even meant to be understood, which is just as good since this in turn promotes curiosity and travelling of some kind.

Vera Polischuk I am naturally inquisitive and I am driven to put my finger on something I don't understand. I will problem solve, do research, and investigate history and the craftsperson's background to know something about his dynamics, all to form some kind of conclusion either negative or positive.

Wendy Mitchell-Burke If it causes you to react in some way, either good, or bad, it's caused you to experience life.

Paul Pearson I might not understand a work, although I created it. There is no defining it in the end, since the work defines itself.

Robert Bowes What I don't understand allows my mind to wander and explore my own ideas. The work then provokes my thinking and allows me to recognize diversity amongst fellow craftspeople, thus opening up new horizons.

Man's Craft, Woman's Craft

Skye Morrison A textile studio in Canada involves a social subtext where women teach mostly women, and the ways to distinguish sexes in crafts of our culture always relate to standard design practices involving texture, colour, and materials. Colour is usually number one, and it's the old practice of pink for the girls and blue for the boys. In cultures like China, however, the sexes are dressed opposite to what people expect in Canada, and it's not unusual in China if a boy has a pink suit on. Thus, in crafts people are terribly conscious of gender in their work, though they don't articulate it because it makes them uncomfortable.

It continues that product design in our culture is dominated by men. There's a tradition that women will always stay home and have babies and not have to succeed as professionals. Historically, the reason why textile crafts in the west are seen as women's work is because women are taking care of children and have to be around the home. Their activities are those you can leave, like work on a loom or stitching, to take care of the kids and cook the meal and then return to weaving. Theoretically, we've destroyed those barriers, but in a deep sense we haven't because we still perceive textiles as women's work. Although eccentricity is fine for a woman, first she has to feel she's okay, safe and comfortable as a human being in the world. As a woman I'm always concerned about safety and vulnerability and social pressures. Of course, this situation affects what I make.

Haakon Bakken This distinction between men and women in crafts, and the stereotyping implied by this concept, no longer applies in our contemporary crafts community.

Alison Vallance I don't know if I see a difference between crafts by women and by men. In some cultures of the world there are crafts that are distinctly men's and others that are distinctly women's, but sometimes a craft in one part of the world is a woman's craft, while in another part of the world it is done by men. In contemporary craft, if you're talking mass-market craft, there aren't a whole lot of men doing quilted dollies and stuff like that, and there aren't a lot of women doing decoys, though I do in fact know one.

There are certainly all kinds of crafts that are predominated by women, like quiltmaking, but there are also some well-known and accomplished men doing it.

Then in craft that calls itself art, I can think of some kinds of craft that women make that men wouldn't or don't. In some forms of artistic expression, and this is true for craft, there's a lot of narrative with personal histories and stories and histories of other peoples, and I think that's largely part of the feminist thing in contemporary art. That narrative is part of the feminist perspective.

Susan Edgerley Men work wonderfully from their concerns and women work wonderfully from their concerns, but often they're very different concerns. So men's craft is very different from women's craft, a distinction in concerns that preoccupy each one. Women are much more concerned about expressing their internal evolution while with men it goes from some physical ability to a technical ability before they feel comfortable expressing their concerns.

Donald and I are both in crafts and we have different perspectives on life. His work reflects a certain male perspective in a very general fashion, whereas my concerns have always been feminine. All my work is not around femininity, mind you, but it's certainly autobiographical. But not all men are the same nor all women. In the early eighties, all the role models and all the teachers were men. There were no women and it was all men. Now it's all changed and a lot more women are in roles of leadership or inspiration to students.

Donald Robertson As the lines of demarcation in our society come down, it becomes an artificial boundary between the craft of men and women. Frequently I can tell if something is made by a man or a woman, but not always, since there are women who are more masculine than a lot of men I know and some men are more feminine than a lot of women, although society imposes really hard boundaries upon people. But these are breaking down in society and naturally in the crafts too.

Valerie Knapp Knitting, weaving and crocheting, all the needle arts, are traditionally in the female domain. But more men are the household names in fashion because when the stakes are higher with bigger business involved, the leading edge seems headed up by men. But when I meet the occasional man who can knit or sew, I'm just so intrigued that I immediately think of him as a better person. I think men are deprived without the option of textiles since they're lacking a life skill in understanding what cloth is. People need to be articulate about everyday things, but many are not educated or knowledgeable about the integrity of good design and good cloth, whereas in other countries it's part of one's upbringing.

Crafts is just a finer development of producing, whether it be utilitarian or decorative objects. If people in our culture had a basic and better understanding of fibre, clay, glass and wood, of all the things we can manipulate, our marketplace would be driven to produce better designers and so we'd have better standards. But it's almost considered a taboo for men to even be interested in the decorative arts and I wonder why shouldn't the man be interested in what kind of fabric they have on their sofas. A lot of men feel that the home is totally foreign to them, so what goes into the home becomes almost trivialized.

Canadian Crafts: Unique or More of the Same?

Winn Burke Canadians as a whole don't look outside themselves very far. They look to the USA, but reject a lot because of a longstanding mistrust of things American. But what indeed is Canadian reverence for any created object when there's an overall cultural lack of reverence for anything? Mostly, Canadians function on a human scale in the role of a peacekeeper, and the Canadian personality stands back, reserved and polite. Still it does contribute to a larger kind of social aesthetic, but that's real nebulous, organic rather than amoebic in quality.

The aesthetic judgment of Canadian society as a whole would gravitate to and revere objects, but there's also an unwillingness to probe one's spirituality in our culture. With the Chinese, for example, there's a reverence for porcelain, and for the spirit and soul of it at a level where the material is not the issue. The Chinese have a context that we can't even hope to think about in our society, one of reverence. We do have richness in our lives, but I think it's more difficult to find, and I think that's the major difference. I don't think there's a sophistication to recognize it, and so it becomes isolated. There isn't the sense of public object to be stimulated by or offended by.

Jeff Goodman I certainly do see very, very well-crafted work all over North America, in both Canada and the United States, but a lot of it is repetitive or derivative. Still you do find a craftsperson who has put the history of glass aside and decidedly said, "This is the specific idea I want to get across and this is how I should do it." On the other side, you find people who are excellent at their crafts and probably have the best work at an exhibition, but it's not the most leading edge or even interesting. It's traditional and beautifully made, and I have nothing against that whatsoever, but I'm always drawn toward work that shows that the maker is really thinking, whatever their country.

Barbara Amesbury I tell people all over the world that I've never seen better woodworking than in Southern Ontario, and it's true. I go to very expensive places in New York and look how their seams are done, how they match things, their finishing, and they're sloppy, sloppy. If you want to know how good a craftsperson is, look how they finish a piece, and Canadians are better at workmanship. Same with the ceramics makers I know. It's not a question of Canadian as such, but the workmanship is just better. Canadians should trust themselves, since our people can stand toe to toe with anybody out there. Canadians are competing on a world class everywhere, except nobody talks about it.

Alison Vallance I think I see a difference between Canadian craft and American craft. On the whole, Canadians tend to be less decorative in their world.

Daniel Crichton In Canada right now there's a lot of interest in glass in relationship to the land and geological ideas. We have variety here, but what's emerging are some of the same issues of critical inquiry as in Canadian art, a concern for the land and culture on it, what we are doing on it and our relationship to it. It's a cultural identity that is most interesting and the most difficult thing to bring out, because it's very easy to import trends from other countries. That's hard to resist and everyone needs a period of self-imposed isolation and not look at those magazines any more. Rather, you need to research and explore the idea, see where it takes you, and break all the colonial habits.

Ingrid Bachmann Indigenous traditions in Canada include certain kinds of basketweaving, quilting and weaving patterns, and broom-making. But the contemporary craft world is pretty international and the values and look of work isn't necessarily bound to a geographic location so much. Still, you might see real distinctions in work that is happening in Eastern Europe, and you do find communities of ideas that formulate around specific practices. Geography can therefore play an enormous role in the aesthetic, the approaches to work, and the support systems like a marketplace and a granting structure. In the past, funding supported much more experimental work, and it's simply not going to be there as the marketplace gains influence.

Artists are formed by where they are, the physical terrain of where they're from, but they're also shaped by other influences. A huge Latino presence shapes an aesthetic, and there's the African-American culture which is prominent in the USA but isn't in Canada. But in Quebec there's another established tradition, perhaps more European. I find that in the USA the shows are too crowded and should have more space, and maybe that's because, in Canada, there physically seems to be more space, it's emptier and our galleries are emptier. Also, in the United States, the economic structure in place plays a role and there's such an unabashed talk about money all the time. In Canada it would seem crass to talk about money.

Terry Craig You can always pick out a Canadian crafts-person because there's a whole different emotion to their work. In the States most of the students are learning to be assistants, but in Canada we want people to experience both our work and our expression. They might teach people to do production work or to help in production work, but it's not their own work. They don't deal with emotion, but, instead, the bank account, so they're not learning from emotion.

Where Does the Craftsperson Belong?

Karen Smeja Crafts are part of me, though they aren't part of the mainstream in our society, so I seek out others to whom I can relate, to whom the crafts are important. It's a smaller society within the larger society of North America, but in Finland I found that people tend to know where linen comes from, where wood comes from, and feel this link is part of their heritage. In North America the mainstream is removed from sources of material. I would love to go back to Finland

Kevin Lockau The stereotype of what the artist should be is a person starving in a garret. I don't agree, and maybe a time will come when recognition of a person working with his hands and mind together is more valued. But I don't think that will be in my lifetime.

Alison Vallance Craftspeople belong wherever they want to be. A craftsperson who is an amateur or hobbyist belongs within that sphere, while the craftspersons who see themselves as designers of objects of limited production belong in another. Craftspeople who see themselves as artists and do one-off work, individual pieces that are investigations and expressions of intent each one unto itself, belong in another sphere. I also submit that people who do work that is not particularly original or well informed, but it is well made, work in another sphere. For me the variety is significant and craftspeople belong in all those places, in the communities where they are accepted.

Joan Chalmers A craftsperson should certainly be considered and recognized as a treasure. Why not, for God's sake, like a national treasure in the Japanese sense? I don't think that a person who makes, say, a dining room table is any less an artist than a painter or a composer, because they contribute originality and uniqueness to our lives. But a lot of people are not concerned with the uniqueness of a craftsperson's creation.

Jeff Goodman There's a real brotherhood among crafts-people. Most of us work really long hours, don't make very much money, and absolutely love what we do. We feel we are doing what we do because we have to. We have no choice since we can't work for other people because we'd just feel we are rotting away. So what we always end up discussing is how we're surviving; that is, if we're making enough money to keep it going and conversely how close we are to doing the absolute work we want to do. At the most basic level those are the two issues for a craftsperson: the bare minimum you can accept to live with your family and how close your work is to where you want it to be, and can you sell it. In other words, how far backward are you going to make salable items. That's a huge issue. It runs your life.

Ingrid Bachmann I consider myself the first audience for my work, but it is very important for me that my work is shown in public arena. I make work to try to understand the world in which we live in some way and that results in these very strange installations and pieces. I wouldn't make work just for me, but I don't know if my work is relevant or interesting or pertinent or if it gives people something, so in that way, it's a big of an act of faith. As I work, there is very much an anticipation of what the reaction might be. That's not a driving motive, but I get these very strange ideas and then I try to realize them. I want to see what they look like and if they'll actually work.

I got into trouble once at a textile conference when I said that I liked textiles because it's a polluted medium. I offended all the traditionalists, but I thought that was a great compliment. Textiles are not pure and can be so many things: a functional medium, the invisible ground surface for painting, a referent to cultural and social traditions that are very particular to class and to culture, mass-produced designer shirts, something that speaks to exploitive labour in the Philippines, industrial textiles used in Holland and in South America. Textiles are therefore the ultimate chameleon, one of great potential, and it's your choice to access that potential or not. Textiles are so incredibly rich and a craftsperson, whatever the medium, belongs in that richness of choice and of possibility.

Haakon Bakken There's no such thing as Canadian crafts if one means contemporary work. The distinction relates to societies which are inherently stable and unchanging, which live in a specific geographic area over a long period of time with little mobility and little exposure to outside design or aesthetic ideals. Contemporary craft work, on the other hand, relates to the sensitivities, ideals and capabilities of one individual, not a large social group.

Susan Warner Keene In our culture you don't acquire specific craft skills and then trot yourself around for people to hire you. Crafts aren't that kind of business. Rather, you function as an artist does, developing your ideas and trying to bring your view forward into the community. Your skills are different from the kind most people have, and yet you are linked to a society in that you are making things for people to enjoy. In some earlier cultures, craftspeople were thought to have supernatural powers, which set them apart from their community, and today we operate in isolation as well. We stay in our studios to produce work, and our connection with others is formalized because it's through exhibition in galleries or at craft fairs, for instance. Except in small towns, people don't say, "That's the teacher and that's the minister and that's the potter," which would be nice, since, the way it is, craftspeople in an urban setting tend to be rather invisible.

Sarah Coote Education includes SOCAD, Nova Scotia College of Art and Design, Kent State University, Alfred University. Now a full-time potter and instructor in Ceramics at Langara College in Vancouver. Has taught widely including Rhode Island School of Design, and as Visiting Professor at La Bisbal in Spain and University of Colorado. Many exhibitions in Canada, USA, and Europe.

Neil Forrest Currently Associate Professor of Ceramics at Nova Scotia College of Art and Design. Education includes SOCAD diploma, B.F.A. from Cranbrook Academy of Art in Michigan, and M. F. A. from Alfred University. Has exhibited in many curated, juried, and one-person exhibitions, and also lectured in Canada, USA, and Europe.

Steven Heinemann Studies at Kansas City Art Institute and graduate work at Alfred University followed 1979 SOCAD graduation. Work is exhibited widely and in numerous private and public collections, both in Canada and internationally. Twice received the Prix d'Excellence at the National Biennial of Ceramics, twice the Fletcher Challenge International in New Zealand, plus Judges' Award at Ceramic International in Japan, and in Canada, Saidye Bronfman Award. Has lectured and taught in Canada, USA, and Europe.

Joanne Noordhuis After Ontario College of Art in graphic design and SOCAD graduation in 1993, residency at Harbourfront Craft Studio. Exhibitions in Canada and USA, plus several awards, including Oakville Mayor's Award, and published images of work. Continues to study widely in Canada and USA.

Karin Pavey B.F.A. from Nova Scotia College of Art and Design after SOCAD graduation in 1983. Teaching includes SOCAD and Toronto's Gardiner Museum. Full-time studio in Toronto. Numerous awards and grants. Recent of many shows include solo exhibit at Prime Gallery in Toronto, and Contemporary Teapots and "For the House and Garden," both in Detroit.

Dale Pereira M.F.A. from Kent State University in 1985 after B.F.A. from Nova Scotia College of Art and SOCAD diploma. Worked three years at Harbourfront Craft Studio and since then a studio potter doing production work. Represented by Prime Gallery. Recipient of a number of Ontario Arts Council grants.

Mary Philpott Studied Fine Art at University of Guelph, focusing on History of Art, Classical History, Latin, Anthropology, Archeology, and Geology. Interest in art and material culture led to study of ceramics and textiles at SOCAD and diploma in 1996. Plans to study in apprenticeship program at Moravian Tile Works in Pennsylvania, then open studio or work in cooperative in Toronto area to make custom tile work as well as functional tableware.

Friederike Rahn Born in England and now maintains a ceramic studio full-time in Vancouver. Completed B.F.A. in Ceramics at Nova Scotia College of Art in 1989, following study at University of British Columbia 1987-88, Emily Carr College of Art in 1987, and SOCAD 1983-86. Exhibitions and publications of work across Canada, USA, and New Zealand.

Laurie Rolland Since SOCAD graduation in 1978, has lived as potter and received numerous grants and awards. Has taught and lectured extensively in Ontario, with intensive workshops at George Brown College in Toronto and Canadore College in North Bay, and in British Columbia. Core member of British Columbia potters' group Fired Up! In numerous publications and in six books including Robin Harper's book *Ceramic Spectrum*. Exhibited in Canada and internationally. In private, public, and corporate collections. Lives in Sechelt, B. C.

Eve Rubenzahl B.Sc. in Psychology from University of Toronto and then studied clay at Koffler Centre in Toronto, then at Capilano College, then graduated from SOCAD. Now member and teacher at Clay Design Studio/Gallery in Toronto that represents twenty potters.

Kee-hung "Eric" Wong Educated in Taiwan, holding B. A. degree in Fine Art. Studied ceramics at SOCAD. Currently a potter in own workshop and teaches at Sheridan College. Exhibited in a number of art and craft shows in Ontario.

Donn Zver Studied at Penland School of Crafts in North Carolina after SOCAD graduation. In 1972 opened studio in Troy, Ontario to create "distinctive line of functional stoneware pottery." Exhibited in Canada, USA, and Europe. In many private and public collections, including National Museum of Civilization, Ontario Potters Collection, Dofasco Collection of Ontario Pottery. Has lectured across Canada, including Banff School of Fine Art and Nova Scotia School of Art and Design.

FURNITURE

Robert Diemert Became journeyman cabinetmaker in 1979 after 4 year apprenticeship with Ernst Schmutz. SOCAD grad in 1983, then furniture designer/maker in Design Cooperative in Toronto. To Dundas, Ontario in 1990 and now designs and makes residential, commercial, and exhibition furniture, especially in "articulated curvilinear forms." Many awards and prizes. Commissions include Bell Canada, Bank of America, the Glenn Gould Foundation, Chalmer's Collection and Toronto's Metro Hall. Technologist at SOCAD Furniture studio since 1995.

Peter Fleming Toronto furnituremaker and designer. Graduate of SOCAD and Humber College. Awards from Metiers d'art du Quebec, Ontario Crafts Council, Ontario Arts Council. Nominated for Bronfman Award in 1990 and Chalmers Award in 1995. Published internationally. Has written criticism and feature articles for major publications. Past member of Ontario Crafts Council Board and many major committees and juries. Leader of workshops in Canada and USA. Teaches furniture design at SOCAD.

Michael Fortune First Saidye Bronfman Award recipient, in 1993, for wood furnishings and in permanent Museum of Civilization collection. His "Number One Revisited Chair" is prized by collectors. Trained and has taught at SOCAD. Known as manufacturing consultant working to turn craft into a "tool for social and economic development" and involved thus in Trinidad and Tobago training workers, under government initiative, to manufacture for export market, and also in Mexico with USA Department of Agriculture.

John Ireland Toronto native, initially involved in carpentry and cabinetmaking, then graduated from SOCAD in Furniture in 1981. Now maintains workshop near Millbrook, Ontario, building furniture mainly. Many major public, corporate and private commissions include Chalmers OCC Building and Toronto Metro Hall. Numerous awards. Married to weaver Barbara Walker.

Randy Kerr Furniture designer and builder in Ottawa, Ontario. Educated at University of Guelph and a SOCAD graduate in 1985. Recipient of Canadian and US awards and grants. Many major exhibitions in Canada, especially Ottawa and Toronto. Many commissions include Ambassador's Desk for Paris Cultural Centre in Paris, France, furniture for Canadian Embassy in Tel Aviv and in Hanoi, and Canadian Consulate in Osaka, and in Munich, ambassador's desk for Canadian Mission at the United Nations.

Sean Ledoux Since graduation from SOCAD Furniture program in 1986 has designed and made everything from commercial reception desks to residential furniture and architectural millwork such as built-in cabinets, stairs, and custom trim. Has developed a production line of living accessories intended as both aesthetic and accessible.

Tom McKenzie Longtime worker in wood and, at age 39, interested in both furniture and sculpture, "left his comfortable life to study furniture at SOCAD." Workshop now in Vernon, British Columbia, where "gainful employment competes with creative time." Expects his young twin sons to inspire "more works reflecting the rediscovered joys of childhood."

Sven Pavey Education includes woodworking at George Brown College, apprenticeship to Paul Epp at Ambiant Woodworks, and SOCAD from 1985-87. Then designed and produced furniture at a Toronto furniture cooperative, worked at woodworking shop in Canmore, Alberta, and now does commission furniture and cabinet work in Wakefield, Quebec.

Sherry Pribik Since graduation from SOCAD in furniture in 1988, has worked as a furniture maker, mostly on residential commissions. Corporate commissions include Truffles Restaurant in Four Seasons Hotel and the Marvelle Koffler Breast Centre at Mt. Sinai Hospital, both in Toronto. Enjoys making speculative pieces for exhibition and sale in galleries.

Tim Rose Owner of Rose Custom Furniture in Caledonia, Ontario since 1989. Does residential commissions, commercial millwork, and speculative work for three Ontario galleries. Taught woodworking at Sheridan College and sells in Canada and the USA. Winner of several awards and grants. SOCAD graduate in 1987. Specializes in high-quality custom furniture.

Clare Scott-Taggart Metalworker and owner of Rusty Girl in Toronto. Makes custom pieces and a small production line of "interesting and whimsical functional garden accessories." A Furniture graduate of SOCAD who, in final year, found metal the only possible material for her designs. Now makes "quirky, expressive forms and strives to capture the life of the sketch in metal pieces."

Jim Todd Graduated from furniture manufacturing program and worked "setting up massive computerized woodworking machinery" with no creative outlet. Studied industrial design and transferred to SOCAD Furniture program, where "the dangerous seed of a furniture designer/maker was planted." Now creates "personal and unique pieces" in Oakville, Ontario studio.

GLASS

Daniel Crichton　　Head of Glass program at SOCAD since 1979. Holds B.A. from Ithica College and a SOCAD graduate. One of the founders of Glass Art Association of Canada, three years member of board of directors of International Glass Arts Society, and brought International Glass Conference to Toronto in 1989. Has lectured and given workshops across Canada, and in Finland, Spain, and the USA. Saidye Bronfman Award in 1994. In many collections including Ottawa's Canadian Museum of Civilization, Montreal's Museum of Fine Arts, Imperial Oil.

Brad Copping　　Graduated from University of Waterloo in 1985, then studied glass at SOCAD. Three-year residency at Toronto's Harbourfront Centre. Studied at Pilchuck Glass School with Dana Zamecnikova and at Haystick Mountain School of Crafts with Michael Schneier. Now, near Aspley, Ontario, does mixed-media sculpture and a line of functional blown glass, and "attempts to find a balance between them."

Laura Donefer　　McGill University B.A. and SOCAD-trained as glassblower. On faculties of SOCAD, Montreal's Espace Verre, Washington State's Pilchuck Glass School, Penland School in North Carolina, and Red Deer College. Has lectured and given workshops at Canadian Embassy in Washington, Tucson Museum of Fine Art, and Tulane University. Many international exhibitions include Japan's Hokkaido Museum of Fine Art, Denmark's Hammelev Arts & Culture Centre, and Art Gallery of Western Australia. Editor of *Glass Gazette* and past president of Glass Art Association of Canada.

Susan Edgerley　　Widely exhibited in North America and Europe, and included in many collections. Taught at SOCAD and now, for eleven years, teaches at Montreal's Espace Verre. Helped establish and develop the many glass programs in Montreal. As president of the board of Le Centre des Metiers du Verre du Quebec, replaced influential glass artist Francois Houde after his tragic death. Responsible for development of "transitional" hot glass studio for graduates of Espace Verre program.

Ian Forbes　　SOCAD graduate and studied at Alfred University, then resident artist at Toronto's Harbourfront Glass Studio for three years, then technologist and teacher at SOCAD. Deep respect for vessel tradition led to study with master Lino Tagliapietra and at Pilchuck Glass Studio. Winner of numerous awards and included in both private and public collections. In 1993, co-founded Bloomfield Glassworks in Picton.

Jeff Goodman　　Graduate of University of Illinois in Fine Art 1986. Also studied at SOCAD 1981-83 and Alfred University 1983-84. Many international exhibitions in Riihimaki Gallery in Finland, France, Germany, Japan, Canada, and USA. Many architectural commissions. Taught at SOCAD 1988-96, plus Red Deer College and Espace Verre. Featured in *New York*, *Time Out*, and *In Style* magazines, plus CBC television. Owns Toronto's Jeff Goodman Studio employing Christina Pickett and Chris Pawluk.

Andrew Kuntz　　SOCAD graduate in 1980 and studied at Ontario College of Art. Numerous awards include AT&T Glass Award. Work in major collections includes Montreal's Musee des Arts Decoratifs and Imperial Oil in Toronto. Exhibited across Canada and USA. Has taught at Alberta College of Art and SOCAD. Glass Studio in Barrie for many years.

Sheila Mahut　　Exhibited internationally and in public collections of the Royal Bank and the Skydome. Graduated from SOCAD in 1984, then B.A. from Illinois State University, studying with glass artist Joel Philip Meyers. Teaches glass-casting and kiln-working at SOCAD. Work reflects variety of interests, from salad bowl sets to large vases to "lost wax" cast figures for sculpture.

Claire Maunsell　　Production glassblower, and work includes perfume bottles, paperweights, bowls, plates, and vases. Hot studio in Kingston, Ontario since 1991. Sells across Canada and the USA. SOCAD graduate in 1988 and resident at Harbourfront glass studio until 1991.

Susan Rankin　　Work in renowned glass collection of Corning Museum. Winner of numerous prizes and published in *New Glass Review* of USA and in *A Treasury of Canadian Craft in Canada/Japan*. Graduated from SOCAD in 1989, three-year resident artist at Harbourfront glass studio in Toronto. Attended workshops at Pilchuck Glass School and Haystack Mountain School of Crafts. Exhibitions in USA, Japan, and throughout Canada.

Donald Robertson　　Currently a teacher and studio head at Le Centre des Metiers du Verre du Quebec in Montreal. Diploma from Dawson College, Ecole Musee des Beaux Arts in Montreal, and SOCAD graduate in 1986. Has studied with glass masters in Europe and USA. Has created many site specific commissions and exhibited in Canada, USA, and Europe. Several research and study grants.

Morna Tudor　　Returned to Vancouver, British Columbia, as a 1986 SOCAD graduate, in 1989, with growing list of awards, grants, and major exhibitions to her credit, and in 1994 co-founded V6 to promote glass art in Vancouver. Recently studied at Pilchuck Glass School and Atlin Art Centre. Work is collected and exhibited worldwide.

Ingrid Bachmann Currently Coordinator of Textile Dapartment at Montreal's Concordia University. Was Visiting Artist at the School of the Art Institute of Chicago, activities include a studio practice, curatorial projects like "Poke Out Her Eyes and Other Stories" with Kai Chan and The Politics of Cloth, writing mostly on textiles and technology, teaching, and collaborative projects. Exhibited extensively in Canada and USA. Recently co-moderated the on-line conference "Persistent Dispositions: Technetronic Identities" that addressed issues of body and technology, and developed the interactive network newsgroup Nomad Web: Sleeping Beauty Wakes Up.

Deborah Kirkegaard B.A. in English from Trent University 1977, courses at Ontario College of Art, and SOCAD graduate in 1984. Teaching includes Department Head of Fabrics Surface Design at New Brunswick Crafts School 1988 and Harbourfront Textile Studio 1988-90. Administrative experience includes Canadian Cultural Centre in Paris 1980, Toronto Dance Theatre 1980-84, Sheridan College Summer School for the Arts 1990-93. Exhibited in Canada and USA. Several awards and grants. Artist-in-Residence at Banff Centre 1990. Featured on CBC TV Arts and Entertainment.

Valerie Knapp After graduation in Textiles from SOCAD in 1975, studied and worked in Paris for one year, and opened Viverie in Toronto to produce printed and painted textiles and clothing until 1987. Then freelanced, including designs for industry, taught for Toronto Board of Education, and at University of Toronto received Ontario Teachers Certificate and a Diploma in Technical Education in 1993. Headed textile program at SOCAD 1993-1996. Exhibited widely and recipient of several awards. Active with Surfacing, Textile Artists & Designers Association, and Ontario Crafts Council.

Anne Lemieux Social Services Diploma from Mohawk College in 1980. SOCAD graduate in 1986, technician in 1988 and became, till now, studio technologist, teacher, coordinator of summer courses and evening programs for SOCAD. Works on commission include prints, murals, tapestries, weavings, and quilts.

Jennifer Morris Works at Reactor Art and Design, a graphic design firm, on embroidery. SOCAD graduate who then worked as photographer's assistant and in 1992 returned to study computer graphics as a means for experimental image making. Resident next at Harbourfront studio. Current explorations involve the Internet as "a new way for the artist to create and reach a new audience."

Loree Ovens Studies at Holland College in P.E.I. and graduate of SOCAD in 1992. Textile Studio resident at Harbourfront Centre for two years. Currently production assistant to Gunnel Hag at Trees Textile Designers and Printers, works at First Hand Canadian Crafts, and owns studio for specialty craft shops production. Has taught silk-screen printing and worked on private commissions. New line of work is "Suburban conscious"

Skye Morrison, Ph.D. Education includes SOCAD 1969-1972, M.A. from Cornell University, Parsons School of Design for summer crafts studies in Japan, and a Ph.D. in Folklore from University of Pennsylvania. Visiting faculty at National Institute of Design in Gujarat, India, and West Surrey College of Art in Farnham, England, and Ontario Science Centre. Longstanding professor at SOCAD. Numerous awards and publications. Extensive exhibitions in Canada, USA, and Europe. Many professional affiliations. A founding life member of Museum for Textiles. Internationally recognized kite expert, thus on TVO's "Kite Crazy" of 1991.

Sarah Quinton M.F.A. in Textile Arts at Philadelphia's Tyler School of Art in 1985. Exhibited across Canada and USA since 1981. Numerous grants and awards. Work in private collections and in Canada Council Art Bank, Kent State University Art Gallery, Wustum Museum of Fine Arts in Wisconsin and others. Has taught at Nova Scotia College of Art and Design, Ontario College of Art, and SOCAD. Wide experience as juror, advisor, visiting lecturer and artist. Since 1994, curator and coordinator at the Museum for Textiles in Toronto.

Carol Sebert In 1988 co-established Creative Matters Incorporated with Donna Hastings and Luba Huzan. Rugs now in commercial and private locations in thirty countries. From Ontario College of Art in 1978 to SOCAD and graduated in 1980. Worked at Stratford Festival and a number of companies. "Continues to work with the manufacturing facilities in Asia to explore the full range of possibilities with custom carpets."

Larissa Swan After high school, explored career options in textiles, ceramics, and early childhood education and decided "to live my life as a maker." Was resident at Harbourfront Craft Textile Studio and is SOCAD Textile program graduate. At Sheridan has taught Textiles in Interior Design and acted as Textile Studio Technologist.

Christina Swerdlow Long intensely involved in fashion textile design and today, with ten years accumulated experience, runs Go-Indigo Fabrics in Montreal, a textile converting company that sells painted fabric to clothing manufacturers. Also Director of VSOP, Very Special Original Prints, and a designer/colour consultant to garment manufacturing companies. SOCAD graduate in 1986.

Barbara Walker One year of weaving at Banff Centre in 1978/79 and to SOCAD, graduating in Textiles in 1983. For six years in Toronto and worked as teacher, colourist and designer of handmade carpets, and other. Exhibited widely in Canada. Coordinator of Millbrook Gallery. Many grants and awards. Since 1988, lives near Millbrook, Ontario with husband, furniture-maker John Ireland.

Biographies — Appreciations and Themes Contributors

Barbra Amesbury, Toronto, Ontario Canadian born but spent most of her working life as a composer and publisher, in the USA and Europe. In 1985 "joined forces with Joan Chalmers to set new standards in the collecting and commissioning of crafts."

Haakon Bakken, Burlington, Ontario SOCAD Metal Studio faculty 1967-80. SOCAD Director 1980-81. Associate Dean Visual Arts and SOCAD 1981-90. Silversmith and jewellery designer widely exhibited in Canada and USA. Fulbright Scholarship recipient. MFA Rochester Institute of Technology.

Helen Beswick, Dundas, Ontario Landscape painter and in '60s to pottery. SOCAD graduate 1979. "Founding mother" of Oakville Potters. Studio in Dundas for 20 years. Writes for magazines & newspapers. Teaches in schools and Burlington Art Centre. Council member in Dundas.

Robert Bowes, SOCAD student 1996-1997

Winn Burke, Bronte, Ontario SOCAD Ceramics faculty since 1972. Extensive research travel includes 3 years archeological excavation photographer in Crete, plus Asia, Middle East, South America, Europe. Frequent consultant. MFA in Art from California State University, taught there & Foothill College.

Jeff Burnette, Vancouver, BC Glassblower since 1979 and SOCAD graduate 1986. Pilchuck scholarship 1994 and studied with Lino Tagliapietra 1994. Taught and self-employed at Andrighetti Glassworks and now part of V6, both in Vancouver. Many Canada and USA exhibitions.

Joan Chalmers, Toronto, Ontario Major philanthropist and long-time financial supporter and leader in Canadian craft movement. Founding member of Canadian Crafts Council and founding president of Ontario Crafts Council. Established Chalmers Fund and several foundations. An Officer of the Order of Canada, recipient of major awards, and sits on major boards.

Lisa Clarke, SOCAD student, 1994–997 Graduate.

Bruce Cochrane, Mississauga, Ontario SOCAD Ceramics faculty since 1979. MFA from Alfred University. Over 100 exhibitions in Canada, USA, Far East. Many major public collections include Victoria and Albert Museum. International workshop presenter and lecturer. Featured in many ceramics publications.

Terry Craig, Oakville, Ontario SOCAD graduate 1996. Resident Harbourfront Glass Studio 1996. Apprentice with William Morris in Seattle 1996-97. Employed by Daniel Crichton, Laura Donefer, Toan Klein.

Daniel Crichton: See Craftspersons' Biographies

Larissa Desjardins, SOCAD student 1996-1997.

Gernot Dick, Atlin, BC Painter, sculptor, photographer, exhibited in Canada and USA. Founder and director of Atlin Art Centre, plus Wilderness Adventure Programs, and teaches by "discovery from within." SOCAD Photography faculty 1970-73 and Design 1973-96. Numerous awards and prizes.

Robert Diemert: See Craftspersons' Biographies

Paul Dolsen, SOCAD student 1994.

Laura Donefer: See Craftspersons' Biographies

Susan Edgerley: See Craftspersons' Biographies

Jan (Finamore) Edwards, SOCAD student 1994-1997.

Peter Fleming: See Craftspersons' Biographies

Michael Fortune: See Craftspersons' Biographies

Jeff Goodman: See Craftspersons' Biographies

Steven Heinemann: See Craftspersons' Biographies

Stephen Hogbin, Lake Charles, Ontario Studied at Royal College of Art, designer for industry, and to Canada in 1968. Taught at University of Toronto, SOCAD, Georgian College, lectured on three continents. Author of books and numerous articles. Curator and cataloguer of several exhibitions. Major commissions include Toronto Resource Library and Queens Park.

Peter James Hollingberry, Artist and SOCAD student 1994

Lisa Hudson, SOCAD student 1994-97. Graduate NSCAD 1998 in textiles.

Deborah Kirkegaard: See Craftspersons' Biographies

Safana Kassam, SOCAD student 1996-1997

Susan Warner Keene, Toronto, Ontario Textile artist and Saidye Bronfman Award recipient. Associate editor, *Ontario Crafts Magazine* 1979-88. Ontario College of Art graduate. Teaches at SOCAD. International exhibitions include Lodz, Poland, Clermont-Ferrand, France, External Affairs touring exhibition of Europe, and Cultural Olympics in Calgary.

Valerie Knapp: See Craftspersons Biographies

Sean Ledoux: See Craftspersons' Biographies

Anne Lemieux: See Craftspersons' Biographies

Kevin Lockau SOCAD instructor of cold-working and hot casting glass since 1986. Ontario College of Art graduate and studied at Pilchuck Glass School. Has given workshops internationally. In many international museums, corporate & private collections

Sheila Mahut: See Craftspersons' Biographies

Sean Martin, SOCAD student 1994-1995.

Donald MacDougall, SOCAD student 1994-1997. Graduate.

Donald MacLennan, SOCAD student 1994-1997. Graduate.

Donald McKinley, Oakville, Ontario Founder and Master of SOCAD Furniture program for 28 years, SOCAD's first director for 5 years. 80+ invitational exhibitions, 60+ juried exhibitions, 50+ prizes and honourable mentions. 60+ public lectures. Extensive participation in conferences, seminars, workshops, and sessions as visiting critic or juror. In many publications, including 15 books.

Wendy Mitchell-Burke, SOCAD student 1996-1999.

Rosalyn Morrison, Toronto, Ontario Now Executive Director of Ontario Arts Council. Arts administrator, international curator, widely published writer. Researches and documents contemporary Canadian glasswork and has curated exhibitions, published catalogues, written extensively on subject. Founding member of the Institute for Contemporary Canadian Craft. Teaches Glass History at SOCAD

Skye Morrison: See Craftspersons' Biographies

Cathleen Nicholson, SOCAD student 1994-1998.

Yukiko Nishiyama, SOCAD student 1994-1997. Graduate.

Theresa Pankratz, SOCAD student 1994-1997. Graduate.

Paul Pearson, SOCAD student 1996.

Verushka Polischuk, SOCAD student 1996-1998.

Sherry Pribik: See Craftspersons' Biographies

Donald Robertson: See Craftspersons' Biographies

Janet Robson, SOCAD student 1994-1995.

Sheldon Schwitek Owner of futon manufacturing business, then SOCAD graduate 1994. Apprentice at the Fabric Workshop in Philadelphia. Works at Museum for Textiles. In Toronto studio works on production items inspired by city's "architectural details."

Karen Smeja (Syrja), Burlington, Ontario SOCAD graduate 1983. From 1983-93 developed and instructed series of children's "adventures in art" programs in schools, libraries, recreation systems of Toronto, Mississauga, and Burlington. Gallery and Weaving assistant at Toronto's BAAS Gallery 1985-87. From 1993 Screenprinting instructor SOCAD.

Stefan Smeja, Burlington, Ontario Four-year cabinetmaking apprentice in Edmonton, to 1980. SOCAD graduate 1983. Manager of Unicorn Universal Woods 1983-84. Technologist SOCAD Furniture studio 1984-1995. Continuing Education Furniture instructor 1988-1996. Now Professor SOCAD Furniture Studio since 1995.

Patricia Taylor, SOCAD student 1996-1997.

Kerri Tedford, SOCAD student 1994-1995.

Jim Todd: See Craftspersons' Biographies

Grace Traya, SOCAD student 1996-1997.

Joanne Trepanier, SOCAD student 1994-1997. Graduate.

Alison Vallance, Toronto, Ontario Academic Director of School of Arts & Design at Sheridan College until 1998. Former associate director at Ontario Arts Council. Textile designer and printer. Graduate of Ontario College of Art and York University with M.E.S. in Environmental Studies.

Barbara Walker: See Craftspersons' Biographies

Dalley Wark, SOCAD student 1996-1999.

Kee-hung "Eric" Wong: See Craftspersons' Biographies

Rachel Young, SOCAD student 1996-1997.

List of Works

CERAMICS

Sarah Coote, Vancouver, British Columbia
pitcher
white stoneware, polychrome glazes
8" wide by 12" high
1995
Photo: Sarah Coote

Neil Forrest, Tantallon, Nova Scotia
Trivet with Flemish lamp pattern
Lantz terracotta, Egyptian paste clay, mortar, & grout
37 cm long by 33 cm wide by 5 cm high
1994
Photo: Jennifer Crane

Steven Heinemann, Richmond Hill, Ontario
Then and Now, vessel
ceramic, multiple firings
67 cm by 58 cm by 23 cm
1995
Photo: Steve Heinemann

Joanne Noordhuis, Toronto, Ontario
Cup and Saucer
porcelain, glossy & matte glazes
5 1/2" by 8" by 8"
1993
Photo: Joanne Noordhuis

Karin Pavey, Toronto, Ontario
wall vase unit
red earthenware, white slip, sgraffito,
coloured glazes
56 cm high by 32 cm long by 14 cm wide
1996
Photo: Karin Pavey

Dale Pereira, Toronto, Ontario
oval platter
earthenware clay, white slip, sgraffito, glaze,
colours over
15" long
1995
Photo: Dale Pereira

Mary Philpott, Burlington, Ontario
tile mural
red earthenware, majolica glaze & stains,
coloured slips & alkaline glaze
150 cm by 100 cm
1995
Photo: Mary Philpott

Friederike Rahn, Vancouver, British Columbia
butterdish
red earthenware, brushed polychrome glazes
8" long by 4" wide by 7" high
1996
Photo: Friederike Rahn

Laurie Rolland, Sechelt, British Columbia
handbuilt jug
stoneware body oxidation fired, chrome oxide stain,
post firing gold; spout/handle w. slip glaze
32 cm high
1996
Photo: Laurie Rolland

Eve Rubenzahl, Toronto, Ontario
soap dish: porcelain, coloured glazes
6 1/2" long by 5" wide by 3" high
1996
Photo: Eve Rubenzahl

Kee-hung "Eric" Wong, Brampton, Ontario
tea pot
stoneware, shino glaze
5"diameter by 4" high
Date: 1995
Photo: Kee-hung "Eric" Wong

Donn Zver, Troy, Ontario
vase
stoneware, reduction fired, teal glaze,
opal blue glaze
14" high by 8" wide
1995
Photo: Elaine A. Daniluk

FURNITURE

Robert Diemert, Dundas, Ontario
Endtable Cabinets
bubinga, macassar ebony
20" high by 24" wide by 24" deep
1995
Photo: Jeremy Jones

Peter Fleming, Toronto, Ontario
Caravel bureau
maple, sandblasted glass, rosewood
760 mm high by 1800 mm long by 720 mm deep
1994
Photo: Jeremy Jones

Michael Fortune, Nelson, British Columbia
Number One Chair
bird's eye maple, ebony inlay, merino wool, silver
26" wide by 26" deep by 34" high
1990
Photo: David Allen

John Ireland, Millbrook, Ontario
railing
bubinga, cast bronze, curly maple, copper, ebony
17' long
1991
Photo: Elaine Kiburn

Randy Kerr, Ottawa, Ontario
Mayor's Council Desk, Ottawa City Hall
curly cherry, burled walnut, walnut, mother of pearl
approx. 1500 mm by 1500 mm by 950 mm
1993
Photo: Justin Wonnacott

Sean Ledoux, North Bay, Ontario
dining/lounging chair
walnut, brass, cotton
22" by 18" by 49"
1993
Photo: Sean Ledoux

Tom McKenzie, Vernon, British Columbia
Eve, writing desk: curly maple, yellow cedar,
blackwalnut, leather, anodized aluminum, quail
feathers, egg shell,
gold leaf
36" high by 36" wide by 20" deep
1993
Photo: Heidi Thompson

Sven Pavey, Alcove, Quebec
fireplace/entertainment centre
bubinga, curly African bubinga veneer,
ebonized curly maple
12' long by 52" high by 24" deep
1989
Photo: Sven Pavey

Sherry Pribik, Toronto, Ontario
Precarious Balance, end table
plywood, 2" poplar squares, poplar legs, dyed maps
15" wide by 15" deep 30" tall
1994
Photo: Sherry Pribik

Tim Rose, Dundas, Ontario
rmoire:
makore, anigre, ebony, mahogany
24 1/2" by 48' by 84"
1995
Photo: Jeremy Jones

Clare Scott-Taggart, Toronto, Ontario
garden gate
cold rolled and cut 16 gauge sheet steel,
interwoven & welded
7' high by 5' wide
1996
Photo: Clare Scott-Taggart

Jim Todd, Oakville, Ontario
armoire: solid australian lacewood feet, lacewood
veneer on medium density fibreboard and flexible
plywood, maple drawers, clear acrylic lacquer
84 1/2" high by 71 9/16 " wide by 20 1/4 " deep
1995
Photo: Peter Hogan

TEXTILES

Ingrid Bachmann, Montréal, Québec
Fault Lines Telemedia Computer Loom project
installation with computer loom, La Centrale,
Montreal, Quebec & Side Street Projects,
Santa Monica, California (with Barbara Layne)
1995
Photo: Paul Litherland

Deborah Kirkegaard, Toronto, Ontario
The Dream
silk-screen printed/pigment/acrylic paint/cotton
60" long by 23 1/4" wide
1990
Photo: Jeremy Jones

Valerie Knapp, Toronto, Ontario
Print Studies 1-12, multi media
97 1/2 cm wide by 161 cm high
1996
Photo: Peter Legris

Anne Lemieux, Waterdown, Ontario
Paysage
Handwoven cloth with painted warp,
screenprinted & beaded
12" by 4"
1991
Photo: David Douglas

Jennifer Morris, Toronto, Ontario
Kaleidoscope
counted cross stitch embroidery, (detail)
46 cm by 33 cm
1992
Photo: Jennifer Morris

Skye Morrison, Hastings, Ontario
Cod Peace: A Kite for the Fishers
Edo style kite, resist-dyed silk laminated to spinnaker
nylon, graphlex rods
90 cm by 115 cm
1995
Photo: Skye Morrison

Loree Ovens, Toronto, Ontario
Urban Dwelling
silk screen print on cotton
9" by 12"
1996
Photo: Loree Ovens

Sarah Quinton, Toronto, Ontario
Acanthus
Wallhanging: wood moulding, acrylic paint, waxed
lacing tape, cotton tape
120 cm by 55 cm by 18 cm
1994
Photo: Peter MacCallum

Carol Sebert, Toronto, Ontario
carpet
handtufted wool, made in Thailand
9' 6"" by 10' 6"
1994
Photo: Carol Sebert

Larissa Swan, Toronto, Ontario
ironing board cover
unbleached cotton, screenprinted, fibre-reactive
Remazol dyes (detail)
16" by 11.5"
1995
Photo: Larissa Swan

Christina Swerdlow, Montreal, Quebec
China Beach
textile print on cotton (82%) & lycra (18%) material
1994
Photo: Christina Swerdlow

Barbara Walker, Millbrook, Ontario
Home Grown Tomatoes
hand dyed linen & cotton
70" by 40"
1987
Photo: Peter Hogan

GLASS

Brad Copping, Apsley, Ontario
Rooted
cedar, hot worked and carved glass
21" diameter
1994
Photo: Brad Copping

Daniel Crichton, Toronto, Ontario
metamorphic vessel
rose quartz
44 cm by 19 cm by 19 cm
1996
Photo: Daniel Crichton

Laura Donefer, Harrowsmith, Ontario
Kali-Black Mother Time
blown glass body parts, bone, sticks, dried kelp,
dried raffia, acrylic paint
5' by 5'
1989
Photo: David Hill

Susan Edgerley, Val Morin, Quebec
Nest/Flight/Bird/Me
gauze, copper, barbed wire, steel
216 cm by 127 cm by 27 cm
1988
Photo: Jocelyn Blais

Ian Forbes, Bloomfield, Ontario
Incalmo bottle
blown glass, hot fused during blowing
38 cm high
1992
Photo: Ian Forbes

Jeff Goodman, Toronto, Ontario
Compass Bowl
handblown glass, etched letters
14" diameter by 8" high
1995
Photo: Tom Feiler

Andrew Kuntz, Georgetown, Ontario
The Conversation
sandcast glass, white portland cement,
cement fondue, silicone
50 cm high
1985/6
Photo: Giorgio Nigro

Sheila Mahut, Etobicoke, Ontario
Seed Pod
vessel & stopper, blown glass bottom,
solid formed glass stopper, powdered
14" high by 5" diameter
1994
Photo: Peter Hogan

Claire Maunsell, Kingston, Ontario
bowl
freeblown glass, coloured w. glass powders,
coloured canes & propane torch
4" high by 9" wide
1991
Photo: Claire Maunsell

Susan Rankin, Apsley, Ontario
Cymbidium White
blown & hotworked glass, sandblasted,
enamelled, painted
28 cm by 21.5 cm by 19 cm
1996
Photo: Trent Photographic

Donald Robertson, Val-Morin, Quebec
The Charge from *The Warrior* series
cast and cut optical crystal, copper, steel
39 cm by 27 cm by 18 cm
1991
Photo: Jocelyn Blais

Morna Tudor, Vancouver, British Columbia
Dulce et Decorum Est from *Sphere Series*
blown glass, reverse painted w. paradise paints,
cut & polished
14 cm by 14 cm by 12 cm
1991
Photo: Kenji Nagai

The School of Crafts and Design

A personal memoir by Donald McKinley

I n 1966 there was a group supportive of the improvement of crafts in Ontario called the Ontario Craft Foundation (OCF). Instead of just looking in the mirror for what they assumed to be true, they concluded through research that there were craftsmen in Ontario who had technical knowledge but insufficient training in design. So they decided that crafts in Ontario needed an actual school of design. They went to the then Minister of Education, Bill Davis, who said they should associate this proposed school with a College of Applied Art and Technology. Around the same time, the OCF discovered a facility in Peel County, which was the bailiwick of Sheridan College, that would be available through lease.

So they found a place to do it and a college to administer the thing. In fact, Jack Porter, who was the first president of Sheridan, had already decided he wanted to have an art program, something not usually anticipated in colleges of applied art and technology. Jack Porter had been a principal of a high school, and he and a former teaching associate, Bill Firth, devised an art course that initially started in Brampton in an abandoned high school. Meanwhile, the OCF did the initial advertising for faculty of the design school. The four studios were to be ceramics, textiles, jewellery, and furniture.

At that time, Bunty Hogg, who worked for the Ontario government in youth recreation and was so active in crafts that her concern extended outside Canada, was proposing and planning the school and suggesting where to look for the school's faculty. Soon she was involved in interviewing the applicants. It's my understanding that there was a wide response of over 150 applicants for the five positions, four studio heads and a director, and they came from over twenty-five countries in North America, Europe, and Australia.

It was assumed that a Canadian applicant who had stayed in Canada wouldn't have as much training as the faculty should have, that advertising in Canada alone would limit applicants to those who had been denied the kind of design school they indeed now wanted to create. So Canadian applicants would have to have travelled somewhere else for education. Anyway, at the time, I was trustee for the good members of the Northeast Region of the American Craft Council. In 1964 I started teaching three-dimensional design as an assistant professor at the State University of New York at Alfred University. Bunty suggested I jury a craft exhibition in Toronto and then asked if I would apply for the position of instructor in the furniture studio.

When I began teaching at Alfred, I was commuting 700 miles each week to get a Master's degree in Industrial Design at Syracuse and feeling more and more confident as to what education ought to involve. What appealed to me, as it did to virtually every other applicant, was to start a new program. I applied for the furniture program and recommended that Jean Delius, who was an excellent administrator, knew jillions of people and was teaching jewellery at Buffalo State, should teach jewellery and/or would make an excellent director, one with whom I had worked in a co-administrative situation.

Then the day I was interviewed and got the furniture job, Robert Held was interviewed for ceramics and Haak Bakken for jewellery, and they both got jobs too. Haak had a Master's degree from the School for American Craftsmen

in Rochester and Bob had his B.F.A. and M.F.A. from California. The textile person they wanted was Doug Mantegna, but Doug was in Italy working on fabrics for fashion at the time, so they talked to him by phone and hired him.

The president of the college, Jack Porter, had been interviewing a lot of applicants for the director's job and was now asking me with increased frequency if I'd be chairman. I was a bit frosted that they hadn't hired my recommendation, Jean Delius, but she didn't have an undergraduate degree and they discovered they could fill all the positions with Master's degrees or, in Doug's case, a professional-technical level equivalent. That was their stated reason, but it seemed reinforced with male chauvinism. Anyway, finally I said I'd be chairman, but only part-time because I wanted to teach furniture. I felt this was a compromise situation, since both positions deserved full-time staff.

If Jean had been hired, she would have been available for dialogue, but they left us shorthanded with four people when there should have been five. Still, with 48 students that would have been a pricey education, but it would have been a better education. In any case, at that point it was a school of design, not crafts, and the 4 by 8 plywood sign outside read "Ontario Craft Foundation, Sheridan College of Applied Art & Technology, School of Design." That sign was up for three or four years until the Ontario Crafts Foundation and the Canadian Crafts Council merged.

So we had 48 warm bodies, most whom were recent high-school graduates, who had expressed an interest, though there were several students in their thirties or older. I'm sure some students were surprised to have classmates the age of their parents. But that wasn't an obstacle then or since. We were leasing, with an option to buy, the 10 1/2 acres called "Lorne Park Collegiate" at 1460 South Sheridan Way in Mississauga, with only a chain-link fence between us and the Queen Elizabeth Highway, and the school year began.

The buildings at Lorne Park were built in 1954 or so as a Free Methodist residential secondary school, and there was a chapel at the opposite corner of the property, which came to be known as the "Design Shrine," whatever the course being taught in it. The residence had two floors and it remained a residence for several years because the Craft Foundation realized there was a need for training that extended province-wide. At least half the students were in residence, and resident directors, a young couple with two children, lived in the building's apartment. The custodian for the Methodists stayed on for many years in the crossover and did the furnace and snowplowing.

Not long after 1970 Sheridan College bought the property for $750,000 which wasn't a bad price for 10 1/2 acres that included five houses where the faculty lived. Incidentally, I took house #5, which was the smallest but the furthest from the QEW and therefore the quietest. Bill Davis had said right at the beginning that the if the design school would associate with a community college that was being funded, then it would be connected to a financial pipeline and get its share. But some say that the Oakville campus of Sheridan College was started with money promised to the Ontario Craft Foundation for the design school.

Whatever the case, after 1970 a wing for textiles was added to the main building, a definitive space for weaving and surface decoration, and then some portable classrooms were brought in from public schools or built. One was the metal studio, one later became a gallery, and the library, before it ended up in Pinecrest, the brick house on the property, was briefly in a pair of portables. Pinecrest also served as a cafeteria for a number of years.

The cast of characters at the school always increased and shifted. During the time I was director, we got Bud Thomas, who had worked closely with Bunty Hogg, as part-time campus administrator. He was a marvellous facilitator, took care of problems we didn't know existed, and had people to his farm for rest and relaxation when they needed it. Betty Kantor also arrived early on and made it clear that her skills were greater than her job as a secretary. She was interested in education and ultimately got her Master's.

By 1976/77, the situation settled down somewhat. Stephen Hogbin had taught design and then he taught it

with Sheila Lamb, and then Gernot Dick, who was teaching photography, took over design. Skye Morrison, a graduate of the program who had got her Master's at Cornell, succeeded Doug Mantegna in textiles. But it was always a community of staff almost from the first day, and we got together a lot. Joyce Chown lived in house #1, Bill Ottemiller in house #2, Bob Held in house #3, where Stephen Hogbin lived for a while, Doug Mantegna in house #4, and I was in #5. In the residence there was a lot of camaraderie among the students, a good thing for those who were isolated for 168 hours a week if they didn't have a car.

But 1976/77 was also a critical year because of cutbacks in construction that began around 1974. Robin Bush, the director for maybe two and a half years after my five years as director, had organized some marvellous proposals for a retail shop and an expansion of the studios, and we thought there was going to be a geodesic meeting hall as well. That fell through and Robin and the faculty lost a little of their heart. Then Giles Talbot Kelly, who had run quite a dazzling program in a polytechnic outside London, England, and was now running his own design office in Toronto, took over.

Giles was there about a year and a half and brought in a lot of part-time faculty, a lot of extracurricular stuff, encouraged people to be non-majors, and had an open-critiquing system in which each faculty took a turn critiquing what students brought in after school. We had the highest enrolment ever when Giles was there, and with the non-major program, people like Susan Schelle, a sculptor now with major commissions around Toronto, as students. The residence was shut down for individual studios and the school had a lot of energy, a definite sense of a director and a direction.

But in some quarters, though there was a big enrollment of maybe 180 students, Giles was perceived as high-handed. For example, in furniture, Stephen Hogbin had left, and we now had Chris Sorensen who was Danish-trained, with Stephen Harris and Paul Epp as part-time and Bruno as technician, all while I was on sabbatical. When Chris called Giles to say he'd be a few days late getting back for the fall semester, Giles told him not to come back then because he didn't work at the school any more. Chris was appalled and he rushed back, and for several reasons, some involving the union, Giles was forced out before Christmas. Into this breach stepped Haak Bakken.

The faculty had agreed by this time that there would now be a rotating chairmanship, and Haak, who was always organized, said he'd take the first shift. He stayed for ten years however, and became a known quality, a stratum, for administration to deal with, and in time as an associate dean who didn't have to deal directly with SOCAD's faculty anymore. Fortunately the faculty had Betty Kantor as a kind of campus administrator all this time, and she became not a stratum but a filter for our views. In this period they shut down the metal program because there were not enough students, but Georgian College then ended up with three times the number of metal students we had had.

One thing that was characteristic of the program initially was that every student had to take four studios all first year and not major in any one of them. So it was perfect for people who wanted occupational therapy training because they felt they might end up teaching "the crafts." That's not why we did it, however, and in time we realized that having students do four studios a week was just making them spin around so they didn't know which one they were doing. Then we said students would take two studios first semester and the other two studios the second semester, and thus get a bigger dose of a studio at one time.

We found that furniture and metal require more planning and concern for accuracy, and that it was almost punishment for a student who ultimately wanted, say, ceramics to simultaneously take metal and furniture. But there is something for a student to learn from each craft, and perhaps have something to fall back on, so today students still take two studios first semester before they decide on a major. That's why the arbitrary amputation of the metal and weaving programs from the school caused many justifiable concerns.

Institutions tend to take institutional certification as a kind of gold sticker and therefore award degrees or

diplomas. But other institutions have acknowledged the achievement of SOCAD too. Dan Crichton, a glassworker, is a graduate of this program and a very important teaching master. Michael Fortune is a graduate and respected furnituremaker who has taught at the school, as has ceramics graduate Steve Heinemann, and all three have received Saidye Bronfman Awards.

Still, no matter its reputation, a crafts school requires a lot of space and fortunately we have had administrations who believe that creative areas should be supported. These administrations have realized that crafts make a difference in people's lives, a different difference than sports do. Every community has an arena for sports, but there aren't as many places that show the arts. In fact, one criticism of many sports is that they end up with a loser, whereas the arts are much like a marathon, in which we celebrate each person finally crossing the line.

When SOCAD started it promised flexibility and an opportunity to be part of a new program that would over the course of time be shaped by the people who were in it. The students made the place what it is, and the quality of what

SOCAD has achieved is because of the participants. So it's important, even just in principle, for the school to stay open as a community of craftspersons, especially as other places are curtailed. SOCAD's contribution is that it opened and stayed open, and the thing to mourn is that not all of the original program is still open. The loss of the metal and weaving studios was painfully significant.

In essence, SOCAD is a place to do things, a place for faculty and students to try things, to explore processes and materials and also find what works as education. We can claim some credit for what a student has accomplished because we did make a situation available, although it was the student's sweat and not ours. We have given easy access to equipment and set up a series of projects, but the quality of the place has ultimately come from the participants, the students.

(Taken from an interview with Donald McKinley, SOCAD's first Director and for almost thirty years its Furniture Studio Master.)